Imogen Cunningham

Portraiture

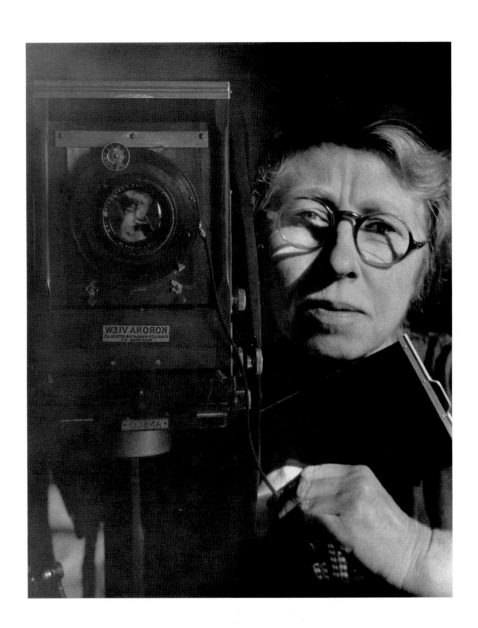

Imogen Cunningham

Portraiture

PHOTOGRAPHS BY IMOGEN CUNNINGHAM
TEXT BY RICHARD LORENZ

A BULFINCH PRESS BOOK
LITTLE, BROWN AND COMPANY
BOSTON ✦ NEW YORK ✦ TORONTO ✦ LONDON

To my mother, Mary Hewko Lorenz,
and in memory of Anna Brodecka Hewko
and Anna Jandrisovits Lorenz Gigler

First Edition

ISBN 0-8212-2437-9
Library of Congress Catalog Card Number 97-71948

Edited by Suzanne Kotz
Designed by Susan E. Kelly and Ed Marquand
Produced by Marquand Books, Inc., Seattle
Type set in Centaur with Arabesque ornaments

Cover: Imogen Cunningham: *Helene Mayer, Fencer*, 1935.
Frontispiece: Imogen Cunningham: *Self-portrait with Korona View*, 1933.
Back cover: Willard Van Dyke: *Imogen Cunningham*, 1933. Collection of The Imogen Cunningham
Trust.

Unless otherwise noted, all illustrations reproduced herein are gelatin silver prints. All photo-
graphs by Imogen Cunningham are in the collection of and reproduced courtesy of The
Imogen Cunningham Trust. Because Cunningham preferred to use the word "about" instead
of "circa" in dating her photographs, this convention is honored in dating her images.

All writings by Alfred Stieglitz are quoted courtesy of the Yale Collection of American
Literature, Beinecke Rare Book and Manuscript Library, Yale University.

All reproduction photography is by Rondal Partridge, except as follows: Center for Creative
Photography, figs. 12, 16, 18, 29; M. Lee Fatherree, back cover, fig. 32, pls. 29, 137; Richard
Lorenz, figs. 3, 5, 17, 20, 21, 35, 36; International Museum of Photography at George Eastman
House, fig. 19, pl. 125.

Bulfinch Press is an imprint and trademark of Little, Brown and Company (Inc.)
Published simultaneously in Canada by Little, Brown & Company (Canada) Limited

PRINTED IN SINGAPORE

Contents

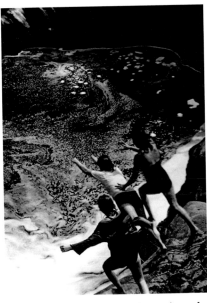

Fig. 1. Imogen Cunningham: *Self-portrait with Bill Hammer,* 1973

Imogen Cunningham: *Portraiture*

The man portrayed and his portrait are two
completely distinct objects.
—JOSÉ ORTEGA Y GASSET[1]

The art of portraiture, even when crafted photographically, can never be
truly objective. Contrary to the longstanding belief that photography pro-
duces honest duplicates of reality, the camera can easily and assiduously lie.
Indeed, the vain sitter frequently demands it, insisting that the photographer
perform a magical transformation. The deception can be achieved by mul-
tiple methods. The environmental context of the photograph modulates its
connotative power. Lighting manipulates and obfuscates reality. The theat-
rics of makeup and costume alter fact and validate illusion. Paradoxically, all
such enhancements and fabrications can still yield the accepted guarantee of
verisimilitude: an unretouched negative. What remains in the end, however,
is largely the creation of the photographer, who has molded the sitter into
what he or she determines the subject should resemble. The dynamics may
fluctuate according to particular personalities, but surely it is the photogra-
pher who always keeps the upper hand (fig. 1).

Philosopher Hans-Georg Gadamer has referred to the relationship
between the portrait image and the sitter as "occasionality" because, within
its pictorial structure, the portrait contains an allusion to the subject that
is the result of the portraitist's intention, not the viewer's interpretation.
The portrait's reference to a particular person, "actually existing outside
the work, defines the function of the art work in the world and constitutes
the cause of its coming into being. This vital relationship between the por-
trait and its object of representation directly reflects the social dimension
of human life as a field of action among persons, with its own repertoire of
signals and messages."[2] Such artistic intent is a reflection of the times and
the individual disposition, experience, and intrinsic talent of the portraitist.

George Bernard Shaw has argued that the camera lens is dispassionate
and unopinionated when compared to the distilled, singular vision of a
painted portrait. He believed that "the painter has a handwriting which
remains the same, no matter how widely his subjects vary. . . . [A photo-
graph] evades the clumsy tyranny of the hand, and so eliminates that curious

element of monstrosity which we call the style or mannerism of the painter."[3] But even the most individualistic personalities can become malleable subjects, if not props, to great declarative photographers, and it is no wonder that we can recognize signature styles in photographic portraiture. Like the paintings of Rembrandt, van Gogh, or Picasso, the works of Julia Margaret Cameron, Hill and Adamson, Cecil Beaton, Bill Brandt, Edward Steichen, Man Ray, Irving Penn, Richard Avedon, Diane Arbus, Robert Mapplethorpe, and others are largely identifiable by their assured, though repetitive and consistent vision. Master photographers translate their subjects into their own language, and their idiosyncratic vocabularies set them apart from the mediocre and the mundane.

In the particular case of Imogen Cunningham, who toiled steadily over seventy years, documenting human complexity while responding to historical precedents as well as developing trends, the interpretation of a body of work is inevitably challenged by its astounding variety. Despite certain repeated motifs and memorable themes, her life's work is divergent and eclectic. Cunningham, photographer of faces, famous or just plain interesting, successfully documented thousands of personalities during her career. Portraiture was her first love and foremost speciality, and, in a sense, the extensive negative and print files she left upon her death form the most illuminating and articulate account of her life—a picture history of her family and friends, her meetings with notable individuals and famous celebrities, students, workers, doctors, and colleagues, not only in America but also in Europe. Cunningham's output corroborates Samuel Butler's surmise that "every man's work, whether it be literature or music or pictures or architecture or anything else, is always a portrait of himself."[4] Gertrude Stein (pl. 94) wrote of herself in the third person and cryptically insinuated her companion Alice B. Toklas to be the author of Stein's life story by entitling it *The Autobiography of Alice B. Toklas*. So might this book of portraiture create the autobiography of Imogen Cunningham, in this case authored by the black-shrouded figure behind her camera.

Cunningham once claimed: "Photography began for me with people and no matter what interest I have given [other things], I have never totally deserted the bigger significance in human life. As document or record of personality I feel that photography isn't surpassed by any other graphic medium."[5] Justifiably, her photographic documents enlighten us with historical and biographical information, charm us with nostalgic appeal, and occasionally thrill us with great beauty and dramatic countenance. The progression of her portraiture through a variety of twentieth-century styles likewise conveys the viewer through a partial history of her medium. From the handsome pictorialism of her early years to the clinically defined modernistic images of the 1920s and 1930s, through the experiments in a surreal-

istic vein and the compelling character studies, often predicated by metaphorical environments, that she created from the 1930s through the early 1970s, and up to the very last images depicting her explorations of old age and impending death, Cunningham was a grand improvisator—responding uncannily to the moment with honest, unpretentious observance and intuitive, artistic vision. She photographed thousands of individuals throughout her career, many in candid public confrontations. The work in this volume was all created for commission or with implicit consent, and thus constitutes the most satisfying dynamic of portraiture: artist and willing subject. These chosen photographs, gleaned from more than twenty thousand images spanning seven decades, confirm Cunningham's rule of thumb: "If a portrait is really good, it is always good."[6]

The pictorial, especially faces, figures, gestures, and the visual expressions of human emotions, always captivated Cunningham. A growing interest in photography compelled her to develop an appropriate course of study at the University of Washington, which she attended from 1903 to 1907. Since photography per se was not taught, she majored in chemistry under Dr. Horace Byers (pl. 2), and took courses in physics, literature, German, and French. As part of a correspondence course, she dabbled with a 4-by-5-inch-format camera during her junior year, and took her first portraits in 1906.[7] These early works include a nude self-portrait and a study of her father, Isaac Burns Cunningham (pl. 1), who built his daughter a makeshift darkroom in the backyard woodshed.

The epochal event that caused Cunningham to decisively focus on a career in photography was her viewing of a profile on Gertrude Käsebier, a New York photographer associated with the Photo-Secession. "Photography as an Emotional Art: A Study of the Work of Gertrude Käsebier" was published in the April 1907 issue of Gustav Stickley's monthly periodical, *The Craftsman*. The article reproduced six studies by Käsebier, including four from her Motherhood series, which profoundly moved Cunningham.[8] The author, Mary Fanton Roberts, writing under the male pseudonym Giles Edgerton, intended to discredit the prevalent idea that photography was a limited mechanical process and introduced Käsebier's images as examples of emotional connotation through photography.

Roberts revealed Käsebier's excitement about artistic photography and its "new method of expression," which was preferable to the stasis in the world of painting: "It is an interesting experience in life to an artist when the medium and the art have grown side by side."[9] The Motherhood images illustrated in the article (fig. 2) were intentionally planned portraits of individuals "with the spiritual side developing during the sitting and being

Fig. 2. Gertrude Käsebier: *The Manger*, 1903. Reproduced in *Camera Work*, no. 1 (January 1903) and *The Craftsman* (April 1907).

accentuated in the printing—in other words, coming through the temperament of the photographer."[10] Käsebier declared that the success of the photographs was achieved by "getting at humanity. . . . I want to acquire the widest possible outlook on life. It's my way of living to the utmost to see other people live, and to prove that I have seen it in my pictures. I do not think of my work as photography, but as opportunity."[11] Her philosophy offered significant stimulus and direction to the young Cunningham, who recalled that "they moved me deeply, those studies of mother and child."[12]

After graduation from the University of Washington, Cunningham worked in the Seattle photographic studio of Edward S. Curtis, well known for the portraits compiled in his twenty-volume compendium, *The North American Indian* (1907–30). His studio was primarily a commercial portrait business with staff photographers whose sitters ranged from visiting celebrities to graduates of the university, including Cunningham (fig. 3). From June 1907 to July 1909 Cunningham worked at the studio principally under the guidance of Adolph F. Muhr, who taught her the technical skills of retouching glass plate negatives and contact printing them on platinum paper in sunlight.[13]

It was while working at the Curtis studio that Cunningham most likely saw *Camera Work,* the quarterly periodical published by Alfred Stieglitz in New York and devoted to new photography, art, and aesthetics. Its exquisitely printed gravure plates, by the leading photographers of the Photo-Secession, undoubtedly encouraged Cunningham to pursue a more complete photographic education. Her university sorority awarded her a $500 fellowship for study abroad, and in the fall of 1909 she enrolled at the Technische Hochschule in Dresden, one of the world's leading institutions for the study of photographic science, under the tutelage of the renowned photochemist

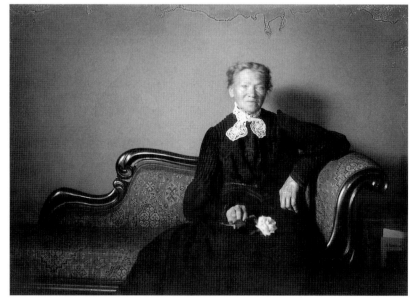

TOP:

Fig. 3. Edward Curtis Studio: *Imogen Cunningham,* 1907. Platinum print. Imogen Cunningham Archives, The Imogen Cunningham Trust, Berkeley, California.

LEFT:

Fig. 4. Imogen Cunningham: *Lady with a Rose,* 1909–10

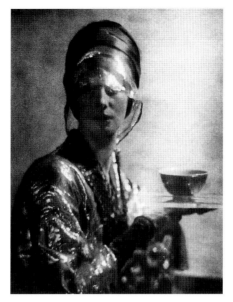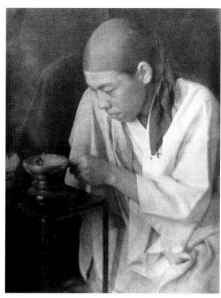

Robert Luther. Although primarily a technician, Luther imparted to Cunningham some sensible and useful information for the practice of portraiture. She commented at a later date about photographing him in his office in 1909–10 (pl. 4): "He said, 'Now I want to do a mathematical problem in my mind, and when you think I've come to the point of greatest intensity of thought, take the picture then.' I think his idea was a good one. . . . Sometimes when people get embarrassed about being photographed I tell them to think about the nicest thing they know. I think that makes a difference. Some people don't think it does. Sometimes people think about nothing at all, and it's hard to get an interesting photograph."[14]

Cunningham took few photographs during her European sojourn, although she did make several handsome portraits of classmates (pls. 5, 6) and their families (fig. 4; pl. 7). These student works are rich images with interesting compositions and convincing chiaroscuro, and are as competent and fully realized as much of the material being published contemporaneously in *Camera Work*. During her stay in Dresden, she visited the 1909 International Photographic Exposition and for the first time closely studied an array of America and Europe's best photographs. She was memorably impressed by the work of Baron Adolph de Meyer and Alvin Langdon Coburn: "The person whose work I remember best at that time was Baron de Meyer, who later came to America and worked for the Condé Nast Company. At that time he lived in Europe and was doing all sorts of delicate and beautiful things with table decorations and fancy elegant women."[15] An image such as de Meyer's *The Cup* (fig. 5), a luminous study of a woman in a shimmering robe and headdress delicately holding a porcelain cup (published in *Camera Work* in 1912), seems a very likely influence on Cunningham and her study of a Japanese friend, *Boy with Incense* (fig. 6).

When she returned to Seattle in September 1910, Cunningham began her own subscription to *Camera Work*, found an affordable studio in an old farmhouse, which had been converted into spaces for artists by a local patron, and set herself up in business as a photographer. Her decision was not merely an answer to the call of the muse, it was a practical matter of selecting a viable profession—an occupation, at that time, primarily sustained through the operation of a portrait studio. During the early years of the twentieth century, there was a scant market for photographs as a collectible art form, and it was necessary to find commissioned work to support the luxury of producing more creative, artistic work. "An occupation merely represents a mode in which the human mind can express itself,"[16] Cunningham once wrote, and years later she recollected:

> It was a matter of making a living. Besides, at that time, magazines weren't taking work from photographers. Or, if they did, it was hardly ever paid for. But I gave them what they wanted, which I don't think anyone else ever did. I was at once popular. I traveled on the streetcar, and I carried a straw suitcase because it wasn't as heavy as a leather one. I packed a 5 × 7 camera in it, twelve plates, and a collapsible tripod. I went to a house and photographed whatever they wanted photographed—usually the children, or Mama and Papa, everybody at home—proofed it, printed it, and was paid very little.[17]

Two artists in studios adjacent to Cunningham's soon became friends and collaborators. Clare Shepard (pl. 12) was a painter of miniatures, and John Butler (pl. 15) specialized in mural paintings. Together and sometimes with John's brother, Ben, they became models for Cunningham's early symbolist-style images. These photographic tableaux (fig. 7) were often set in local forests and along the shores of serene, reflective ponds. Cunningham's models, dressed in classical or medieval garb, enacted scenes from literature such as William Morris's prose romance, *The Wood beyond the World*, or the verses of Yone Noguchi. Cunningham would later refer to this time as her "'dream period' when I read William Morris and thought I understood poetry, especially Swinbourne."[18] Occasionally, the costumes were left behind, literally and figuratively.[19] Cunningham photographed her friends in a purely intuitive fashion (fig. 8), utilizing the landscapes through which they hiked to create effective backdrops for her figural compositions, recalling similar examples in *Camera Work* by such photographers as Clarence White, George Seeley, and Herbert French.

The influence on Cunningham of works reproduced in *Camera Work* was notable. She even wrote Stieglitz a letter of appreciation for "how alive, human and beautifully photographic the Stieglitz gravures are to me."[20] Discussing Clarence White and Stieglitz, she said, "Around 1910 I was interested in everything I could lay my hands on, but always mostly photographs of

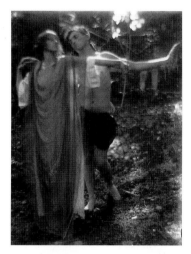

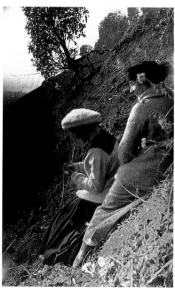

people. I am not very fond of making comparisons either as to work or influence . . . [but] I like each for his own way of expressing an idea. Some of White's things take me into another world. I think Stieglitz always stayed in this one."[21] Cunningham asked Stieglitz for his opinion of a sampling of her work that was on exhibit at the Brooklyn Institute of Arts and Sciences in 1914:

> I do not know of course whether you do keep in touch with these shows or not but wish very much that if you do see my things you would write something about them. You may think if your opinion be discouraging that it is useless but I do not mind discouragements. I want to know. I may as well frankly tell you my ambition—I want to be represented in "Camera Work" some day and I want to work toward that.[22]

Stieglitz responded that he was "doing a great many other people's work," but might manage to see her show. Interestingly, he diminished the importance of photography to his grander scheme of art:

> Picture making as such has its place in the world, but I am interested in ideas and movements and always have been interested in such. . . . Of course I know that every ambitious photographer all over the world would like to see himself, or herself, represented in the pages of "Camera Work." And there is no doubt that much work is being done which is just as good as some of the work which has been represented in its pages. But "Camera Work" means a very definite thing to me and everything that appears in it has a very definite relationship. . . . When I will have stated the cases for photography and art completely, and that work is nearly completed, I shall discontinue publishing the magazine. You see the publication is really a magazine only in name. Its purpose has been least understood by the photographers.[23]

Stieglitz ceased publishing *Camera Work* in 1917 and Cunningham was never included within its pages.

The clientele of Cunningham's Seattle studio included socially prominent men and women, notable authors, musicians, and artists (pl. 8), and mothers and daughters. Many of these early commissioned works are fine examples of period portraiture; occasionally they transcend into fine art through a mechanism noted by turn-of-the-century art critic Sadakichi Hartmann:

> A portrait becomes a work of art only when sitter as well as artist have a strong and decided individuality. If these conditions do not exist, the portrait invariably becomes a conventional interpretation.
>
> To produce a likeness of an ordinary vapid being is impossible without ignoring the laws of art in some way or other, and, sad to state, a portrait that is a work of art is rarely a perfect likeness.[24]

Cunningham's early portraits were exquisitely printed on platinum paper and usually attached to layered gray and brown paper presentation mounts, much in the manner of the Curtis studio. She experimented with nonsilver processes, including gum bichromate and an early form of color photography, the autochrome, a type of positive color transparency developed by Auguste and Louis Lumière. The only extant autochrome by Cunningham is a striking portrait of Lydia Gibson (about 1915, pl. 125), a poet who contributed to Max Eastman's radical periodical of the teens, *The Masses,* and wife of Robert Minor, an artist for *The Masses.*

From these early years on, Cunningham felt a challenge to transform the ordinary sitter of uninteresting appearance by finding "a sense of beauty of the inner man" and discovering those "worthily photographic" traits.[25] She appreciated the eccentric and different over unchallenging and stereotypical beauty, and thought that "one must not have a too pronounced notion of what constitutes beauty in the external, and, above all, must not worship it."[26] Sadakichi Hartmann agreed that the photographer had to be a quick study: "A portrait photographer should be even a better character reader than a portrait painter. He should put into practice the theories of physiognomists . . . as he is continually confronted by people he has never seen. He cannot get acquainted with them like a painter, who commands numerous sittings; he has to rely on his general judgment."[27]

Through her friendship with John Butler and Clare Shepard, Cunningham came to know their former classmate Roi Partridge, who was in Europe studying art. They communicated by letter for two years, until the outbreak of World War I forced Partridge to return to Seattle in 1914. They were married the following year, and Partridge took a studio next to Cunningham's. Partridge soon became a major figure in her imagery, a position he would hold for the next twenty years. One of Cunningham's earliest portraits of him, looking foppish and continental, is taken at the front door of her studio (pl. 16). Within three years, they had three sons, including twins, and Cunningham, posing herself with her babies, began a series of motherhood images (pls. 18, 19) that recalls and rivals that of Käsebier.

In 1917 the family moved to San Francisco, and Cunningham ceased commercial portraiture until 1921. During this hiatus almost all her photographic work revolved around her family, parents, and relations. Frequently shot on the grounds of her parents' farm in Graton, California, these images present an evocative, naturalistic slice of Americana. Cunningham's use of a smaller Graflex camera imparts an immediacy and informality to the portraits of this period (fig. 9, pls. 20–23), in which she effectively utilized the out-of-doors and natural sunlight.

When Cunningham returned to commissioned work in 1921, the family had moved to Oakland, where Partridge had taken a teaching position at

Fig. 9. Imogen Cunningham: *Susan Elizabeth Cunningham on the Farm, Graton,* 1916

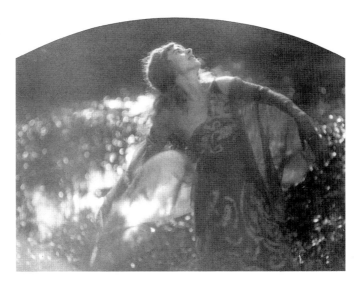

Mills College. Her first significant job was to document the Adolph Bolm Ballet Intime, whose featured dancers included Ruth Page (fig. 10) and Caird Leslie. Once again, Cunningham worked outdoors, setting her shoot of the costumed dancers on the San Francisco site of the 1915 Panama-Pacific International Exposition (now the Palace of Fine Arts). The photographs from this session are literal, artificial, and uninvolving, with little emphasis on personality apart from the dancers' act (fig. 11). But within the year Cunningham would return to more compelling interpretations of her sitters, studying them with enhanced precision. Her portrait of Dane Coolidge (pl. 27), the naturalist and novelist (married to Mary Elizabeth Burroughs, a professor of sociology at Mills College), is a breakthrough image for its assertive realism and unmannered, integral presentation. Likewise, that same year, on a trip to the Monterey peninsula, Cunningham boldly captured a grim-faced fisherman in the brilliant sun (pl. 28), and seemed to realize the urgency and effect of such tightly cropped, detailed pictures. Possibly influenced by the modernist aesthetic of the portraits of Paul Strand taken on the streets of New York City (published in a special double issue of *Camera Work* in June 1917), Cunningham for the first time empowered her pictures by condensing them—focusing closely on her sitters, presenting them honestly with a clear realism, and often ridding the image of pictorialist space.

Partridge and Cunningham were at the center of a group of artists in the Bay Area that included the photographers Anne Brigman, Johan Hagemeyer, Dorothea Lange, and Lange's husband, the painter Maynard Dixon. Hagemeyer (pl. 31), a Dutch emigrant who shuttled between the San Francisco area and Los Angeles, had befriended two other photographers in Los Angeles, Edward Weston and Margrethe Mather, who shared a studio in Glendale. Weston hit it off with Cunningham and Partridge during a trip north in 1920. Later that year, Hagemeyer showed a portfolio of Weston and Mather's work to Cunningham and Partridge, and delivered to them two gift

LEFT:

Fig. 10. Imogen Cunningham: *Ruth Page, Dancer*, 1921

RIGHT:

Fig. 11. Imogen Cunningham: *Adolph Bolm, Dancer*, 1921

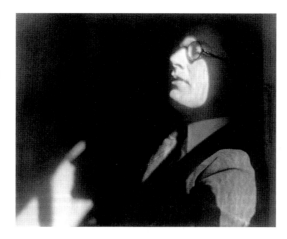

prints from Weston. One of the photographs, *Sun Mask* (fig. 12), a dramatically lit composition of sitter and shadow, elicited a rave response from Cunningham. She commended Weston on his "beautiful and intellectual" imagery: "While it might appear a stunt to most people [*Sun Mask*] is so wonderfully carried out as to be much more."[28] It is interesting to compare Cunningham's 1922 homage to Weston's *Sun Mask* in her portrait of Partridge (fig. 13), one of a group of variants she attempted with different placements of his head in a shaft of light.[29]

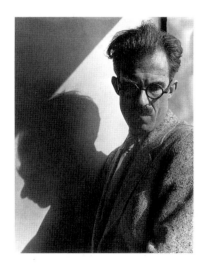

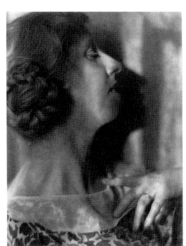

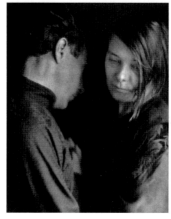

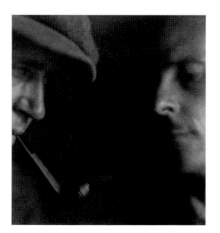

In 1922 Cunningham visited Weston and Mather, and they photographed one another in the Glendale studio using Weston's 11-by-14-inch view camera with an 8-by-10-inch back (fig. 14).[30] Although the use of the same camera and setting imparted similarities to each of the portraits, there are some revealing differences. An emphasis on double portraits emerges in Cunningham's series (fig. 15; pls. 30, 32), perhaps from her viewing of Mather's exceptional study of Hagemeyer and Weston (fig. 16), taken the previous year. (Interestingly, *Vanity Fair* ran an article in December 1922 on "royal" couples from stage and screen such as Douglas and Mary Fairbanks, and Lunt and Fontaine, illustrated by Nicholas Muray with double profile portraits compositionally based on the design of tribute medallions.) After trying Weston's view camera, a size she had not before used, Cunningham was motivated to adopt the 8-by-10-inch format. She continued to explore personas and the nature of relationships in tightly composed dual head studies (pl. 34).

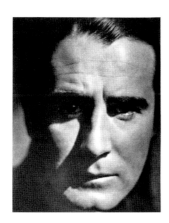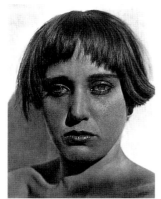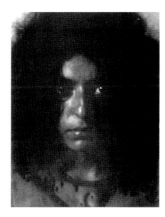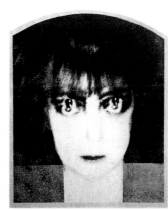

The shift from pictorialism to modernism is evident in the pictures of all of California's premier photographers during the early 1920s. Cunningham, Weston, Mather, and Hagemeyer all tended to reflect one another's ideas contemporaneously, and by 1923–24 each photographer's work betrayed an interest in capturing an ambiguous and provocative essence in their subjects. The viewer is assaulted by glaring stares from the eyes of Roger Sturtevant by Cunningham (pl. 29); the actor Rex Ingram by Mather (fig. 17); the Mexican artist Nahui Olín by Weston (fig. 18); and the actress Rose Bogdanoff by Hagemeyer (fig. 19). All these images seem presaged by the appearance in *Vanity Fair* (October 1922) of Man Ray's haunting portrait of the Marchesa Casati, a shocking double exposure that endows the fabled eccentric society figure with a gaze that stuns (fig. 20).[31] When the work of the West Coast photographers is compared to Man Ray's experiments, only Cunningham's displays a similar inventiveness at so early a period. By about 1923 she had begun to explore the superimposition of imagery, as in

LEFT TO RIGHT:

Fig. 17. Margrethe Mather: *Rex Ingram*, 1923. Courtesy of the Estate of William Justema, Berkeley, California.

Fig. 18. Edward Weston: *Nahui Olín*, 1923. © 1981 Center for Creative Photography, Tucson, Arizona Board of Regents.

Fig. 19. Johan Hagemeyer: *Rose Bogdanoff*, 1924. International Museum of Photography at George Eastman House, Rochester, New York.

Fig. 20. Man Ray: *Marchesa Casati*, 1922. Reproduced in *Vanity Fair* (October 1922).

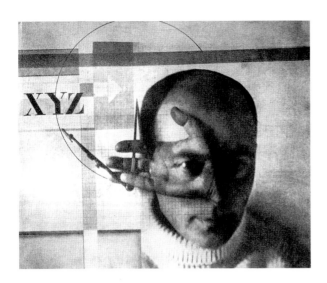

Fig. 21. El Lissitzky: *The Constructor*, 1924.
Reproduced on cover of *foto-auge* (1929).

a portrait of her mother, overlaid with a still life of a pewter pitcher full of spoons (pl. 36). Cunningham had expressed peripheral interest in Italian futurism as far back as 1915, when James Hunecker's article on the Italian futurists appeared in *Vanity Fair*. Marcel Duchamp's infamous cubo-futurist masterpiece, *Nude Descending a Staircase (No. 2)*, the sensation of the 1913 Armory Show in New York, was well known to Cunningham and Partridge as it happened to hang in the Berkeley home of Partridge's print dealer, Frederic C. Torrey. Cunningham's desire to exceed three dimensions into the fourth dimension of time, therefore, entered her work around 1923 but was expanded much more rigorously later in the decade, when she routinely created double exposures as significant variants of many portrait sessions (pls. 60–62).

Cunningham and Weston, along with his son Brett (pl. 33) and the San Francisco photographer Roger Sturtevant, participated in the seminal 1929 *Film und Foto*, an international exhibition in Stuttgart, Germany, that largely defined the nature of avant-garde photography of the period. The catalogue for the exhibition and a companion publication, *foto-auge*, edited by Franz Roh and Jan Tschichold, reproduced numerous innovative images including multiple exposures, photomontages, photograms, and negative imagery. The cover of *foto-auge* reproduced El Lissitzky's self-portrait of 1924, *The Constructor* (fig. 21), a striking example of multilayered graphic design and photographic image, and Roh's stimulating and challenging essay is a call for photographers to experiment: "Contrary to graphic art the principle of organization in photography does not lie in all-ruling manual re-forming of any bit of reality, but in the act of selecting an in every way fruitful fragment of that reality. If in the graphic arts there are a thousand forms of recasting and reducing the exterior world, there are a hundred possibilities of focus, section and lighting in photography, and above all in the choice of the object."[32]

Roh's suggestions may have renewed Cunningham's interest in multiple exposure as an expression of reality, a notion reinforced by Alfred Stieglitz in a statement which Cunningham filed in her notebooks: "To demand the portrait that will be the complete portrait of any person is as futile as to demand that a motion picture be condensed into a single still."[33] The pages of *Vanity Fair* at this time frequently illustrated novel experimental photography, such as the multiple exposures of Baruch, Steichen, and Beaton, and even an occasional photographic advertisement, like a hallucinatory promotion for Fougère Royale aftershave in which an unhappy face floats above and out of a smiling one.

Cunningham's passion for *Vanity Fair* went back at least as far as the mid-teens. The magazine was started in 1914, and from its masthead it shouted, "Modernism is sweeping the intelligent world," and contended that it was a "forum where the most brilliant minds of two continents exchange their ideas" about art and modern thought, that it was, "in a true sense, the mirror of modernity." Published by Condé Nast and edited by Frank Crowninshield, *Vanity Fair* covered a surprisingly wide range of avant-garde art and literature. Cunningham first submitted work to the magazine in 1929. She had photographed the cellist Gerald Warburg (pl. 49) and the Stradivarius Quartet (pl. 50) and thought it likely that *Vanity Fair* would be interested, since Warburg was married to Nast's daughter, Natica. Although these pictures and several subsequent submissions were returned unpublished, Cunningham's persistence paid off when two images she had taken of the dancer Martha Graham were published in the December 1931 issue, aside the blurb: "The rare phenomenon of an American audience cheering a native interpretive dancer occurred in New York last season at the conclusion of Martha Graham's compelling *Primitive Mysteries,* a composition which has been called the most significant piece of choreography yet to come out of America."[34] Cunningham had exposed ninety Graflex negatives in a full-day session with Graham, who, with characteristic expressiveness, emoted and gestured against the dark recess of an open barn door (pl. 59). In the series Cunningham proved her interest in an expanded realism by adding innovative multiple exposures to the pictures (pl. 60).

Vanity Fair managing editor Donald Freeman established a cordial relationship with Cunningham and asked her to commute from Oakland to Los Angeles to photograph movie people. She accepted, on a trial basis, and with a caution to Freeman:

> I am not certain to what extent it would be possible to pierce the shell of artificiality with which the film stars surround themselves, especially if the photographs would have to please them and their managers first before you could use them. I am presuming that you wish me to get as far away as possible from the type of

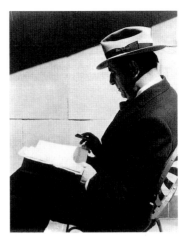

LEFT TO RIGHT:

Fig. 22. Imogen Cunningham:
Joan Blondell, 1933

Fig. 23. Imogen Cunningham:
James Cagney, 1932

Fig. 24. Imogen Cunningham:
Ernst Lubitsch, 1932

portraiture which fills the movie magazines of the day. I should not be interested unless I might be free to try and get more character than this into the work.[35]

Cunningham photographed numerous personalities for *Vanity Fair* during the next four years. Her portraits of actors Spencer Tracy (pl. 66) and Cary Grant (pl. 67) show them relaxed and natural off-screen, while her portraits of actresses Frances Dee (pl. 64) and Joan Blondell (fig. 22) are, if not glamorous, then romanticized. Cunningham thoroughly enjoyed working with those personalities whom she considered "ugly," and she probably was most satisfied by her portraits of screen villains and heavies James Cagney (fig. 23), Wallace Beery (pl. 63), and Warner Oland (pl. 65), which appeared in an article titled "They're Tough To Be Famous." Not all Cunningham's sitters were actors; she photographed the German film director Ernst Lubitsch reading outdoors on a studio lot (fig. 24), and Upton Sinclair (pl. 91), then running for governor of California with his "EPIC—Eliminate Poverty in California" campaign.

Other photographers working in northern California echoed the realism and clarity that Cunningham achieved in her images of the late 1920s and early 1930s. A young photographer named Willard Van Dyke (pl. 72) convinced a group of professional and amateur photographers in 1932 to form a small camera club based on their mutual respect for realism and pure technique. The name "Group f.64" was taken to indicate their interest in sharp focus, the f.64 stop on a camera lens being the aperture capable of yielding the greatest depth of field and clearest image. The members included Cunningham, Edward Weston, Ansel Adams, Van Dyke, Sonya Noskowiak (pl. 68), Henry Swift, and John Paul Edwards, and they agreed to be bound only "by appreciation of pure photography as a medium of personal expression." They felt "that the greatest aesthetic beauty, the fullest power of expression, the real worth of the medium lies in its pure form rather than in its superficial modifications."[36] Edwards contended that the members harbored "no controversy with the photographic pictorialist," yet

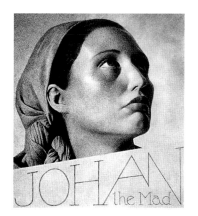

Fig. 25. William Mortensen: *Johan the Mad*, 1931. Reproduced in *Monsters and Madonnas* (1936).

it is obvious that Group f.64 was partly a reaction to the postpictorialism epitomized by the Southern California photographer William Mortensen, whose overwrought images are excessively manipulated with negative reworking and texture screens (fig. 25).

In 1934 Cunningham accepted an offer from Frank Crowninshield to travel to New York for *Vanity Fair.* She photographed Mrs. James Roosevelt, the mother of President Franklin D. Roosevelt, who posed for a Travelers' Aid organization ad with an infant from a modeling agency (pl. 83). She also visited Alfred Stieglitz at his gallery, An American Place, and convinced him to allow her to photograph him with his own 8-by-10-inch view camera, with Georgia O'Keeffe paintings as backdrops (pl. 82; fig. 26). She wrote to him after her visit: "It confirmed my ancient memory of you as the father of us all, the man who has stuck to the anastigmat thru all the futile tossing about of the single meniscus,"[37] and she later recalled:

> I went to New York with plenty of film holders, but neglected to take along an 8 × 10 camera because I thought I would be able to borrow one—which I did. The pictures were to be made by the gray light from a window in the American Place, but the thing that worried me was the Goerz-Dagor lens which had a bulb shutter release. As early as I had begun photography, I had no experience with this equipment. Since the lens markings were so corroded that I couldn't read them, I finally decided to stop down as far as I could and then hold the shutter open as long as I dared—meanwhile watching Stieglitz like a hawk. The exposures of between 5 and 7 seconds may account for the lack of wire sharpness in the negatives; certainly it wasn't subject movement. For although Stieglitz was over seventy at the time, he stood rock-steady for every shot.[38]

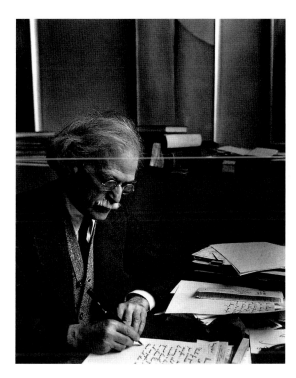

Fig. 26. Imogen Cunningham: *Alfred Stieglitz, Photographer, at His Desk*, 1934

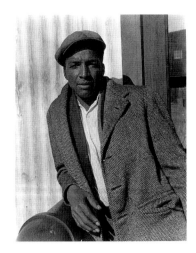

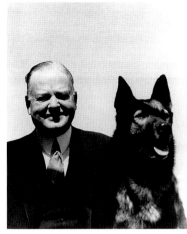

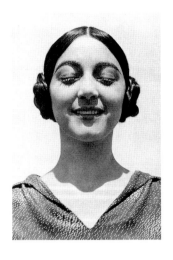

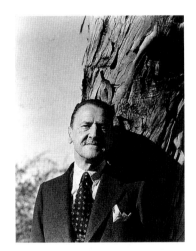

Stieglitz responded positively to a set of prints from the session: "How delighted both O'Keeffe and I were with the prints you were so kind to send us. I never know about portraits of myself. I always consider them good. Crowninshield is going to use one in the next issue of *Vanity Fair*. . . . I often think back to your visit with pleasure."[39]

In 1934 Cunningham demonstrated increasing interest in a combination of formal and documentary photography. Perhaps the breakup of her marriage in that year, with her children grown and out of the house, allowed her the freedom to explore subjects beyond her home base. The trip to the East Coast netted a wealth of fine outdoor candid portraits, especially those done in Hume, Virginia, where she visited old friend John Butler and met local families (pls. 84–86). Walks about the Hooverville at the Oakland waterfront, where the homeless congregated, presented her with opportunities for humane interaction and compelling social documents (fig. 27). Her spontaneously chosen sitters are presented dispassionately in their impoverished surroundings, formalized and ennobled through Cunningham's eye.

Even in her later work for *Vanity Fair*, Cunningham created a casual feeling within what is essentially a formally arranged photograph. She certainly appreciated Edward Weston's outdoor portraits, his heroic heads, shot boldly from below against the sky in clinically delineating sunlight, and she occasionally attempted similarly designed studies. She photographed Herbert Hoover in his study with the distinguished hierarchic formality appropriate to a former president (pl. 95), but then departed from such reverence in another session, where Hoover appears outdoors with his dog, lit by brilliant sun against an unobstructed sky (fig. 28). Cunningham contrasted her picture with Weston's style in a letter to photographer Consuelo Kanaga:

> I have just done Herbert Hoover, and did I sweat. I have no feeling for what I got, since I don't really understand him as a person. I like to try all sorts of people but I go at different kinds differently—I have no rules—and if I had they wouldn't be rules for another person. . . . It is hard to define what makes a thing click but it is also

quite unmistakable when it is there. . . . I am thinking of what you said about the Weston photograph which you call the "fishwife" [fig. 29]. It is a very good likeness of Mrs. Covarrubias. For me the bisymmetry and the pattern of it does not destroy the lady but if you tried the same thing on a clumsy stoic like Mr. Hoover, the result would be caricature.[40]

The study of Hoover was Cunningham's last portrait assignment for *Vanity Fair.* The magazine soon after was incorporated into *Vogue.*

Throughout the 1930s Cunningham produced an enormous body of commissioned portraiture of individuals from the worlds of art, music, literature, dance, and sports. She documented the compelling faces of creative expression in portraits of assorted San Francisco artists such as the Bruton sisters, Maxine Albro, Marian Simpson, John Winkler, and Frida Kahlo, who visited the city while her husband, Diego Rivera, was painting murals at the California School of Fine Arts and the Pacific Stock Exchange. She made eloquent photographs of dancers such as Martha Graham, Hanya Holm, Marian Van Tuyl, and José Limón, and Cunningham's studies of literary figures—Gertrude Stein, John Masefield, James Stephens, and W. Somerset Maugham (fig. 30)—become important aids in understanding the personality behind the prose or poetry. One of Cunningham's finest portraits is a study of her close friend, Helene Mayer, an Olympic fencer who had emigrated from Germany and taught German at Mills College (pl. 97). Mayer's subtle flesh tones and serene expression are juxtaposed with the gleaming wire mesh of her ovoid mask and the brilliant sheen of her saber, which cuts the picture in two, creating both a remarkable formal composition and an iconic representation of a courageous athlete.

Cunningham became a visiting instructor in the newly created photography department of the California School of Fine Arts (now the San Francisco Art Institute) in 1947. The department, headed by Ansel Adams during its first year, came under the direction of Minor White during Cunningham's tenure. White (pl. 193), a young photographer greatly influenced by Edward Weston and Alfred Stieglitz, emphasized metaphysical symbolism. A believer in the significance of a photograph as an "equivalent" of the experience of receiving the image—the visual communication of ecstasy, which was an extension of Stieglitz's philosophy—White also created a novel method for exhibiting images in series, which he called "sequences," to broaden and contexualize the images, often paired with poetic text. Viewing a contact sheet by Cunningham from a representative walkabout from the mid-1940s (fig. 31) in fact can elicit a similar feeling to a White sequence.

White gave Cunningham the portrait class, noting that the students were thoroughly engaged by "her sharp wit and practical understanding of the problems of a direct approach to portraiture."[41] Occasional field trips netted spontaneous and quirky results, such as Cunningham's portrait of

Fig. 31. Imogen Cunningham: *Self-portrait, Mother Lode,* 1945. Contact sheet.

the young photographer Rose Mandel lying on a Half Moon Bay cemetery tombstone and shielding her eyes from the hot afternoon sun (pl. 140). By this time Cunningham had moved from the use of a large-format camera to a medium-format Graflex and, since 1938, a 2¼-by-2¼-inch Rolleiflex. With these portable cameras, Cunningham could respond intuitively to what the world presented her, and from the later 1930s and into the 1950s her imagery —although never overtly political, militant, or journalistic—follows a steady documentary course.

While teaching at the California School of Fine Arts, Cunningham met Lisette Model (pls. 131, 138), whose husband, Evsa, was a visiting instructor in textile design. Model, a staff photographer for *Harper's Bazaar,* had become known for her provocative and caustic portraits of aristocrats taken in Europe during the 1930s, and for her pictures of derelicts, the physically deformed, and the dispossessed in New York City during the 1940s.[42] She became Cunningham's friend and compatriot in a search for meaningful imagery within the subcultures of San Francisco. Model's penchant for the

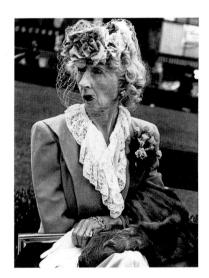 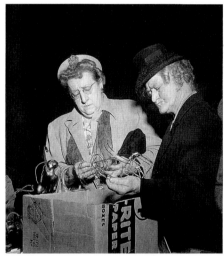 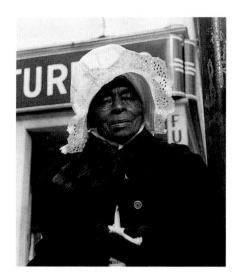

bizarre significantly impacted Cunningham, whose own tendencies toward shock value were definite but more subdued. Model may have intended to present biting social satire and a mockery of ostentatious wealth in her portrait of an outrageously overadorned matron resting on a Union Square bench (fig. 32), but Cunningham never mocked to the point of hurt or insult. Her portraits are not as confrontational nor do they penetrate as viciously; they are generally infused with humanity or a modicum of light-hearted humor (fig. 33). She appreciated the absurdities and extravagences of fashion and frequently photographed women in odd hats or attire who sometimes seem as bemused as Cunningham (fig. 34). Mutual appreciation is a not uncommon aspect of her work, as she herself stated when asked about her

philosophical approach: "Have a good life and let other people have one,
too. I don't interfere with anyone. I'm not jealous of anybody. I just believe
in working. I'm not one of those romantic explainers of my own individual
point of view."[43]

If it was Model who validated and augmented Cunningham's interest in
combing San Francisco's backstreets for stimulating and challenging imagery,
it may have been Minor White who contributed the idea of adding dimen-
sion to a picture by metaphorical allusion, achieved by setting a portrait
within a connotative environment. White's work of the late 1940s often cap-
tured mysterious figures in abstracted, provocative locales, as exemplified by
his industrialized and urbanized Minotaur, descending into the city streets
(fig. 35). White once described his terms, which were largely contrary to
Cunningham's: "My own personal trend of thinking has been towards psy-
chological analysis of photographs. Carrying out the theme that the photo
reveals as much or more of the person than what he photographs to its logi-
cal conclusion, leads to analysis of the inner person as shown by the things
chosen to photograph. . . . An artist has only one subject—himself."[44] Even
if a pragmatic and unemotional realist, Cunningham did absorb White's
predilection for random or natural disintegration as a psychologically reso-
nating context for a photograph. The viewer should seek meaning deeper
than surface appearance, as White suggested in the title for a 1950 sequence
of photographs, "Things for what else they are." White believed that the
"camera *records* superbly, [but] it *transforms* better!" and to read his photo-
graphs is to share the rapture he felt while capturing the image.[45]

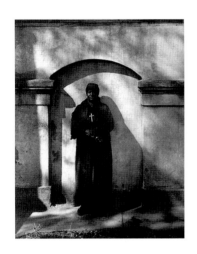

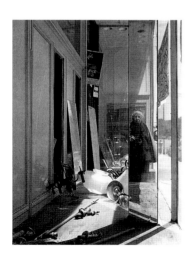

One of Cunningham's most acclaimed portraits is her haunting and introspective study of Morris Graves (pl. 145), the transcendental Northwest painter.[46] Graves's expression of peaceful resignation belies his true distress at and exhaustion with the process of being photographed. White, in fact, used Cunningham's portrait of Graves in his classes on reading photographs, a course of study Cunningham treated with skepticism. "Personally," she claimed, "I don't believe in teaching how to read a photograph. I believe each fellow should learn for himself. What Minor does in teaching I don't know. But he gave them this photograph of mine. They knew nothing of the person photographed. They wrote down their ideas about it, and . . . I said I believed he had more poets in his class than photographers. . . . But the comments were very interesting because they did pick out a lot of stuff that is extremely like Morris Graves, so maybe I did say something about him."[47]

Another significant influence on Cunningham was her appreciation for the mystery and preponderance of signifiers in the work of Clarence John Laughlin. Laughlin, who had guided and worked with Edward Weston during his trip to New Orleans in 1941, visited the Bay Area in the early 1950s to document Victorian architecture. He became an admirer and friend of Cunningham's and presented her with a small collection of his photographs.[48] As one of the few American surrealist photographers, Laughlin produced a large body of work based on themes of death and decay, frequently shot among the ruins of Louisiana's antebellum mansions and the mausoleums of New Orleans's cemeteries. Under his directorial guidance, his models, often veiled to imitate phantasms, created enigmatic tableaux. Laughlin could also uncannily transform reality, as in his superb portrait of the Voodoo priestess "Mother" Brown, who stands before an arched alcove whose shadows form an ominous black scythe (fig. 36).

During the 1950s Cunningham explored the presentation of symbols in her work (pl. 152), although her motifs never seem as calculated, profoundly Zen-inspired, or paranormal as White's or Laughlin's. Cunningham was content to let chance aid her, and she often serendipitously caught her self-portrait image in the most unsuspecting moments. She enjoyed discovering a miragelike mirror image in the debris of abandoned storefronts (fig. 37), like a phoenix out of ashes, or her shadow figure prominent before her camera on building facades, sidewalks, and window displays. For her commissioned portraiture, she began to prefer the idiosyncrasies of urban decay. Writing to a magazine picture editor about these types of images, she noted: "These portraits are not in the mood of your favorite Mr. Karsh but show the environment of the person as important almost as the figure."[49] To photograph the poet Theodore Roethke, she turned his dark coat backward on his chest and, fusing its blackness with the background, isolated his grimacing face (pl. 171). A variant image depicts Roethke before a wall, his figure anchoring

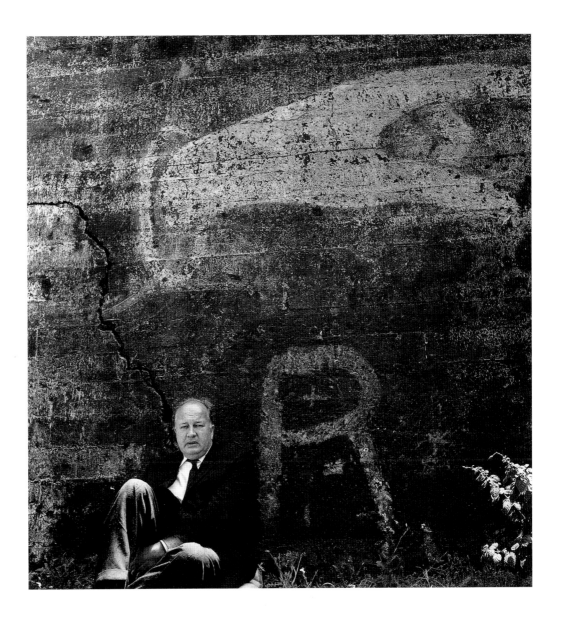

a large crack in a surface that displays assorted graffiti signifiers, including an enormous "R" (his initial) and a pointing hand (fig. 38). Cunningham recalled the session:

> Roethke was a very difficult man, but charged with energy. He was a very special person. You see, I photographed him in his hotel and those were just head shots, so I took him to an alley downstairs where there was a wall. I said to Mrs. Roethke: "Oh, I have a crack coming out of his head," and she said: "Very appropriate." You know, he went off into terrific depressions and had to go to the hospital. He had the saddest life I've ever come in contact with.[50]

In 1956, through the helpful intercession of Lisette Model, Cunningham had a solo exhibition in New York City at Helen Gee's Limelight Gallery, the first in the United States devoted exclusively to the exhibition and sale of photography. While in Manhattan to attend the opening, Cunningham produced a quantity of what she called "documents of the streets" (fig. 39).

Fig. 38. Imogen Cunningham: *Theodore Roethke, Poet, 1959*

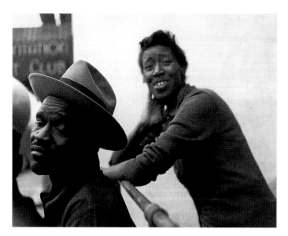 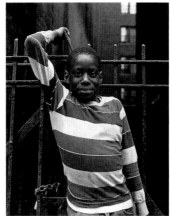 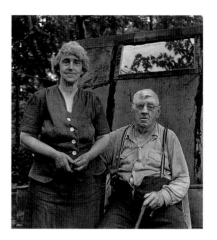

She frequently concentrated on minorities, especially blacks, sometimes taking wide views of frenetic street activity but usually closing in on a compelling face or candid emotion. Her often-reproduced image of a child braced against a padlocked iron gate (fig. 40) well illustrates a critical comment on her Limelight show: "Miss Cunningham's concern with people, reflected in photographs of Negro children on the streets of San Francisco, is at an opposite pole from Lisette Model's intensity of indignation. Miss Cunningham's orientation toward the alienated person is one of quiet sympathy."[51]

Cunningham's East Coast sojourn included a trip to Maine, where she visited her old friend John Butler. Traveling in the countryside, she found many local characters who obliged her with a pose (fig. 41). Regarding her choice of sitters, Cunningham observed: "I don't look for anything. People have to hit me. If you go around looking for something that you've already thought of it's not going to work. It has to arise, it has to come in front of you; it has to be *for* you—and what is for one person is not for another."[52]

As a humanitarian, liberal, and supporter of civil rights, Cunningham produced countless portraits of blacks during the years of segregation. Today it is hard to imagine the power and significance some of her photographs held. Her many images of interracial couples were considered both daring and strident. *Coffee Gallery* (fig. 42), for example, was often singled out by critics as reflecting Cunningham's commitment to equality and social justice: "'In the Coffee Gallery, Grant Avenue, 1960,' showing the affection and understanding between a Negro boy and a white girl, is as powerful an indictment of segregation as many more dramatic photographs."[53] And Alfred Frankenstein, writing of her "particular eloquence as a large-hearted humanitarian with the strictest photographic conscience," suggested to his readership: "Look up . . . the one of the white girl and the Negro boy drinking Seven Up. That one will break your heart into a million pieces if you have any heart at all."[54]

LEFT TO RIGHT:

Fig. 39. Imogen Cunningham: *Couple on the Street,* 1950s

Fig. 40. Imogen Cunningham: *Boy in New York,* 1956

Fig. 41. Imogen Cunningham: *Brother and Sister in Maine,* 1956

Unplanned, uncommissioned portraits were undoubtedly more creatively satisfying and interesting to Cunningham than many of her paid assignments. As the demand for her portrait services increased during the 1950s and 1960s, she became ever more agitated by the difficulty of satisfying commissioning sitters, whose desire for a flattering portrait was often in conflict with her own interest in documenting an interesting but not necessarily handsome face: "People cannot accept themselves as they really are and that's the problem [for] the portrait photographer."[55] Her antipathy grew so acute that she declared:

> I am beginning to hate it. I've already advertised this fact widely. I am not going to photograph anybody who has money and hates his face. That's it. I'm not going to be conned into doing it because of money. I ought to be in a position where I can have a few choices. At first, I never had any choice, and I did the best I could, but believe me, I've had plenty of disappointments from people who don't like their faces.[56]

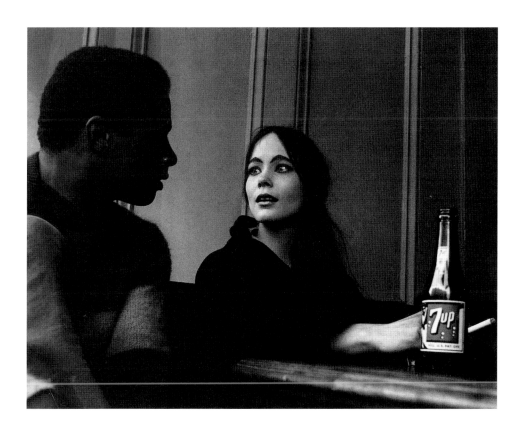

She ran into particular problems with her female clients. Although she recognized that a woman's dress and environment offered creative possibilities unavailable when working with a man, she felt hampered, declaring that "I very seldom have encountered a man who is as vain as women are."[57]

Cunningham contended that "people want themselves the way they see themselves."[58] A case in point was her experience with poet Marianne

Moore, who obliquely critiqued Cunningham's generous and gentle portraits of her (pl. 168): "Isn't it a pity that when I have things on my mind and have been up late, I can defeat any camera? . . . I am afraid I can't say use them."[59] Showing the letter and photographs to the poet Stephen Spender (pl. 169), who considered them "a speaking likeness," Cunningham had to conclude about Moore: "All she wants is to be twenty-five years younger than she is. That's really all she wants. She cannot take time. She can't reconcile herself to her age. Now, you see with me, I don't give a damn."[60]

Vanity annoyed Cunningham and she loathed having her work judged merely for its capacity to flatter. To another unhappy sitter she offered the following comments that she would eventually file with the notation: "Kept this because it shows HOW I dealt with so-called failure":

> There is always the possibility that I am NOT your photographer, and that you should have make up, maybe a little, maybe a lot . . . or the kind of enthusiastic version one hears on the radio "wouldn't it be wonderful to know that your complexion is clear, deep down where beauty begins," and so on ad infinitum. I think we discussed some stuff that is supposed to remove the under-eye effect, if that is the one you are mostly thinking about. . . . You find a good plaster and come back. . . . The truth of the matter is that whenever a camera is in front of a person, no matter how short the exposure of the film, there is always the feeling in the mind of the sitter that the camera is there. My job is supposed to consist of making the shot at the most unconscious moment and to make the sitter forget a bit about the camera.[61]

If not dealing with egoistic conflicts in her sitters, Cunningham often encountered resistance to the photographic process of discovery and submission. She cited her difficulties with Sigmund Freud's daughter, the psychologist Anna Freud, whom she photographed in 1959 (pl. 173):

> We didn't get on too well. She was so tightly programmed I had only fifteen minutes to do the job. She was wearing a pale yellow sweater and no brassiere—all wrong! I asked her "Have you got a dark sweater?" She had, and I buttoned it up to her neck. She still wouldn't unbend, so I suddenly threw a whole pile of Navajo jewelry into her lap to get some reaction. "You treat me like a child," she complained. I said, "Well, it has its advantages."[62]

Cunningham seemed to rediscover delight in darkroom manipulation in the 1960s. She had visited Man Ray in Paris in 1961 (pl. 182),[63] and he undoubtedly helped inspire her to renew assorted darkroom experiments upon her return to America (fig. 43). Another influence was perhaps Germany's Otto Steinert, whose series of Subjektive Fotografie books and exhibitions (in which Cunningham had participated) encouraged many creative tendencies in photography throughout the 1950s, including those seen in the work of Henri Cartier-Bresson, Raoul Hausmann, Heinz Hajek-Halke, Mario Giacomelli, Frederick Sommer, and Val Telberg, which he contrasted with

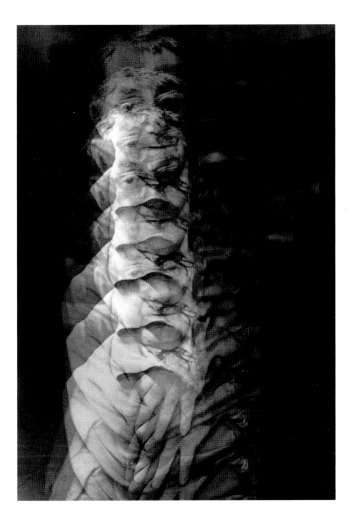

the earlier influences of Man Ray, László Moholy-Nagy, and Herbert Bayer. The various emergent styles included negative images, multiple exposures, photomontages, manipulated negatives, and high contrast printing, all representative of Steinert's opinion that "only a photography sympathetic toward experiment can provide the means to the shaping of our visual experiences. A new photographic style is one of the demands of the time."[64] Cunningham had experimented with these formats in the 1920s and 1930s, and once again took them up. It is interesting to compare the double exposure (or composite negative) portrait on the cover of Steinert's first book, which is printed in negative form (fig. 44), with Cunningham's experiments in portraiture of the following years, such as her negative combination print of Roberta Boynton (fig. 45) and her double exposure of James Broughton (pl. 191), a poet and filmmaker. The Broughton portrait allows identical twins to examine each other within its frame; other similar multiple versions of Broughton on Cunningham's film actually resulted from a chronic jamming problem in her Rolleiflex camera.

In addition to these alternative methods of producing a skewed version of reality, Cunningham frequently salvaged imperfect prints that had become

LEFT:

Fig. 43. Imogen Cunningham: *A Man Ray Version of Man Ray,* 1961

RIGHT TOP, BOTTOM:

Fig. 44. Otto Steinert: *Mask of a Dancer,* 1952. Reproduced on cover of *Subjektive Fotografie* (1952).

Fig. 45. Imogen Cunningham: *Roberta (Negative),* 1961. Unique negative composite print. Imogen Cunningham Archives, The Imogen Cunningham Trust, Berkeley, California.

Fig. 46. Imogen Cunningham: *Sydney at Davenport,*
1964. Unique solarized gelatin silver print. Imogen
Cunningham Archives, The Imogen Cunningham
Trust, Berkeley, California.

accidentally solarized in the developing process (fig. 46), their random drip
patterns juxtaposed with reality and forming delirious accidental imagery.
"Unreality is interesting to me," Cunningham claimed, "but difficult, in such
an exact medium, to achieve. A long time ago I had the idea that printing
from a positive to make a negative picture would be enough unreal for me.
. . . I go along with jamming all sorts of things together but am not always
satisfied with the results."[65] Perhaps Minor White validated Cunningham's
tangent into such abstraction with his comment: "'Camerawork in the pur-
suit of increased consciousness' proves to be a workable way of coming at
the problem of photography for serious individuals of the 1960s. . . . It's in
the air."[66]

White produced the first major publication to laud Cunningham's
achievements. As editor of *Aperture,* the important photography periodical, he
devoted the entire winter 1964 issue to Cunningham, reproducing forty-four
images, from her early Seattle portrait of Mrs. Elizabeth Champney (pl. 8)
to several new portraits created especially for the issue. The Polaroid Land
Corporation sponsored the back cover with an advertisement reproducing
an image made on its new film by each issue's participating photographer.
Cunningham obliged and managed to overcome a frustrating period of
experimentation with the Polaroid materials: "I should put myself in a posi-
tion to get a job with Polaroid as I was so intrigued with doing the adver-
tisement for this issue, that I nearly killed myself every day. . . . I think it
is the most exciting invention of the century in the photographic field and
it is the MOST FRUSTRATING in actual practice."[67] She produced a
startlingly odd and sexy picture of a reclining nude black man, a Munch-like
painting hovering over his shoulder (fig. 47). White was shocked by the
portrait and concerned about model William Halliman's "power and

arrogance."[68] He eventually did use the image, but inside, and placed a "safer"[69] image on the back cover, of Cunningham's neighbor Jose Lerma, contemplatively gazing through his window (fig. 48) to offer the Polaroid endorsement.

Until about 1973 Cunningham continued a period of intense experimentation with manipulated composite negatives, often incorporating accidental happenstance. A composite of two or three sandwiched negatives as in *Warning* (pl. 204) or straightforward double exposures such as *Two Aikos* (pl. 205) exemplify the zest with which she still created imagery. She had an incredible capacity for creative solutions and took a dadaesque delight in the possibilities presented by random accidents. For *Chris through the Curtain* (pl. 206), she made a composite of a 2¼-by-2¼-inch portrait negative with a completely damaged 4-by-5-inch Polaroid negative of nothing but abstract pattern. She found interesting vignetted form in another damaged Polaroid negative of Dennis Hall (pl. 207) and fully enjoyed the occasional glitches made in negatives when her camera inadequately advanced film and overlapped frames (pl. 208).

Cunningham, in her ninetieth year, planned a major new series appropriately called After Ninety. Her interest in photographically documenting the lives of nonagenarians, her own as well as others', carried her waning energies to the end of her life. The series stands in final testament to the all-encompassing humanity of Cunningham's portrait career. She confronted the manner in which the old exist in our society, and how they relate their

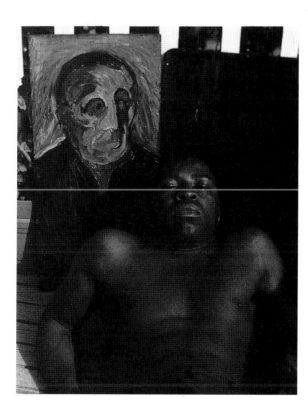

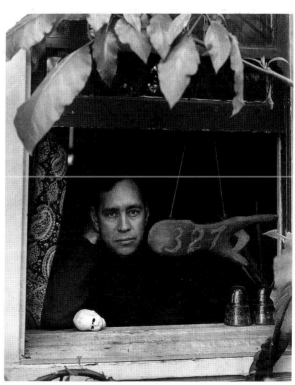

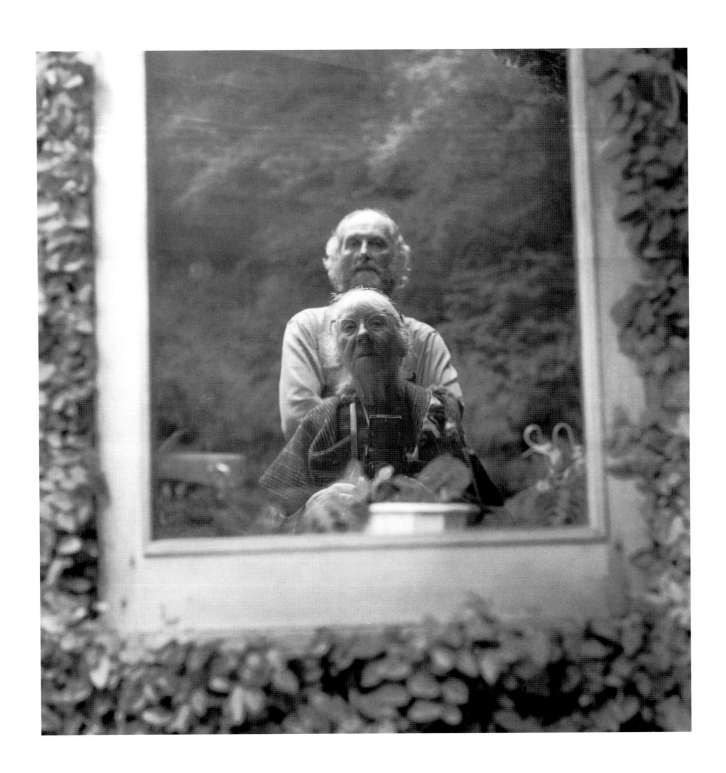

Fig. 49. Imogen Cunningham: *Self-portrait with Morris Graves 2*, 1973

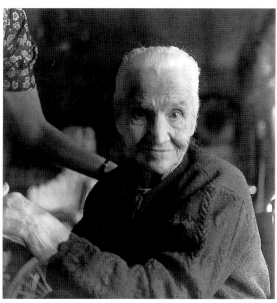

Fig. 50. Imogen Cunningham: *Woman in Convalescent Center, Berkeley,* 1975

present lives to past accomplishments and abandoned dreams. Resolved to primarily photograph society's true elders—her chronological equals—Cunningham nevertheless stretched the parameters of the series to include other interesting but not quite as ancient individuals. She sought out friends from the past, like Morris Graves, who once again projected his haunting beauty into her lens (pl. 213, fig. 49); her former husband, Roi Partridge (pl. 215); and colleagues such as Ansel Adams (pl. 211) and Karl Struss (pl. 218). Many of her subjects, however, appeared serendipitously or in narrower searches in convalescent centers (fig. 50) and convents (pl. 220). In the introduction to what would be a posthumously published monograph, Margaretta Mitchell noted that "few artists live or work to such a fine old age . . . whose work confronts this stage of life without fear, without condescension, but with self-identification and compassion."[70] Simone de Beauvoir in *Coming of Age* admonishes us to "recognize ourselves in this old man or in this old woman. It must be done if we are to take upon ourselves the entirety of our human state."[71] Perhaps that is Cunningham's most poignant message.

Her real achievement, according to one critic, can be best found "in those photographs that are as straightforward, unselfconscious, and no-nonsense as she herself was. . . . [Cunningham's] pictures of people . . . reflect . . . what seems to have been an untiring and continually self-renewing inquisitiveness."[72] That curiosity naturally propelled her to uncover the intrinsic attraction of the portrait photograph:

> The thing that's fascinating about portraiture is that nobody is alike. Ansel [Adams] once said to somebody that I was versatile, but what he really meant was that I jump around. I'm never satisfied staying in one spot very long. I couldn't stay with the mountains, and I couldn't stay with the trees, and I couldn't stay with the rivers. But I can always stay with people, because they really are different.[73]

NOTES

1. José Ortega y Gasset, "The Dehumanization of Art" (1925), in *Ortega y Gasset: Velázquez, Goya and the Dehumanization of Art*, trans. Alexis Brown (New York: W. W. Norton, 1972), p. 68.

2. Richard Brilliant, *Portraiture* (Cambridge: Harvard University Press, 1991), pp. 7–8. Brilliant refers to Hans-Georg Gadamer, *Truth and Method*, trans. G. Barden and J. Cumming (London, 1975), pp. 127–29.

3. George Bernard Shaw, "The Unmechanicalness of Photography, An Introduction to the London Photographic Exhibitions, 1902," reprinted in *Bernard Shaw on Photography*, ed. Bill Jay and Margaret Moore (Salt Lake City: Peregrine Smith Books, 1989), pp. 77–78.

4. Samuel Butler, *The Way of All Flesh* (New York: The Modern Library, 1950), p. 85.

5. Quoted in John Paul Edwards, "Group f:64," *Camera Craft* 42, no. 3 (March 1935), p. 113.

6. Cunningham to Ann E. Armstrong (Museum of Modern Art, New York), Oct. 28, 1946, Imogen Cunningham Archives, The Imogen Cunningham Trust, Berkeley, California (hereafter cited as ICA).

7. For a detailed account of Cunningham's early years and a discussion of the dating of her first photographs, see Richard Lorenz, *Imogen Cunningham: Ideas without End* (San Francisco: Chronicle Books, 1993), pp. 11–13.

8. Cunningham stated in a 1959 interview that her entrance into photography was a result of viewing Käsebier's work: "The way I got there was just from seeing something, and I never have forgotten the impact of the photographs I saw in a number of *The Craftsman*. . . . It was the work of Gertrude Käsebier that interested me. . . . I can remember to this moment the things in one article in *The Craftsman*: her daughter standing in a doorway, her hand on her child—mother and child—things like that." See Imogen Cunningham, interview by Edna Tartaul Daniel, June 1959, transcript, Regional Oral History Project, University of California, Berkeley, pp. 18–19 (hereafter cited as Cunningham/Daniel).

9. Giles Edgerton (Mary Fanton Roberts), "Photography as an Emotional Art: A Study of the Work of Gertrude Käsebier," *The Craftsman* 12, no. 1 (April 1907), p. 87.

10. Ibid., p. 92.

11. Ibid., p. 90.

12. Grover Sales, "Imogen," *San Francisco* (Aug. 1971), p. 28, clipping, ICA.

13. Barbara A. Davis, *Edward S. Curtis: The Life and Times of a Shadow Catcher* (San Francisco: Chronicle Books, 1985), p. 54.

14. Cunningham/Daniel, p. 59.

15. Ibid., p. 51.

16. Imogen Cunningham, "Photography as a Profession for Women," *The Arrow of Pi Beta Phi* 29, no. 2 (Jan. 1913), p. 204.

17. Imogen Cunningham, quoted in Paul Hill and Thomas Cooper, *Dialogue with Photography* (New York: Farrar/Straus/Giroux, 1979), p. 296. To the question "At that time did your portraiture have a soft-focus, pictorialist style?" she responded, "In 1910 I had a Pinkerman Smith lens and I used it alot, but not for portraits. I had a sharp lens for those. . . . I think all the regular studios used sharp lenses."

18. Cunningham to John Szarkowski (Museum of Modern Art, New York), 1963, ICA.

19. Cunningham, having photographed herself nude in a field in 1906, began a series of outdoor studies of nude male and female couples in 1910. These images of her first and last paid models provided her with another avenue for creative figurative expression. Cunningham explored the nude in the landscape repeatedly throughout the years. See Lorenz, *Imogen Cunningham*, pp. 17–20.

20. Cunningham to Alfred Stieglitz, Dec. 28, 1911, Alfred Stieglitz Papers, Beinecke Rare Book and Manuscript Library, Yale University, New Haven, Conn.

21. Cunningham to Peter Bunnell, c. 1960, Imogen Cunningham Papers, Archives of American Art, Smithsonian Institution, roll 1634.

22. Cunningham to Alfred Stieglitz, Feb. 5, 1914, Stieglitz Papers.

23. Alfred Stieglitz to Cunningham, Feb. 20, 1914, Stieglitz Papers.

24. Sadakichi Hartmann, "Portrait Painting and Portrait Photography," in *The Valiant Knights of Daguerre, Selected Critical Essays on Photography and Profiles of Photographic Pioneers by Sadakichi Hartmann*, ed. Harry W. Lawton and George Knox (Berkeley: University of California Press, 1978), p. 36.

25. Imogen Cunningham, quoted in Flora Huntley Maschmedt, "Imogen Cunningham—An Appreciation," *Wilson's Photographic Magazine* 51, no. 3 (March 1914), p. 97.

26. Ibid.

27. Hartmann, "Portrait Painting and Portrait Photography," p. 44.

28. Cunningham to Edward Weston, July 27, 1920, Edward Weston Papers, Center for Creative Photography, University of Arizona, Tucson.

29. Perhaps not in direct homage to Weston's *Sun Mask*, Cunningham made many photographs of individuals holding masks in bright sun, allowing the shadows of the masks to form variant grotesque shapes on their own faces and bodies. These images range in date from about 1923 to 1932.

30. Weston also photographed Roi Partridge at the same time, and Partridge made an etching of Weston posing with his studio view camera (Collection of Rondal Partridge, Berkeley, California), as well as a study of Mather (now lost). Photographs of Cunningham and Partridge by Mather have yet to be discovered. It is unclear if Cunningham photographed Hagemeyer in the San Francisco area or in Los Angeles. Although Hagemeyer photographed Partridge (for an illustration, see plate 14 in Richard Lorenz, "Johan Hagemeyer, A Lifetime of Camera Portraits," in *Johan Hagemeyer*, The Archive, Center for Creative Photography, University of Arizona, Tucson, no. 16 [June 1982]), no portraits of Cunningham by Hagemeyer have been discovered.

31. "Marchesa Casati: A Subject for Twenty Painters, A Few of the Many Portraits of Her, Executed by European Artists," *Vanity Fair* (Oct. 1922), p. 46. Man Ray's portrait is observed to "convey the Marchesa's gift of double vision." A photograph of a Jacob Epstein bronze bust of the Marchesa also appeared in the same article. The bust, "by England's most widely known sculptor," had been recently exhibited at the Sculptor's Gallery in New York. Cunningham would coincidentally photograph the same Epstein bust for David Prall between 1923 and 1927 for his book *Aesthetic Judgment* (1929). Prall, brother-in-law of Sherwood Anderson, was a professor of philosophy at the University of California, Berkeley, and a friend of the Partridges. Cunningham's still life of the bust is dramatically sunlit and an unusual example of art reproduction photography performed outdoors.

32. Franz Roh, "Mechanism and Expression, The Essence and Value of Photography," in *foto-auge*, ed. Franz Roh and Jan Tschichold (Stuttgart: Akademischer Verlag dr. Fritz Wedekind, 1929), p. 16.

33. Stieglitz quote written in Cunningham's hand, undated, ICA.

34. "Martha Graham," *Vanity Fair* (Dec. 1931), pp. 50–51.

35. Cunningham to Donald Freeman, Jan. 19, 1932, ICA.

36. Edwards, "Group f:64," p. 107.

37. Cunningham to Alfred Stieglitz, Dec. 18, 1934, Stieglitz Papers.

38. Imogen Cunningham, quoted in "The Last Word: Letters from Our Readers," *Modern Photography* 15, no. 5 (May 1951), p. 10.

39. Alfred Stieglitz to Cunningham, Feb. 3, 1935, ICA.

40. Cunningham to Consuelo Kanaga, Oct. 2, 1935, copy, ICA.

41. Minor White, "Photography in an Art School," *U.S. Camera* 12, no. 7 (July 1949), p. 49.

42. Lisette Model, Austrian by birth, immigrated to the United States in 1938. She lived in San Francisco during the summer of 1946, at which time she had an exhibition of her photographs at the California Palace of the Legion of Honor. She photographed a group of individuals who contributed to the "intellectual climate of San Francisco," including Cunningham, for an article in the February 1947 *Harper's Bazaar*. Model also taught at the California School of Fine Arts during the fall semester of 1949.

43. Hill and Cooper, *Dialogue with Photography*, p. 306.

44. Minor White to Ansel Adams, March 8, 1947, quoted in Peter Bunnell, Maria Pellerano, and Joseph Rauch, *Minor White: The Eye That Shapes* (Princeton: The Art Museum, Princeton University; Boston: Bulfinch/ Little Brown, 1989), p. 25.

45. Minor White, *Mirrors Messages Manifestations* (New York: Aperture, 1969), p. 106.

46. Morris Graves, having been denied conscientious objector status during World War II, was imprisoned for refusing induction into military service. A recurring motif in Graves's paintings was a reclusive and tormented bird with which he identified.

47. Cunningham/Daniel, pp. 132–33.

48. Laughlin titled his prints but additionally mentioned to Cunningham: "I don't think I should write you any notes for these—as I feel that you are quite sensitive enough to figure out things for yourself. P.S. If I do get back to San Francisco—I hope we can have a meeting of kindred spirits again" (Laughlin to Cunningham, Jan. 6, 1952, Cunningham Papers, roll 1633). Interestingly, one of the prints Laughlin sent was *Remembrance of Things Past* (1951), the Proustian title Cunningham also used for her own 1970–73 double-negative image.

49. Cunningham to J. Strassberg (*Wisdom Magazine*, Beverley Hills), c. 1956, ICA.

50. Hill and Cooper, *Dialogue with Photography*, p. 307.

51. John Barkley Hart, *The Village Voice*, June 6, 1956, clipping, ICA.

52. Judith Rich, "Westways Women: In Focus with Imogen Cunningham," *Westways* (Aug. 1976) p. 22, clipping, ICA.

53. "Photography: Imogen Cunningham, San Francisco Museum of Art," exhibition review, *Artforum* (April 1965), clipping, ICA.

54. Alfred Frankenstein, "The World of Art: A Photographic Conscience," exhibition review, *The San Francisco Chronicle*, Feb. 25, 1965, clipping, ICA. In a later interview, Grover Sales credited the image with summing up an era "when white goddesses of the 'beat' culture began to discover that 'black is beautiful,'" although Cunningham maintained, "That picture was an accident—I pushed the 7Up bottle over to him to get something in the picture to indicate where they were" (Sales, "Imogen," p. 31).

55. Imogen Cunningham, undated audio tape, ICA.

56. Hill and Cooper, *Dialogue with Photography*, p. 303.

57. Imogen Cunningham, undated audio tape, ICA.

58. Rich, "Westways Women," pp. 18–19.

59. Marianne Moore to Cunningham, undated (1957), ICA.

60. Cunningham/Daniel, p. 135.

61. Cunningham to Ruth Anderson, March 20, 1955, ICA. Cunningham wrote her again two years later: "This is the year that I have decided upon to settle all my obligations or throw them out the window. I feel sure that you will have gone elsewhere in the last two years, but still I would like to try again, having perfected in the meanwhile what I call 'facelifting.' When you came to me, I was not conscious that you needed any such treatment but your note, which I have kept, now reminds me that some little something beside the direct photograph would suit you better. . . . The Eastman House in Rochester . . . [is] now collecting me for their historic museum. I am sure that not all the portraits I have done are of interest in this way, but I am always hoping and trying and mostly with what photographers call difficult people. I do not exactly know what that means. I usually think it is people who cannot face themselves. We all have a little of that, and some have more. . . ." (Cunningham to Ruth Anderson, Jan. 6, 1957, ICA).

62. Sales, "Imogen," p. 28.

63. About photographing Man Ray, Cunningham recounted: "When I photographed him in Paris, I tried to put something in his hand, a long pencil with a flower on the end of it that I thought looked like an interesting symbol, and I handed it to him, and he said, 'I can't hold that. It belongs to my wife.'" Quoted in Margery Mann, *Imogen! Imogen Cunningham Photographs 1910–1973* (Seattle: University of Washington Press, 1974), p. 16.

64. Otto Steinert, "What This Book Is About," in *Subjektive Fotografie, A Collection of Modern European Photography* (Bonn/Rhein: Brüder Auer Verlag, 1952), p. 26.

65. Cunningham to Janet Greenberg (*Modern Photography*), May 10, 1972, ICA.

66. Minor White to Cunningham, Nov. 12, 1963, Imogen Cunningham Papers, roll 1634.

67. Imogen Cunningham, "Imogen Cunningham," *Aperture* 11, no. 4 (Winter 1964), p. 174.

68. Minor White to Cunningham, Feb. 23, 1964, Imogen Cunningham Papers, roll 1633.

69. Ibid.

70. Margaretta Mitchell, *After Ninety, Imogen Cunningham* (Seattle: University of Washington Press, 1977), p. 9.

71. Quoted in ibid.

72. Thomas Albright, "The Cunningham Paradox: Photography of Imogen Cunningham: A Centennial Selection," exhibition review, *San Francisco Chronicle* (Review section), March 6, 1983, p. 13.

73. Hill and Cooper, *Dialogue with Photography*, p. 307.

Plates

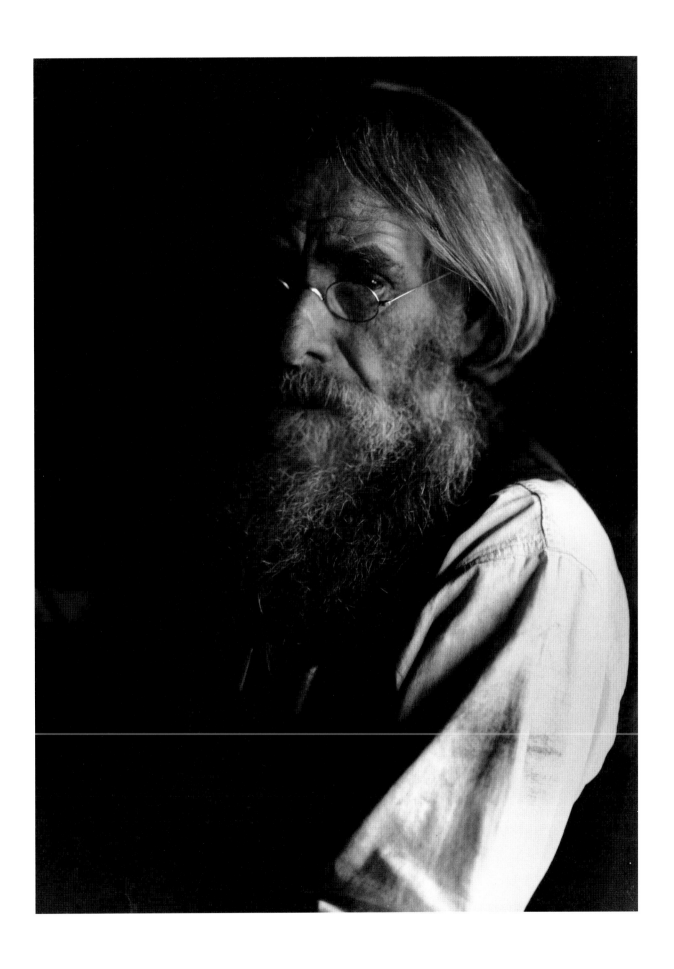

PLATE I

My Father at Sixty, 1906

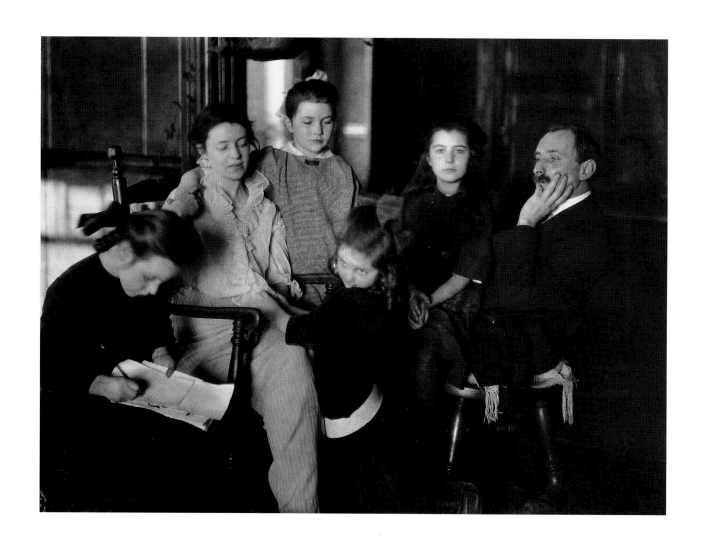

PLATE 2

Dr. Horace Byers, Chemistry Professor, and Family, Seattle, 1906–9

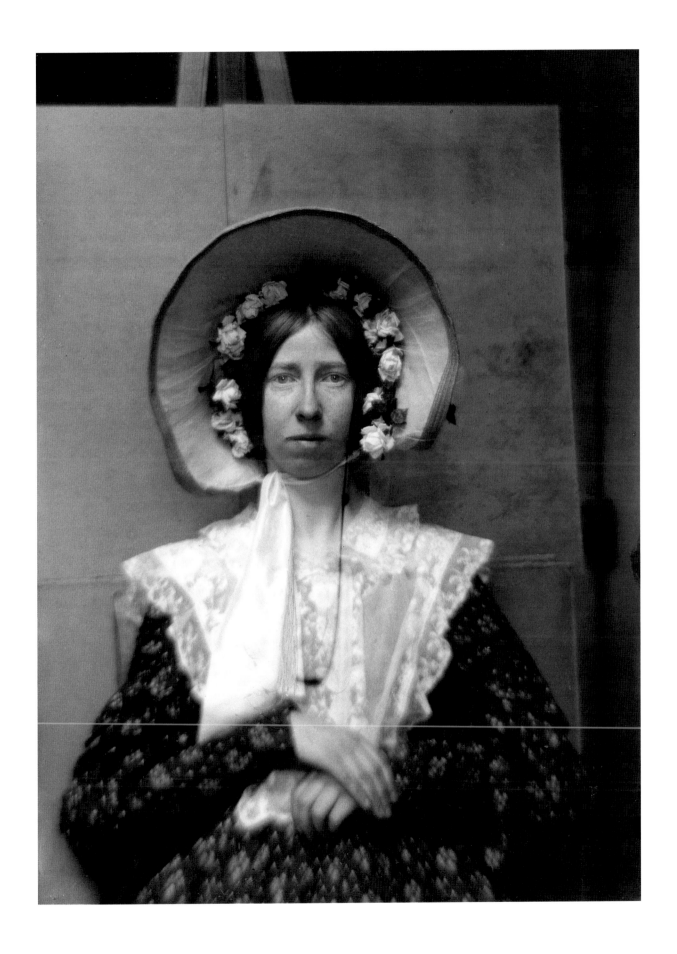

PLATE 3
Self-portrait in 1863 Costume, 1909

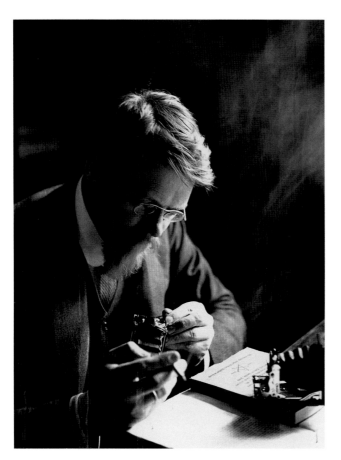

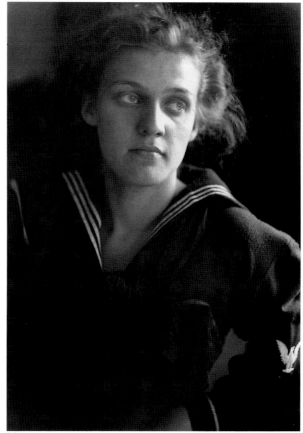

PLATE 4

Herr Doktor Robert Luther, Dresden, 1909–10

PLATE 5

Maryla Patkowska, Dresden, 1909–10

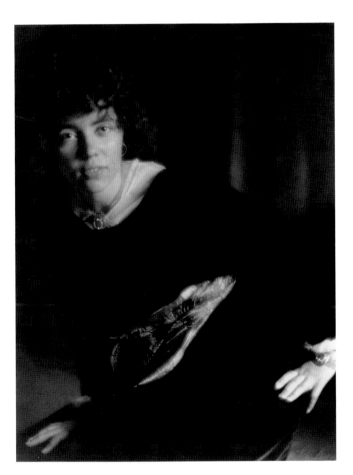

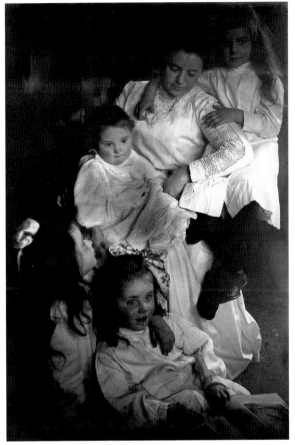

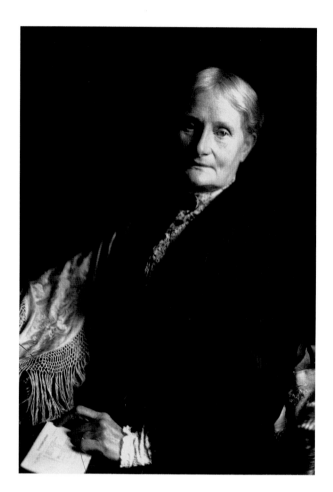

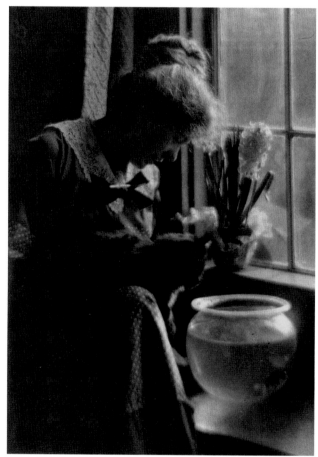

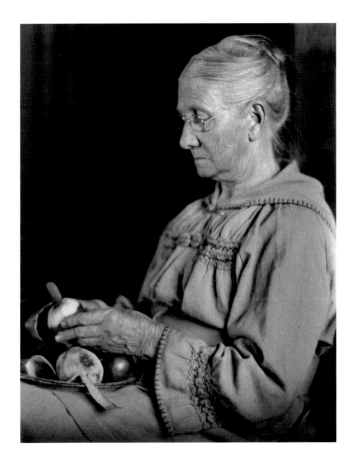

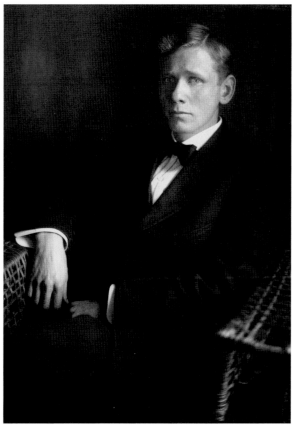

PLATE 10

My Mother Peeling Apples, about 1910

PLATE 11

Burns Cunningham, about 1910

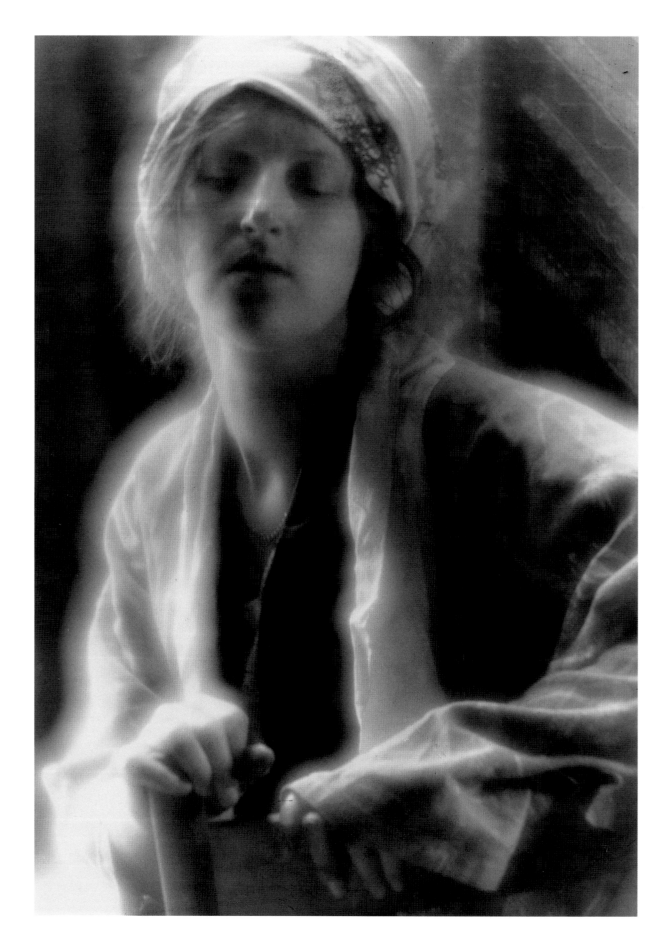

PLATE 12
The Dream, 1910

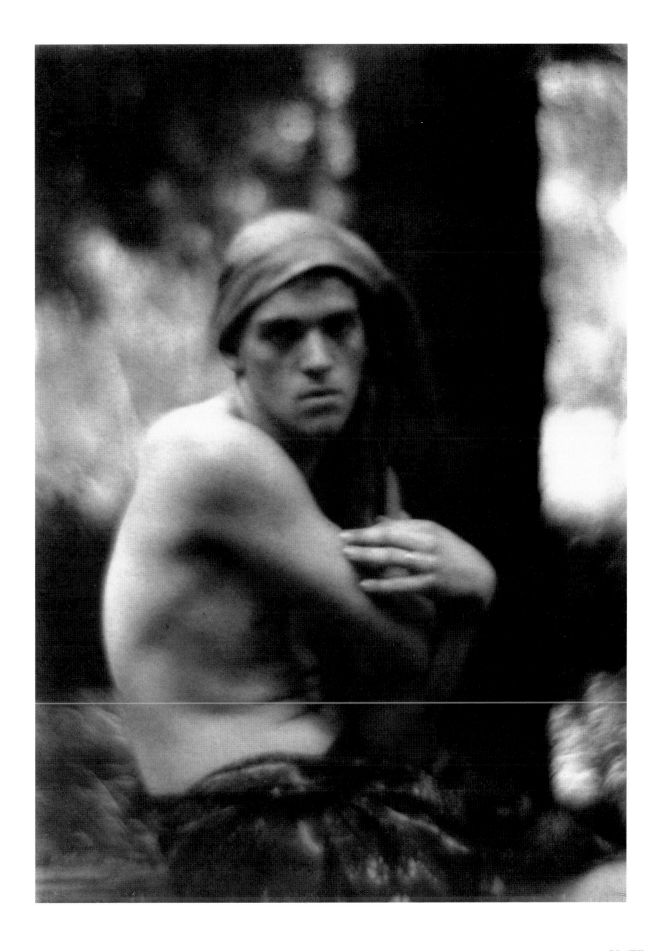

PLATE 13
Ben Butler, 1910

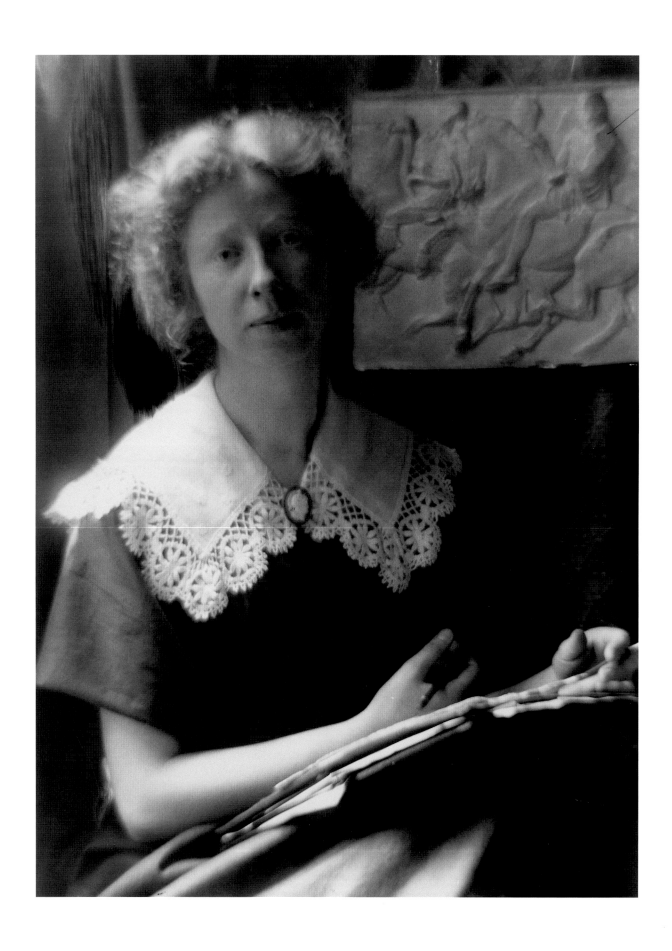

PLATE 14
Self-portrait, 1910

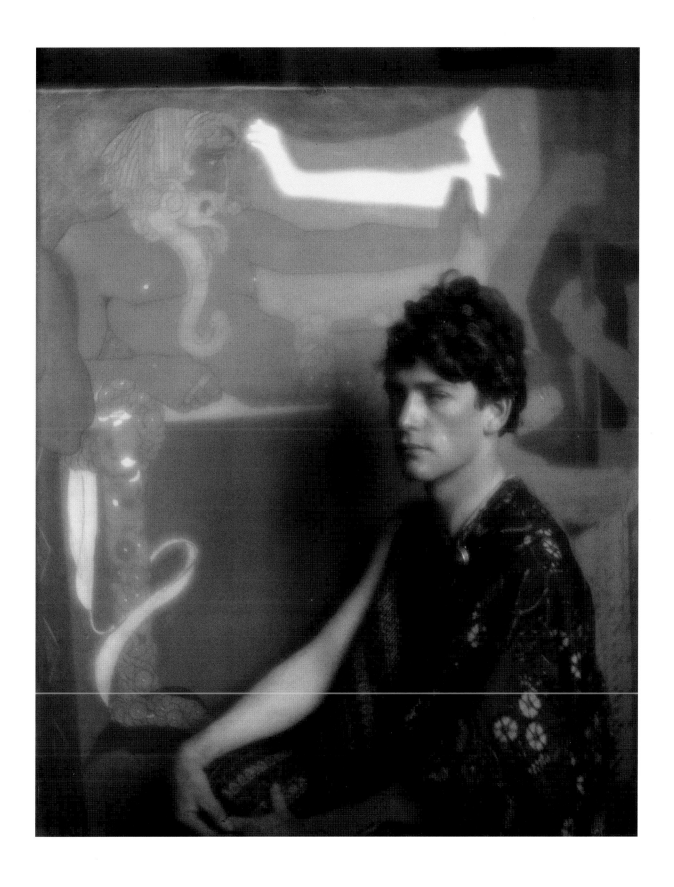

PLATE 15

John Butler with His Mural, 1912

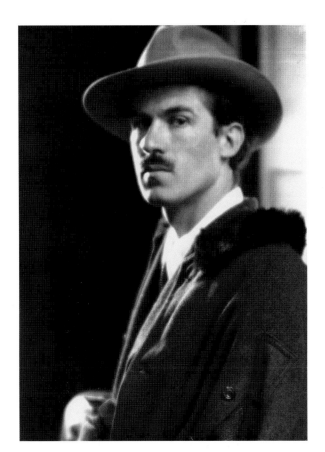

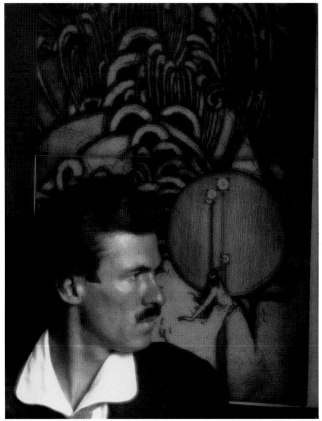

PLATE 16

Roi Partridge, 1915

PLATE 17

Roi Partridge, Etcher, 1915

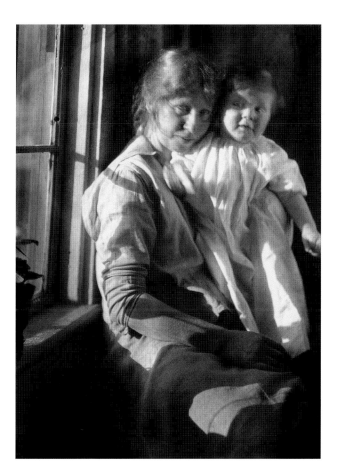

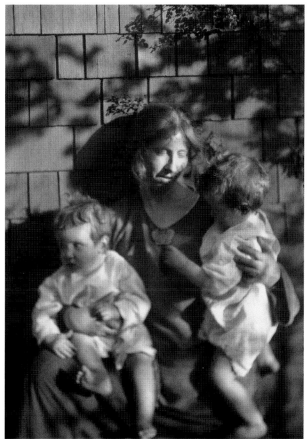

PLATE 18

Self-portrait with Gryff, 1917

PLATE 19

Self-portrait with Twins, 1918

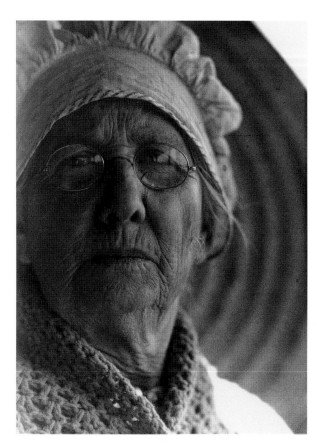

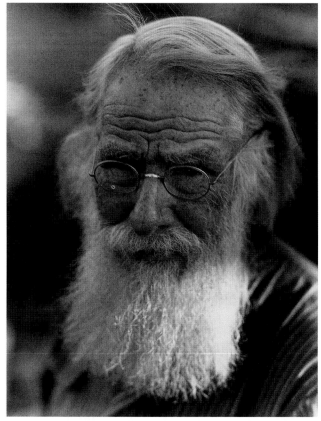

PLATE 20

My Mother, about 1918

PLATE 21

My Father, about 1918

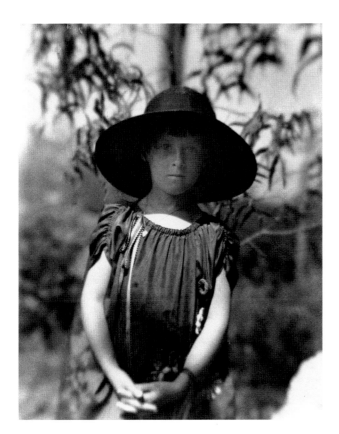

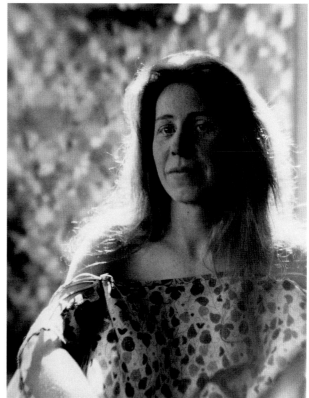

PLATE 22

Mary Ann Bremmerton, 1919

PLATE 23

Paula Cunningham, 1920

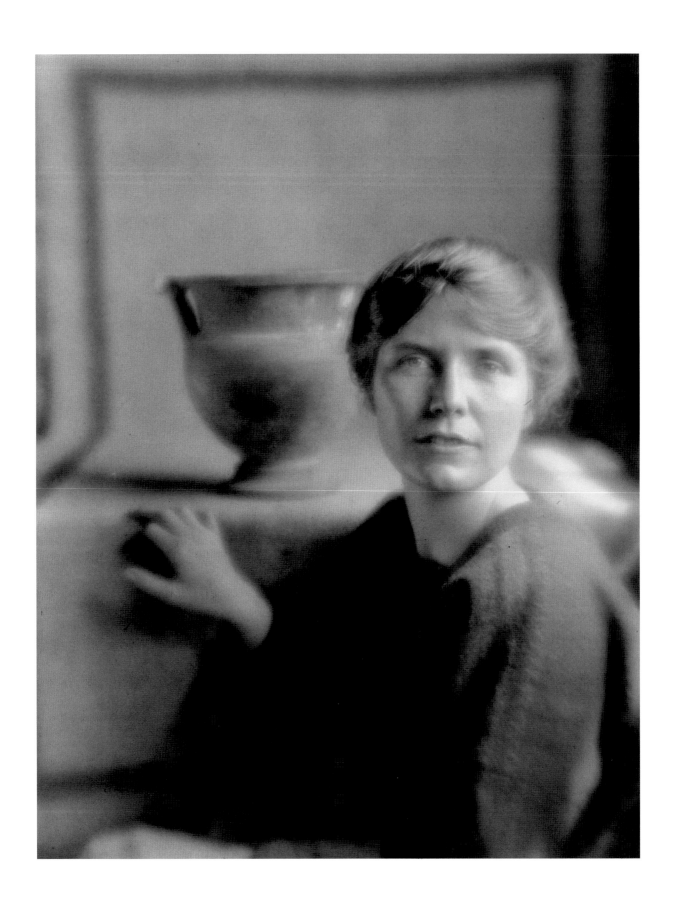

PLATE 24
Anna Cox Brinton, 1920

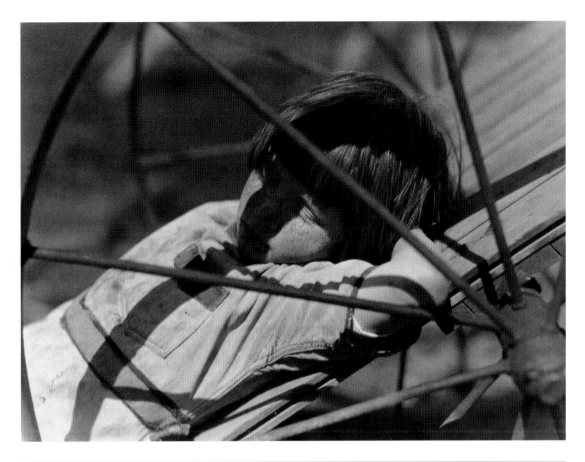

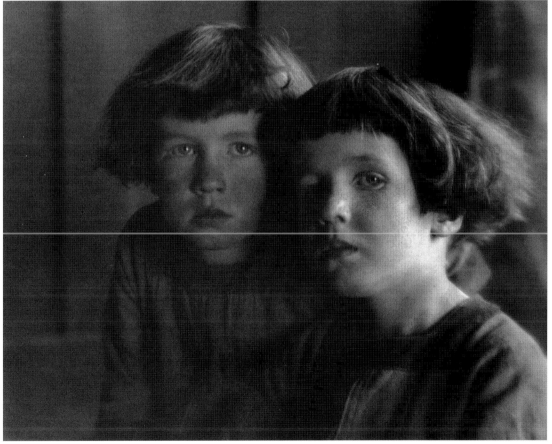

PLATE 25 PLATE 26

Gryff, 1921 *Rondal and Padraic,* 1922

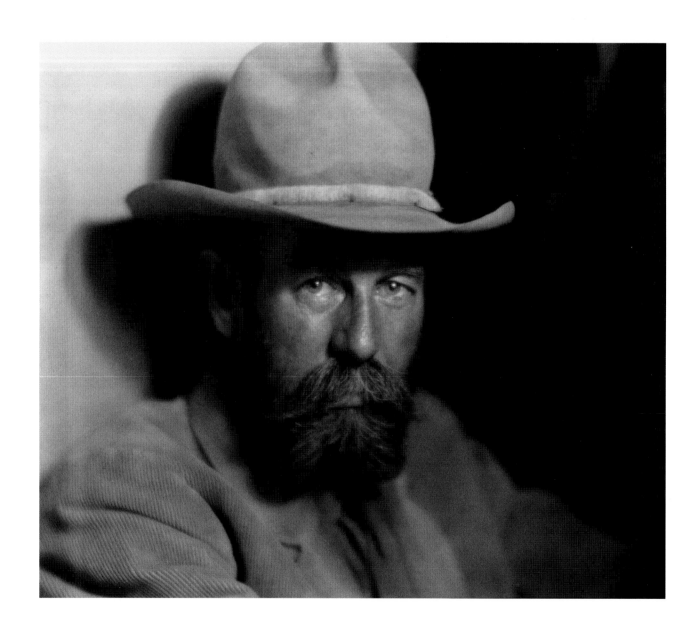

PLATE 27
Dane Coolidge, about 1921

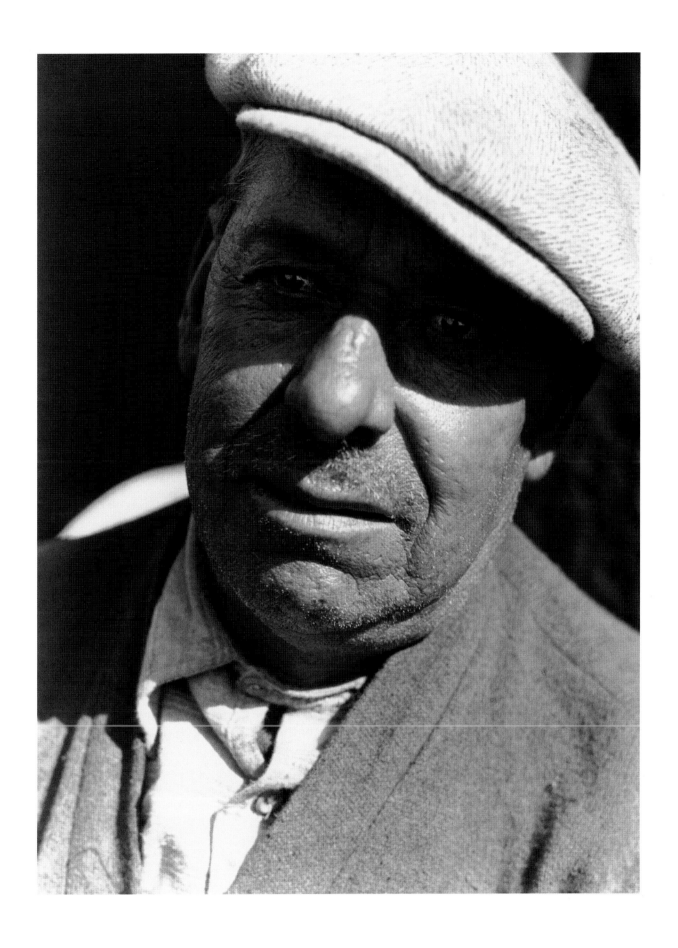

PLATE 28

Monterey Fisherman, 1921

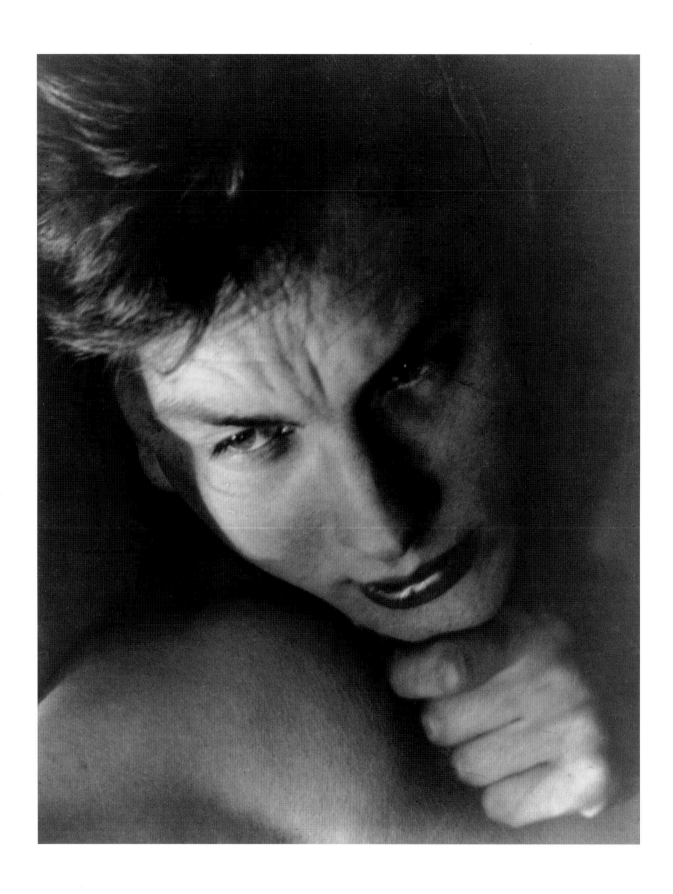

PLATE 29
Roger Sturtevant, Photographer, about 1922

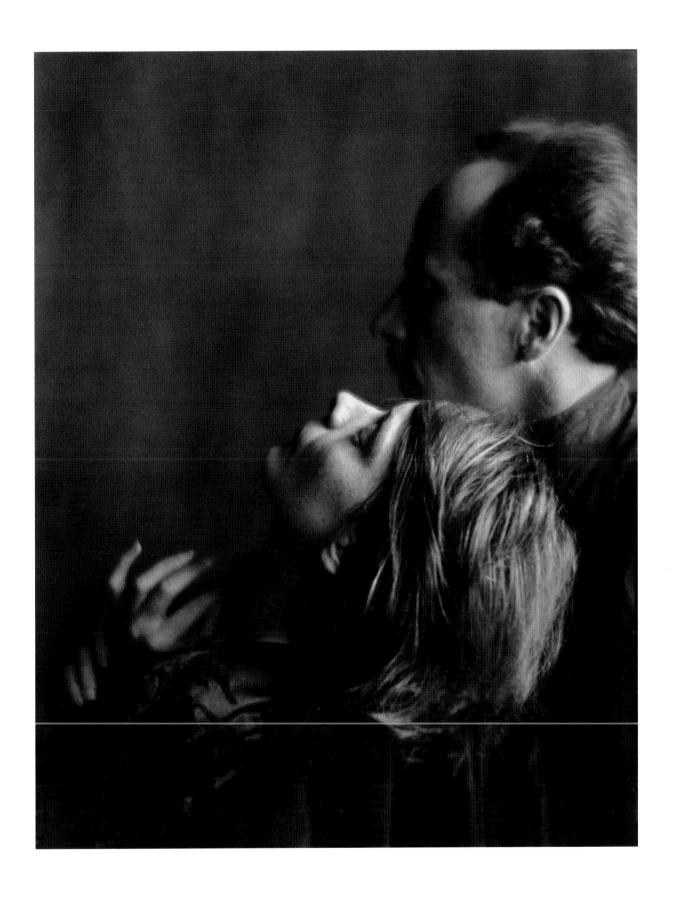

PLATE 30

Edward Weston and Margrethe Mather, 1922

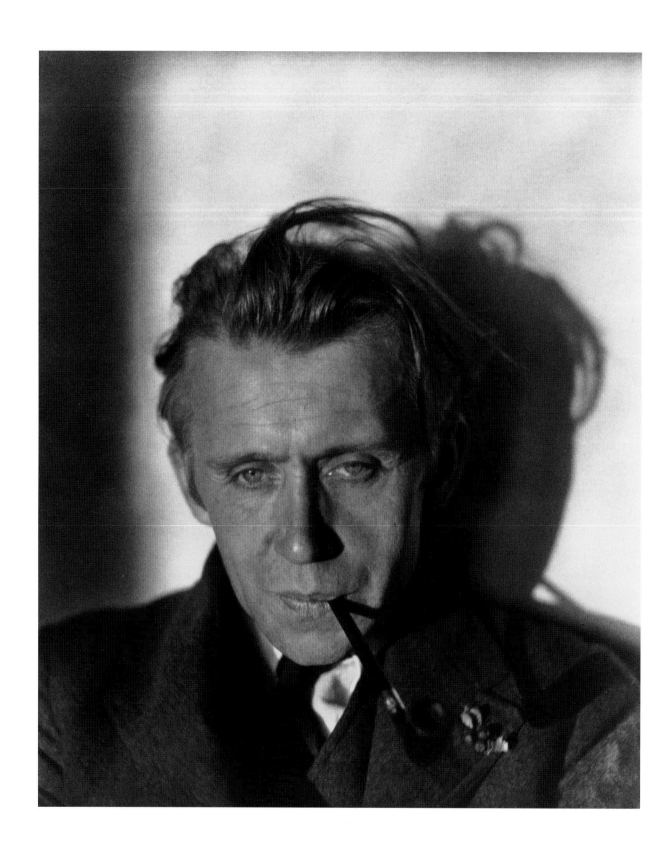

PLATE 31
Johan Hagemeyer, 1922

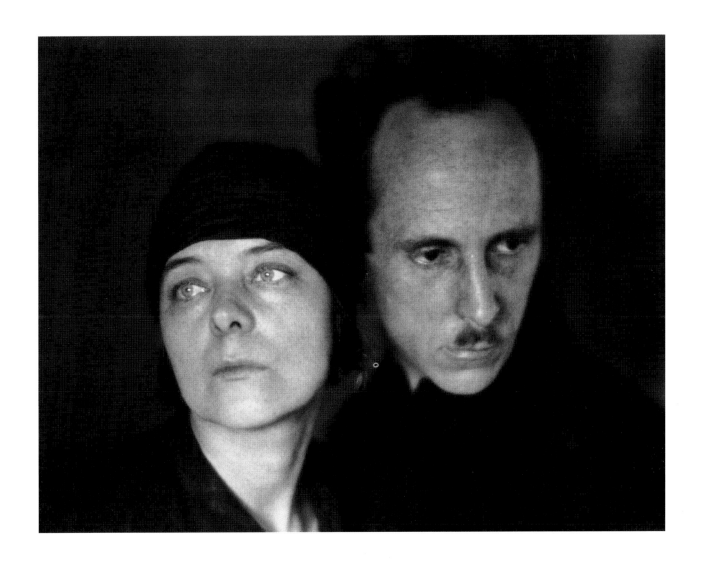

PLATE 32

Edward and Margrethe 3, 1922

PLATE 33
Brett Weston, 1922

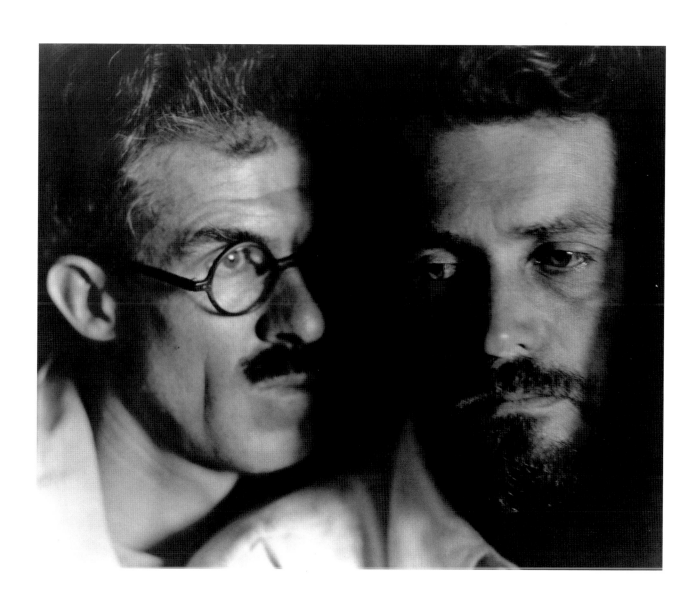

PLATE 34

Roi Partridge and John Butler 2, 1923

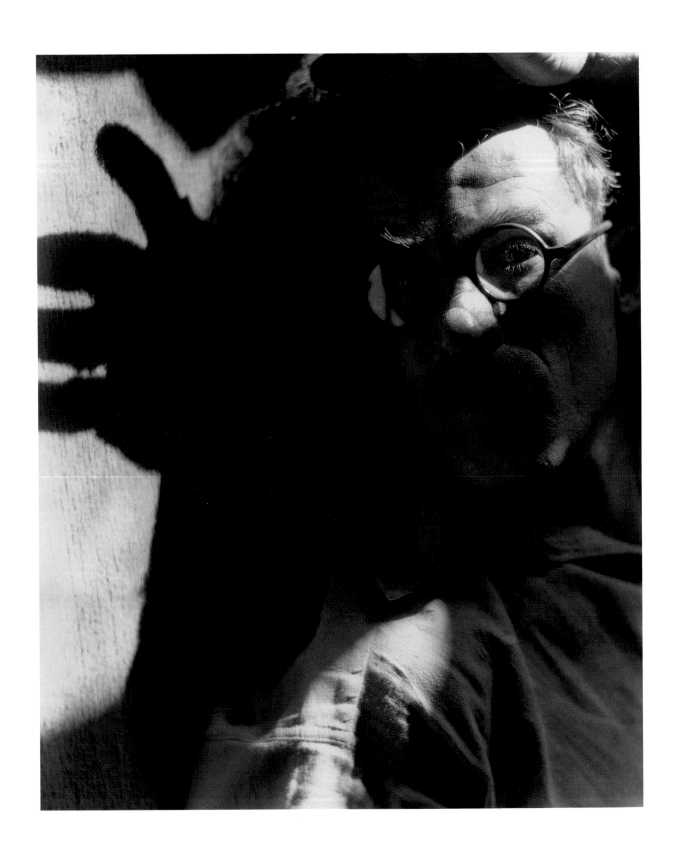

PLATE 35
Roi Partridge with Shadow of a Hand, 1922

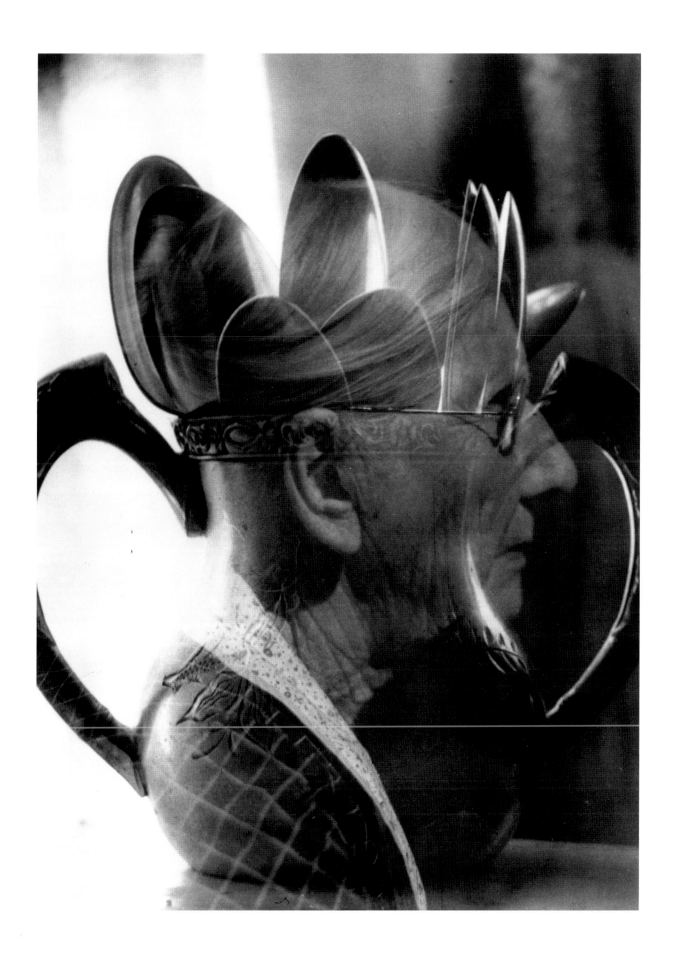

PLATE 36
Susan Elizabeth Cunningham, about 1923

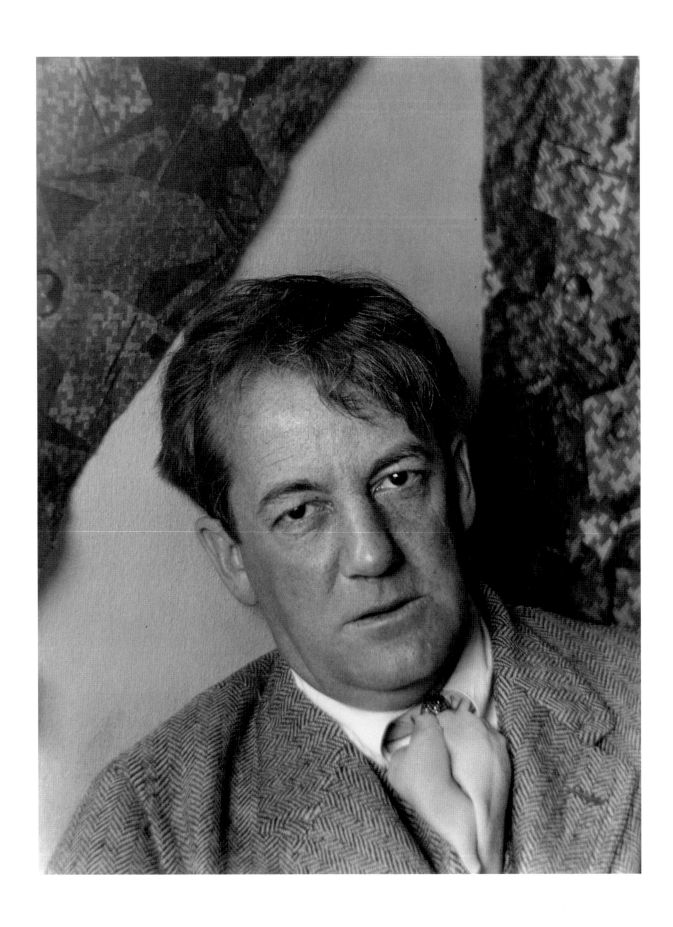

PLATE 37
Sherwood Anderson, Writer 2, about 1923

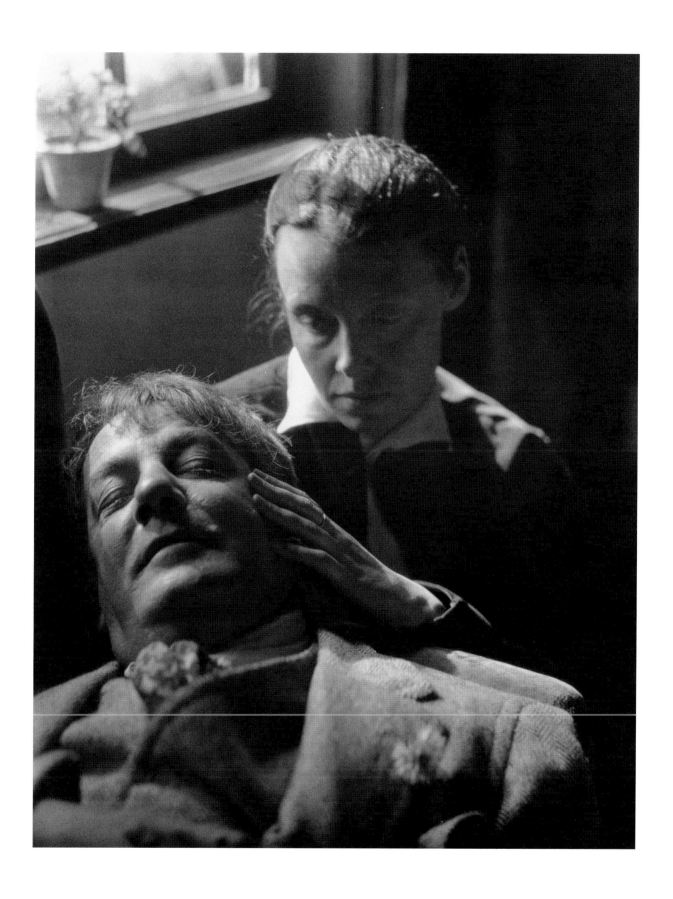

PLATE 38

Sherwood Anderson and Elizabeth Prall, about 1923

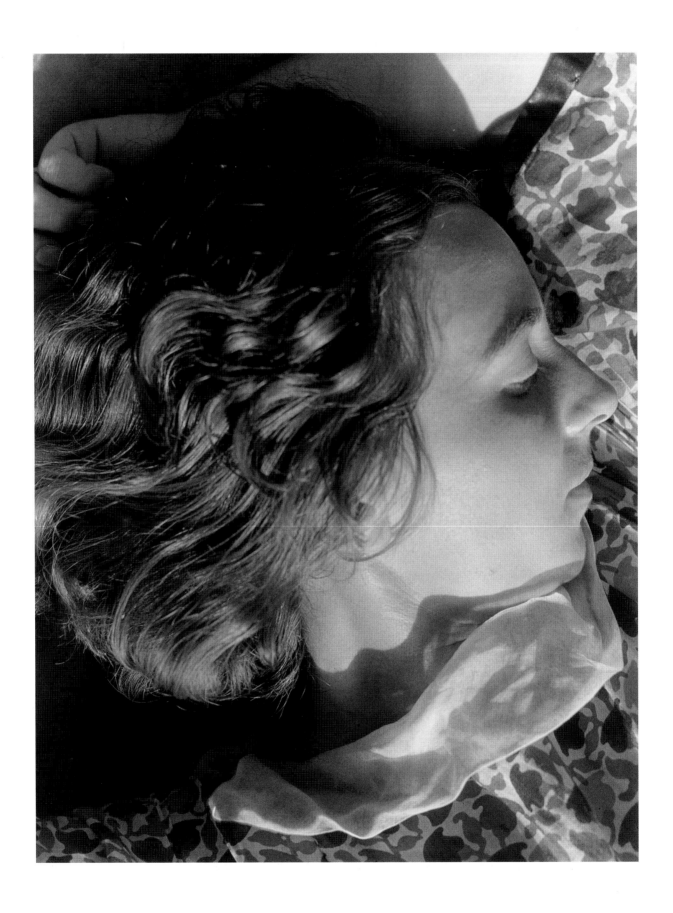

PLATE 39
Gertrude Gerrish, Dancer, 1924

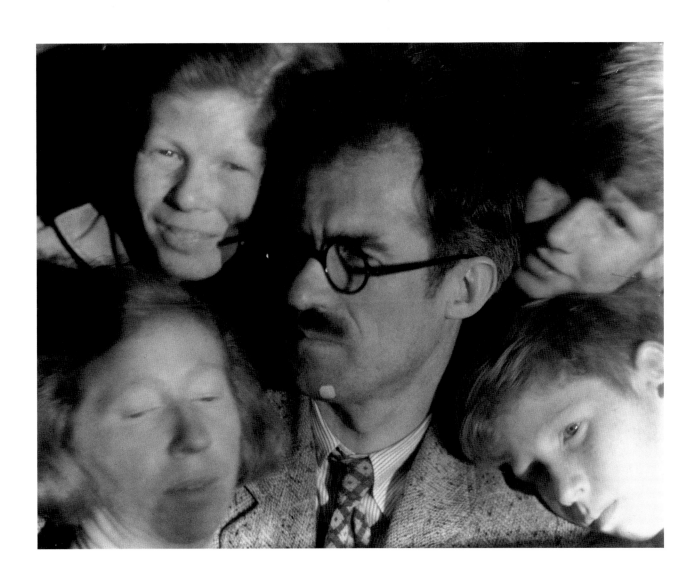

PLATE 40

Self-portrait with Family, about 1925

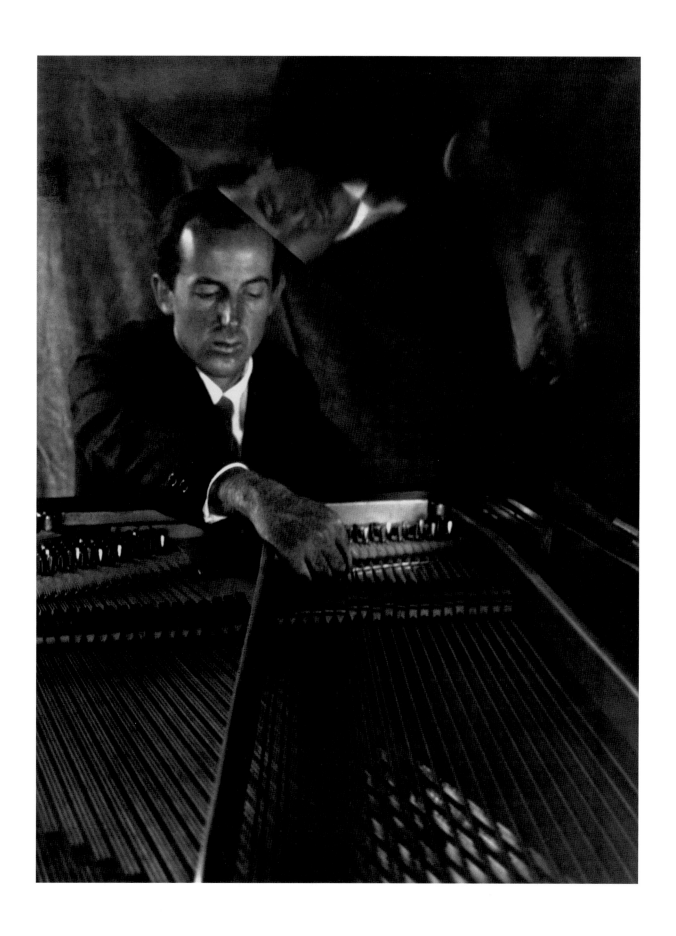

PLATE 41

Henry Cowell, Composer, 1926

PLATE 42

Roi Partridge with Navajo Rug, 1927

PLATE 43
Gryff, 1927

PLATE 44
Rondal and Padraic, 1927

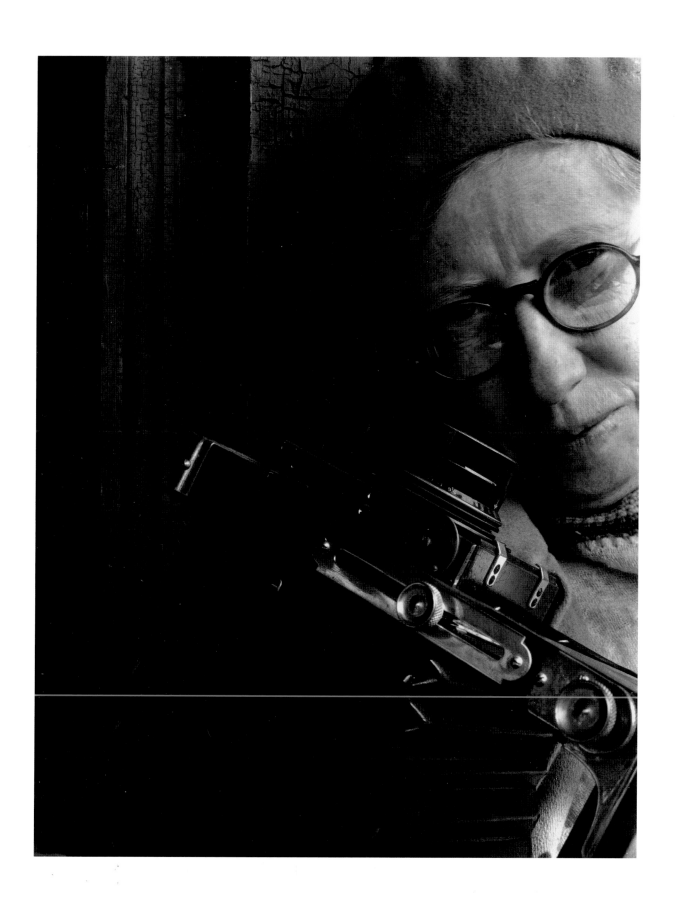

PLATE 45
Self-portrait with Camera, late 1920s

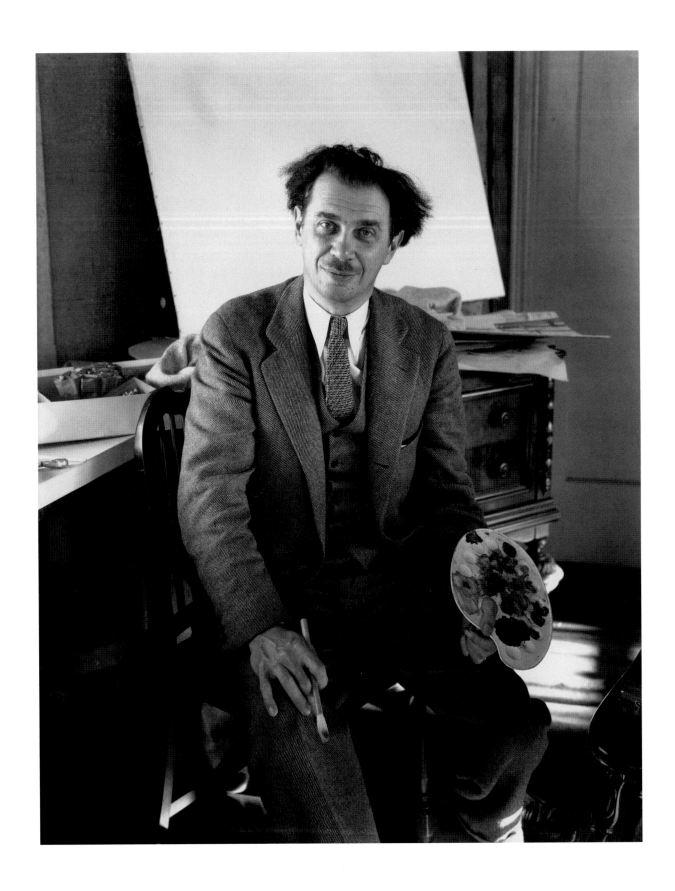

PLATE 46
Nicholai Remisoff, Painter, late 1920s

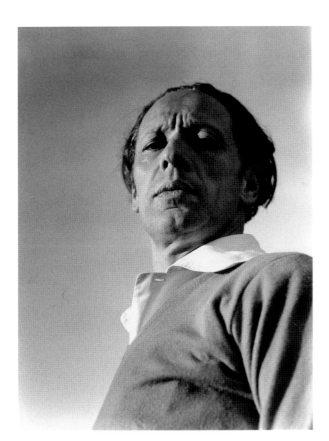

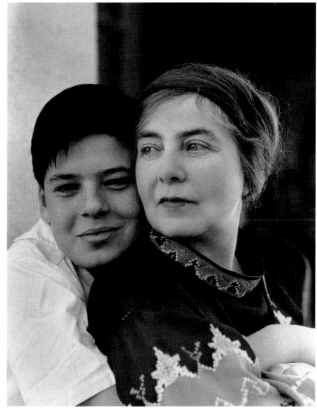

PLATE 47
Adolph Bolm, Dancer and Choreographer, late 1920s

PLATE 48
Family of Adolph Bolm, late 1920s

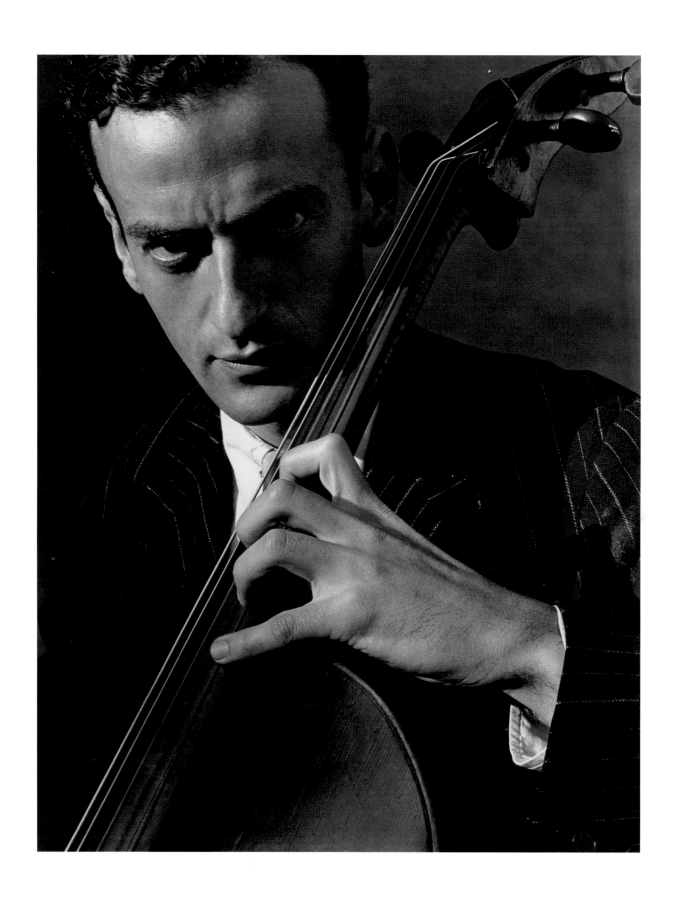

PLATE 49
Gerald Warburg, Cellist, 1929

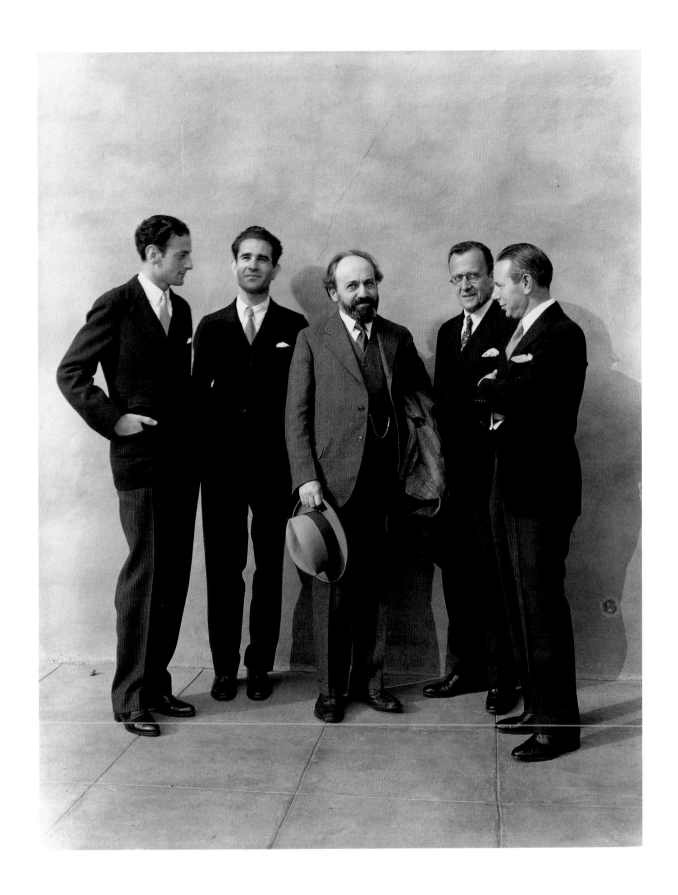

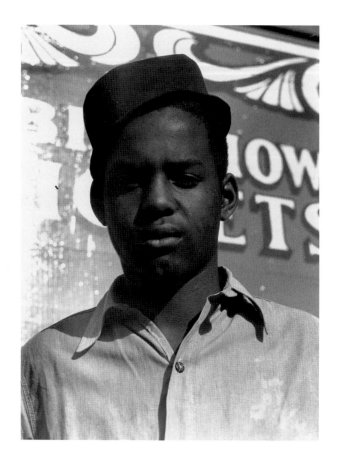

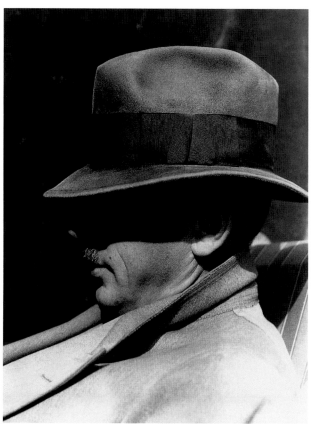

PLATE 51

Circus Roustabout, late 1920s

PLATE 52

Ken Weber, Architect, late 1920s

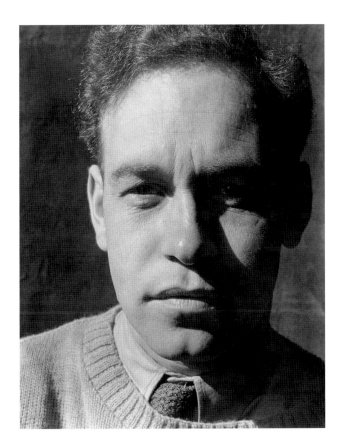

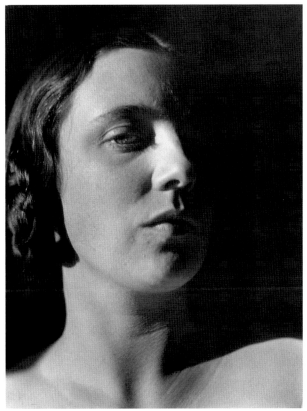

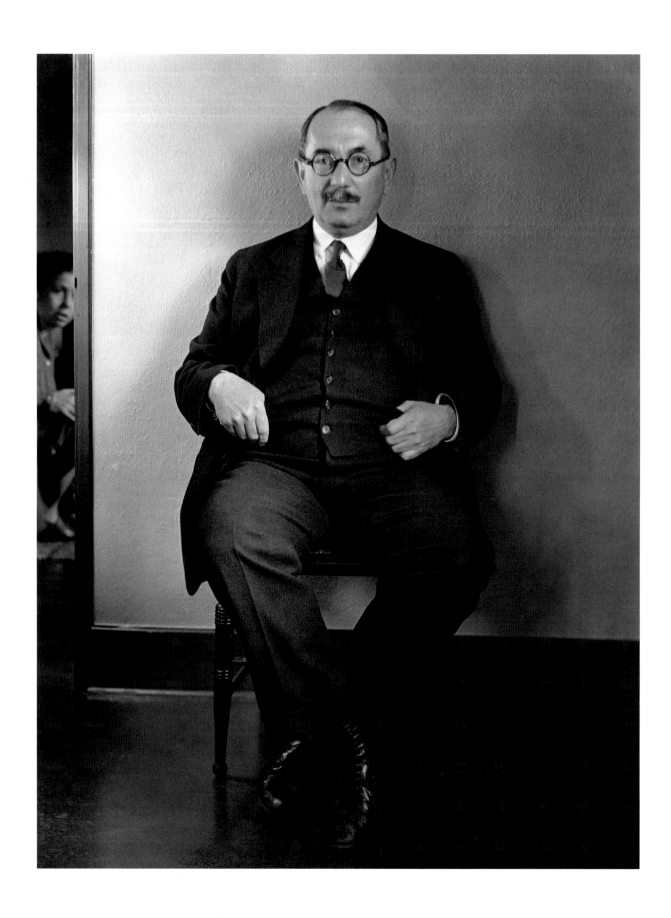

PLATE 55

Max Radin, Professor of Law, 1929

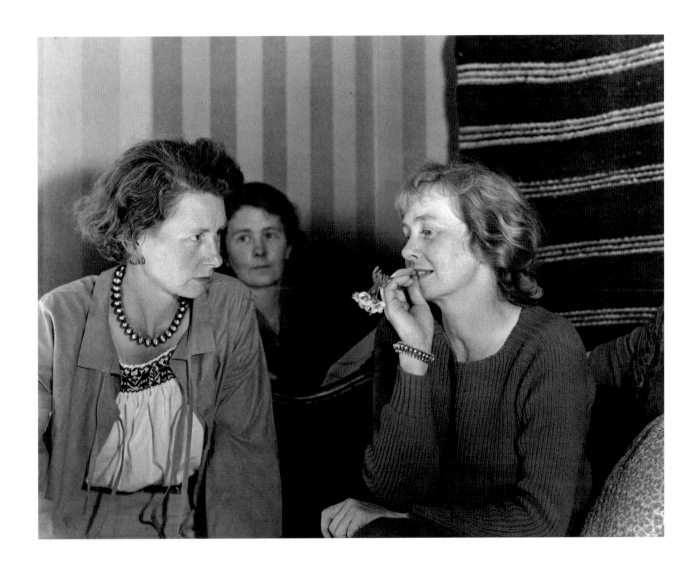

PLATE 56
The Bruton Sisters, Artists, 1930

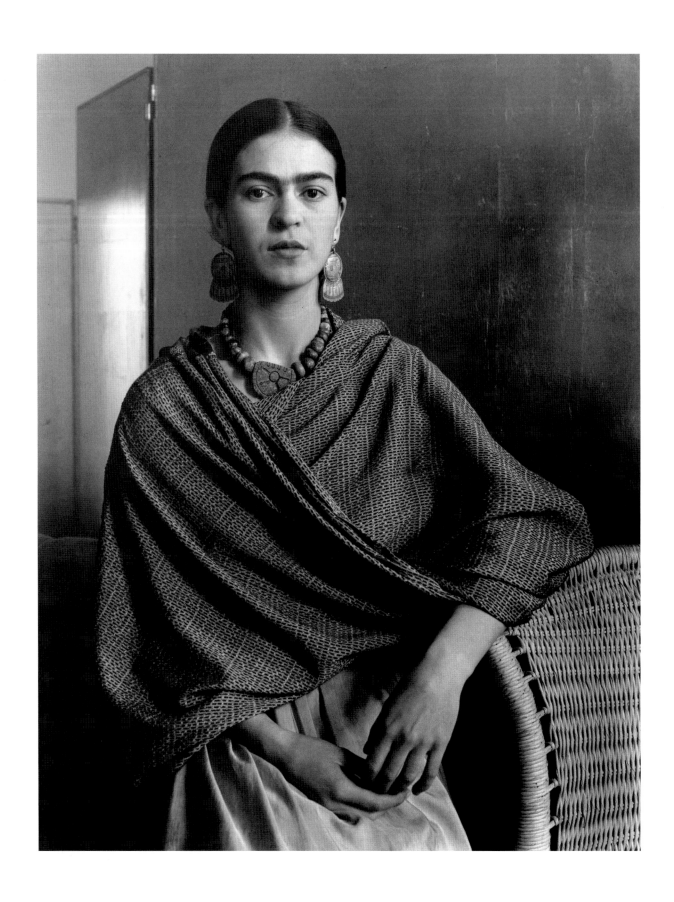

PLATE 57
Frida Kahlo Rivera, Painter and Wife of Diego Rivera, 1931

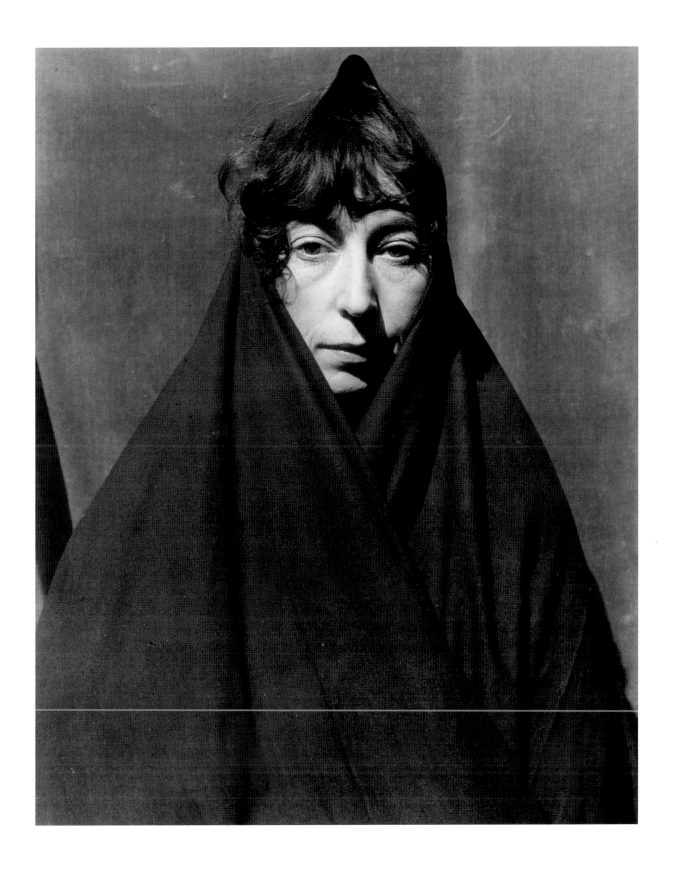

PLATE 58
Maxine Albro, Painter, 1931

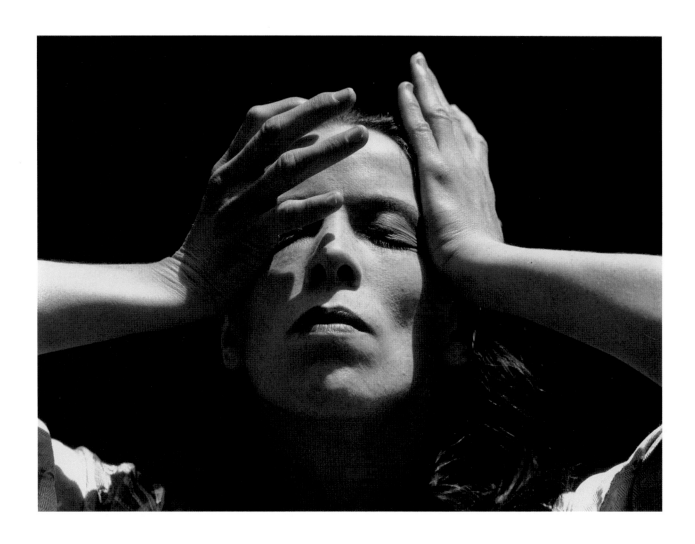

PLATE 59
Martha Graham, Dancer, 1931

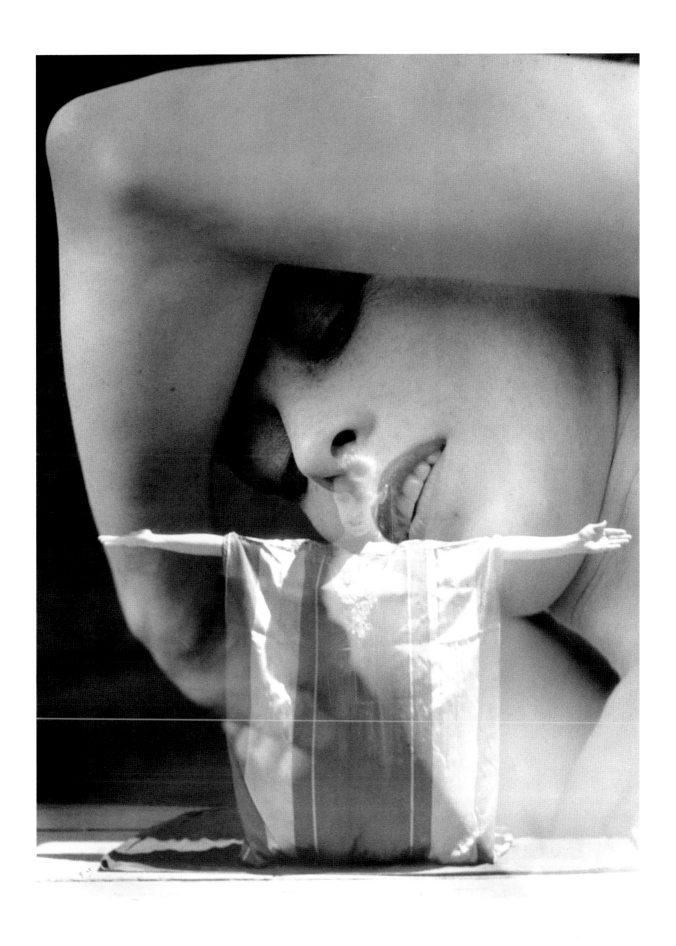

PLATE 60
Martha Graham 2, 1931

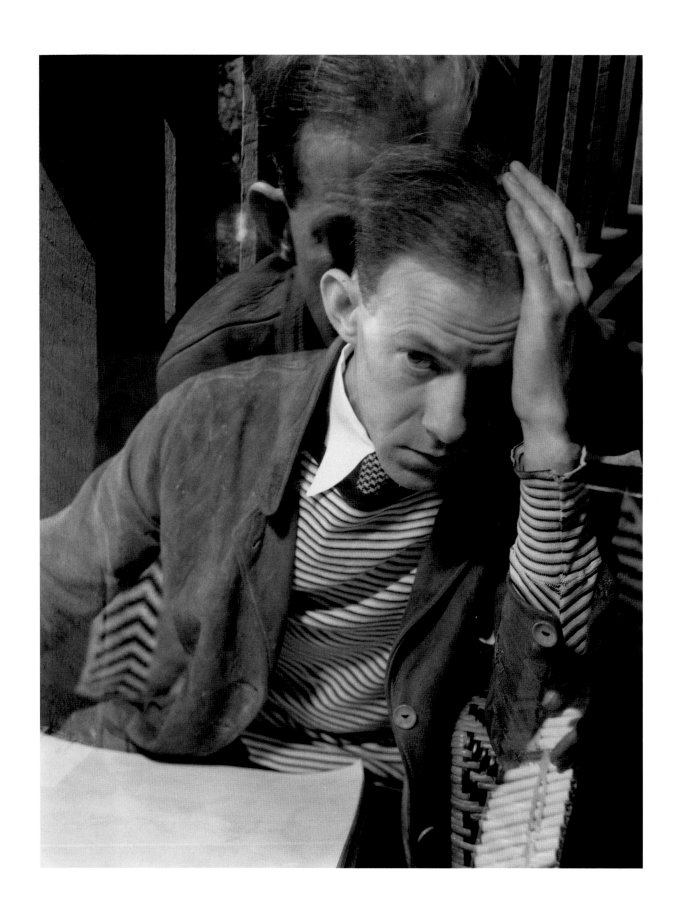

PLATE 61

Joseph Sheridan, Painter, 1931

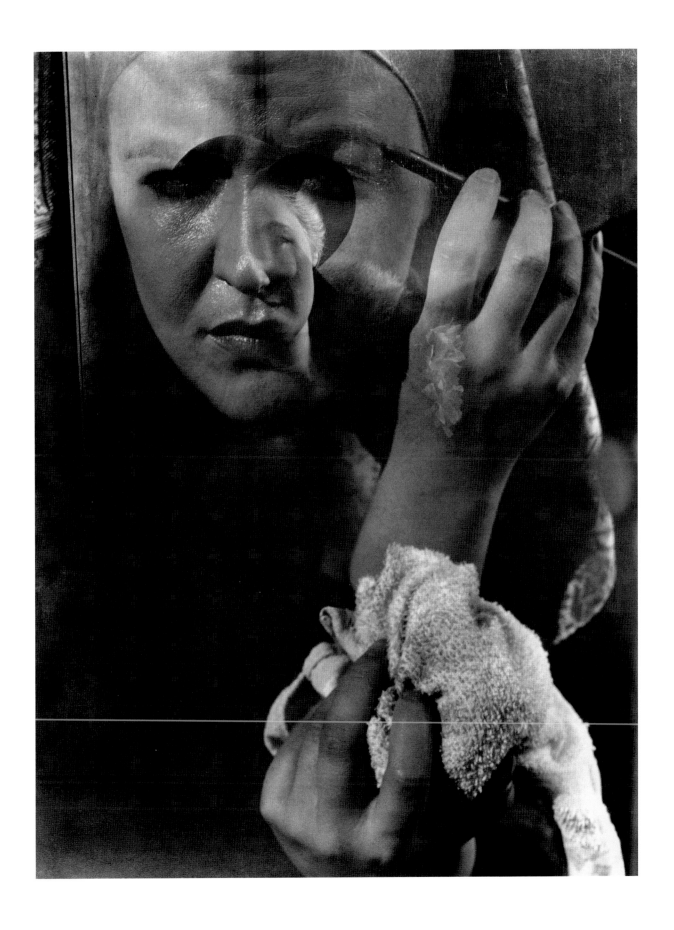

Hands of Laura LaPlante, about 1931

PLATE 63

Wallace Beery at Glendale Airport, 1931

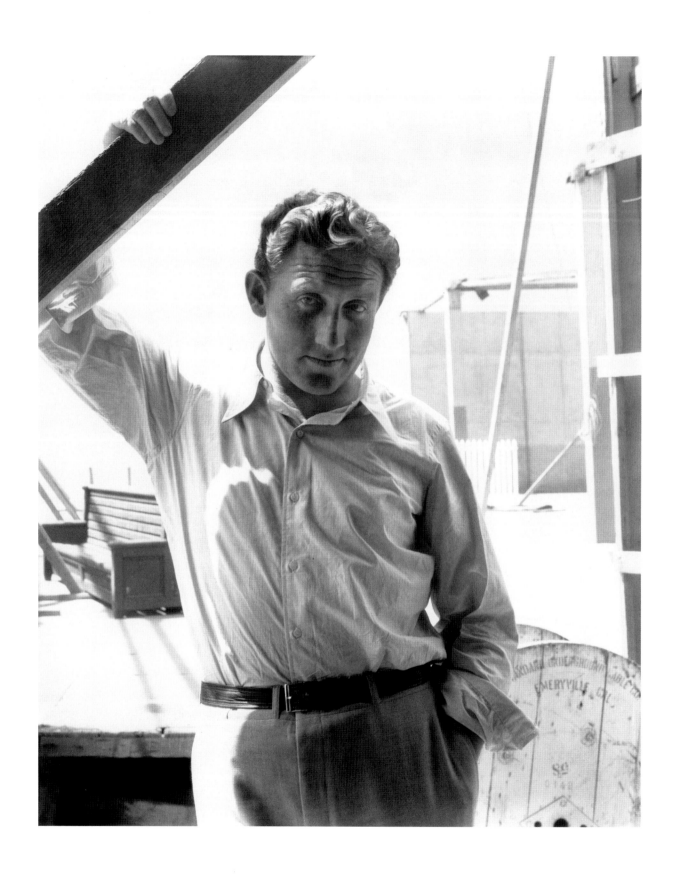

PLATE 66

Spencer Tracy on Location, 1932

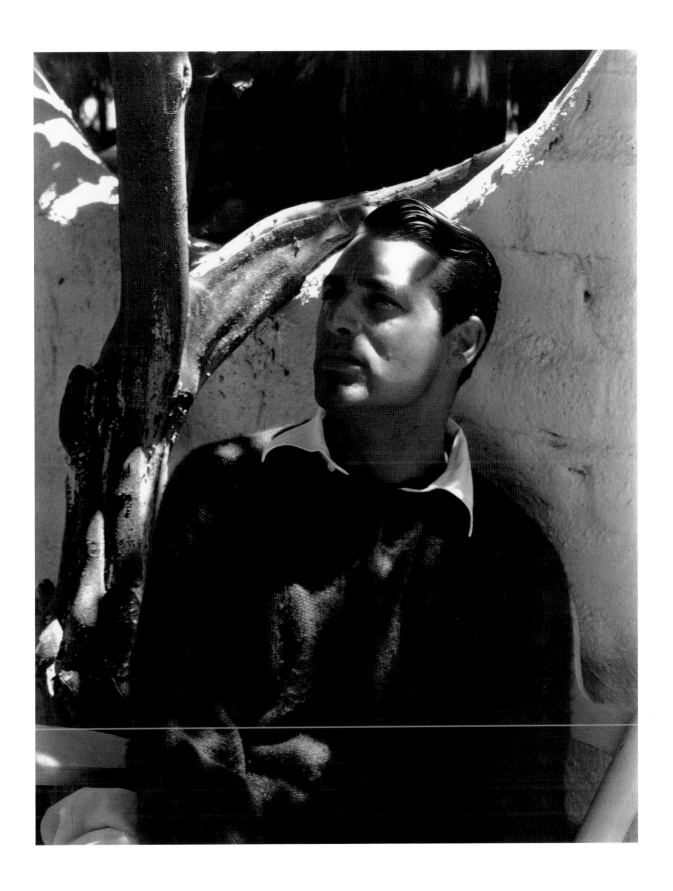

PLATE 67
Cary Grant, Actor, Hollywood, 1932

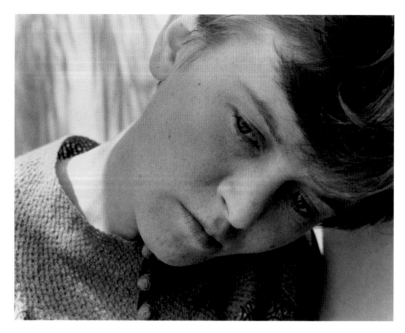

PLATE 68

Sonya Noskowiak, Photographer, about 1932

PLATE 69

Rondal and Padraic, early 1930s

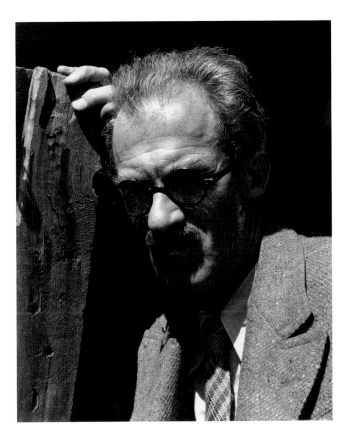

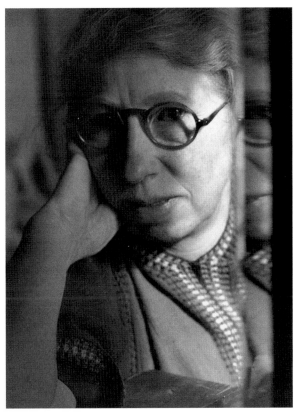

PLATE 70

Roi Partridge, 1932

PLATE 71

Self-portrait, 1933

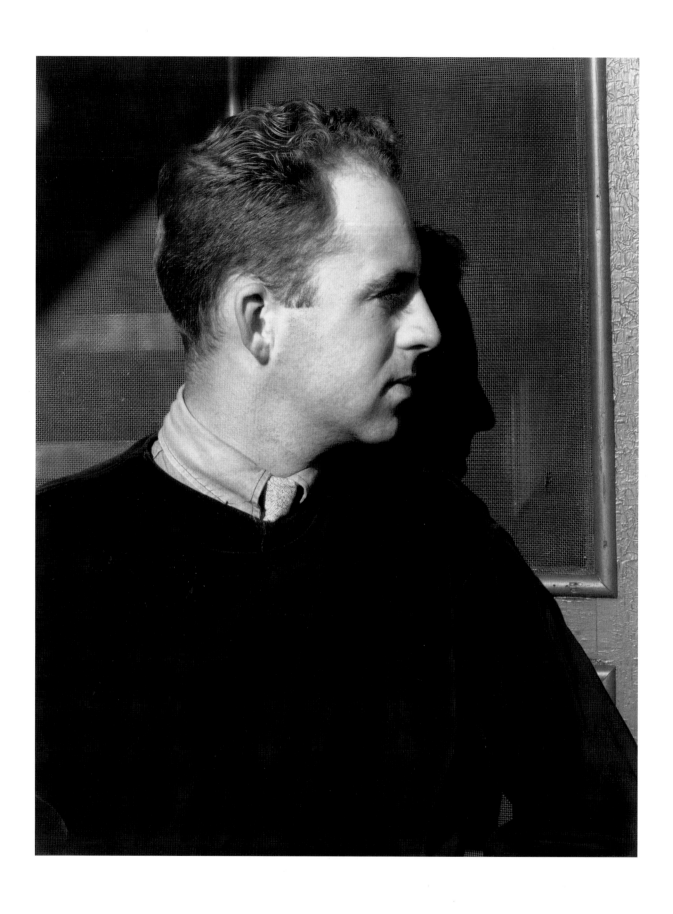

PLATE 72

Willard Van Dyke 2, 1933

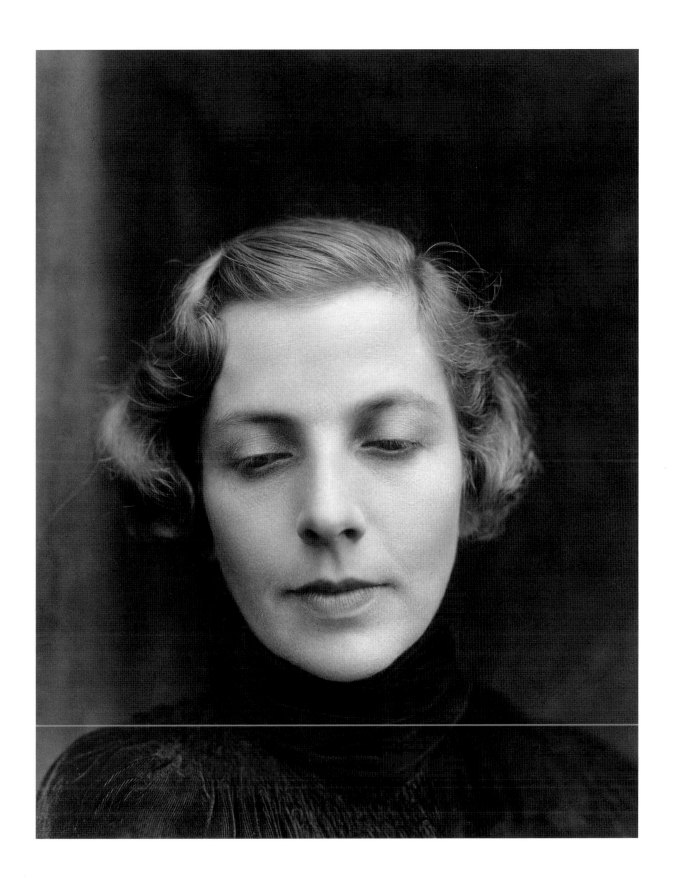

PLATE 73

Gunst Portrait, early 1930s

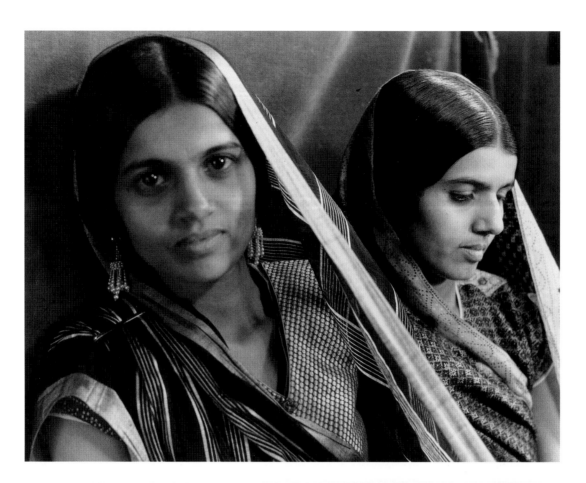

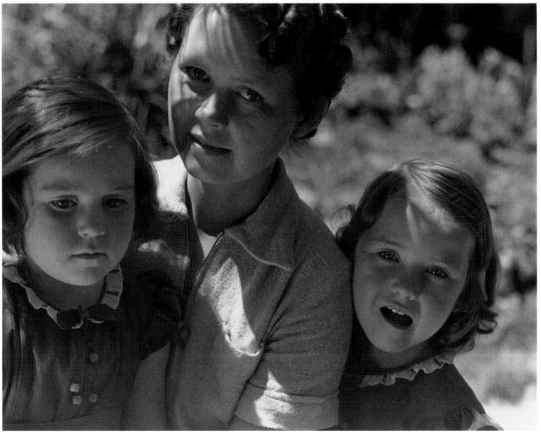

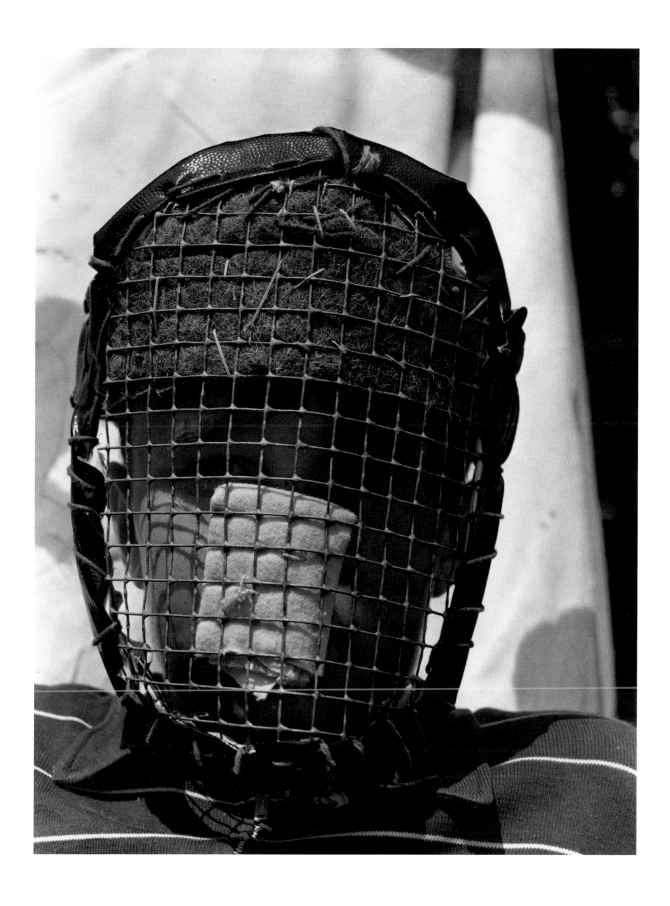

PLATE 76
Guthrie Child, early 1930s

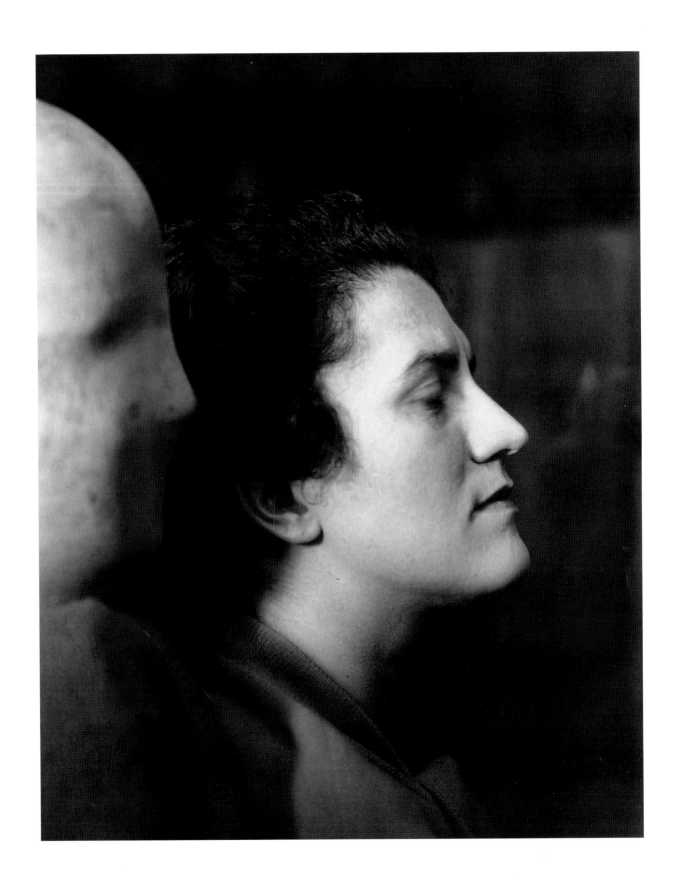

PLATE 77
Mary Ellen Washburn, early 1930s

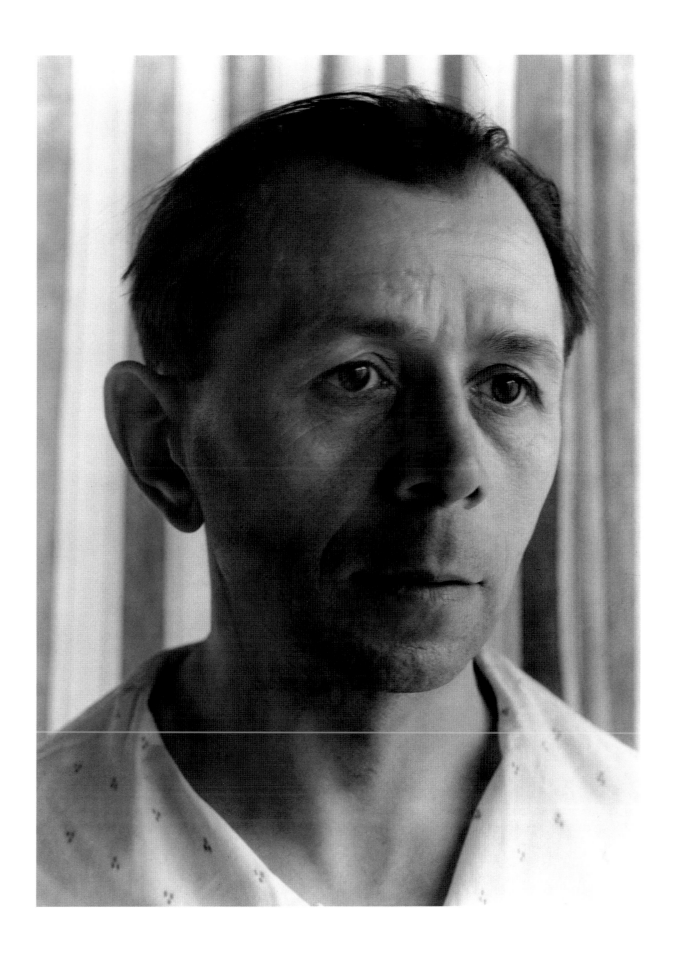

PLATE 78
John Winkler, Etcher, 1933

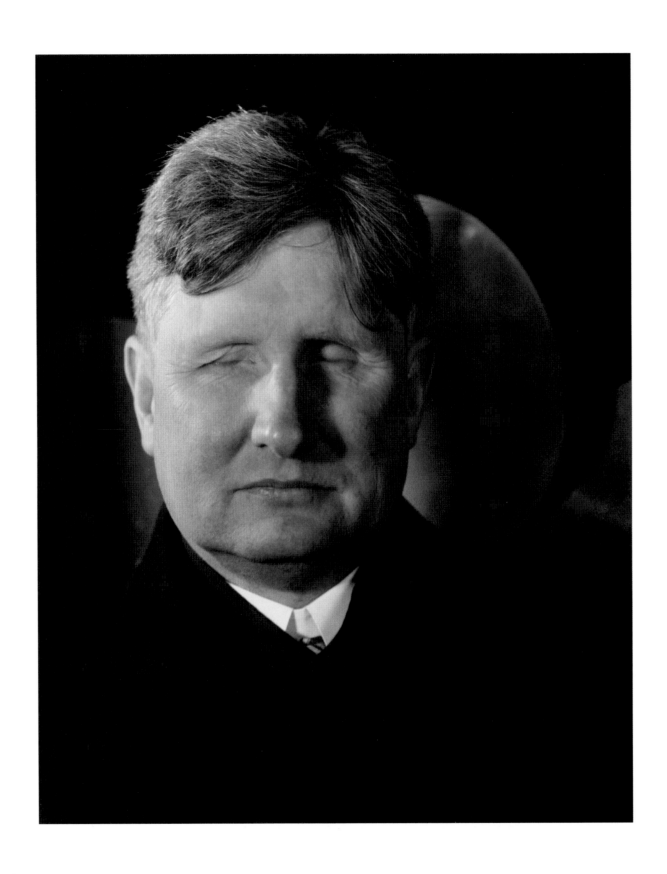

PLATE 79

Robert Irwin, Executive Director of American Foundation for the Blind, 1933

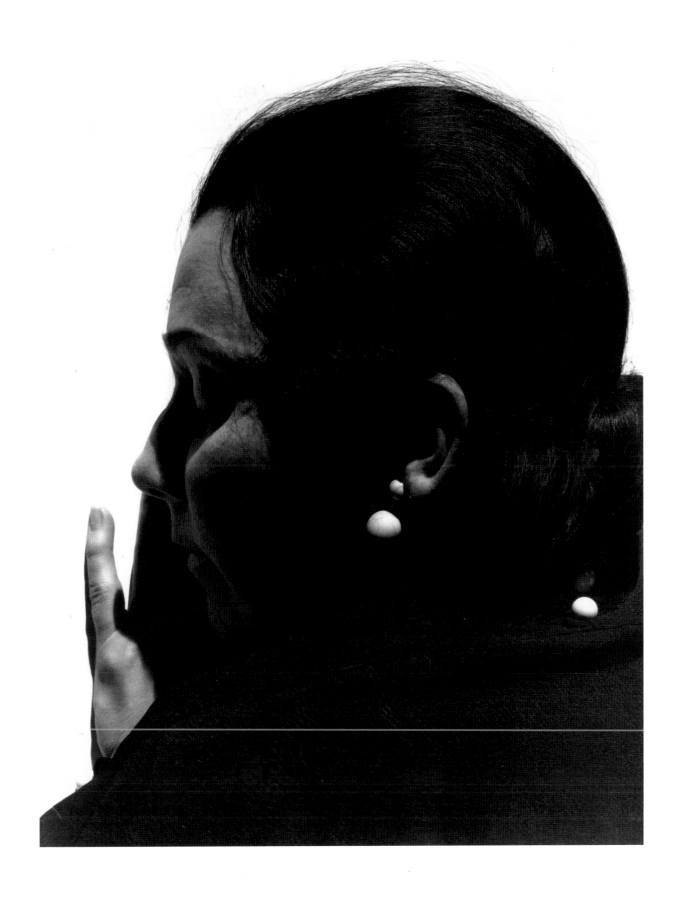

PLATE 80

Marian Simpson, Painter, 1934

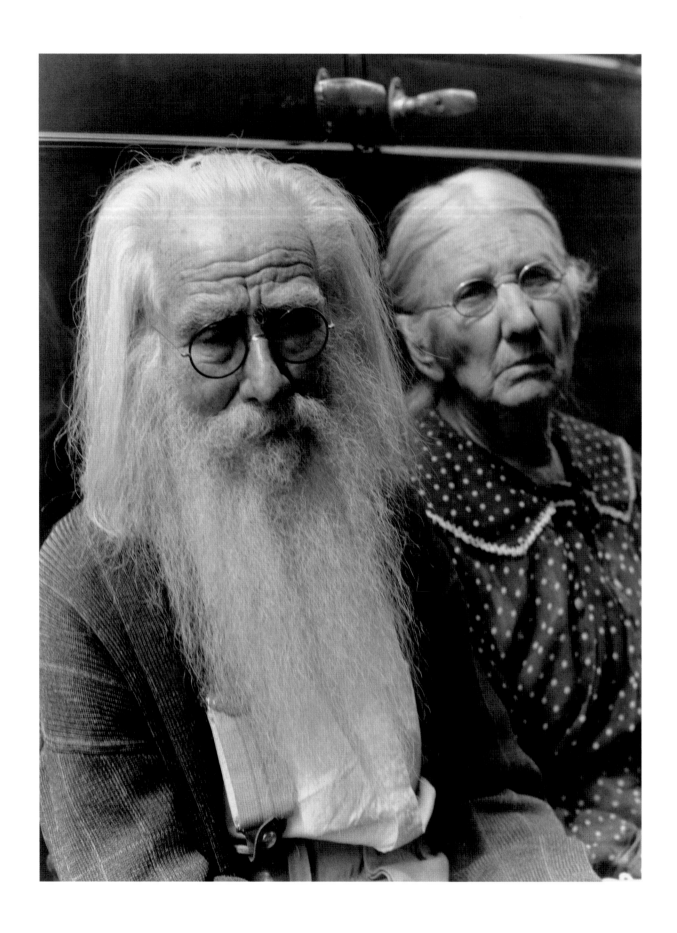

PLATE 81

My Father and Mother, 1933

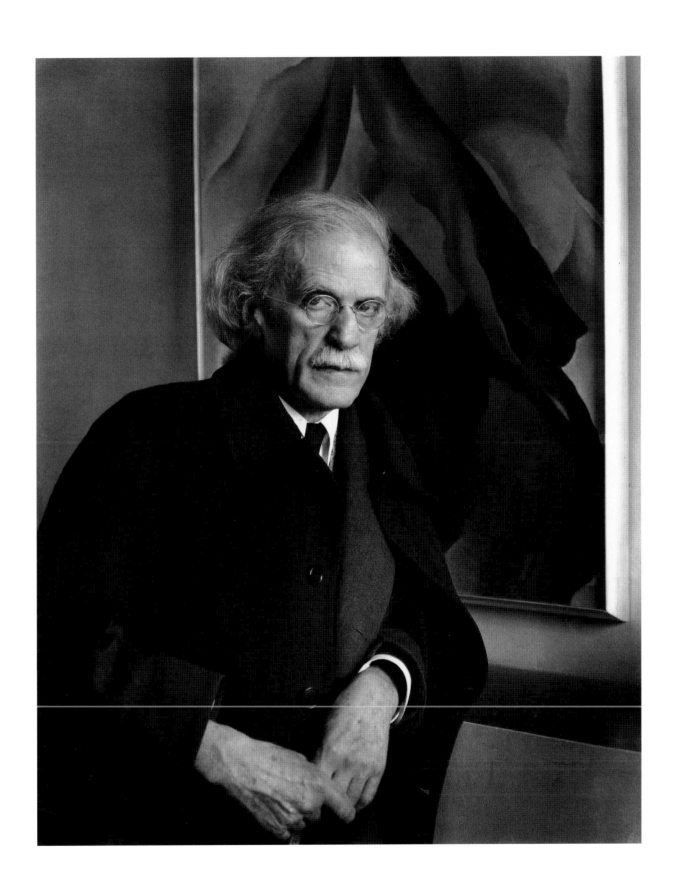

PLATE 82

Alfred Stieglitz, Photographer, 1934

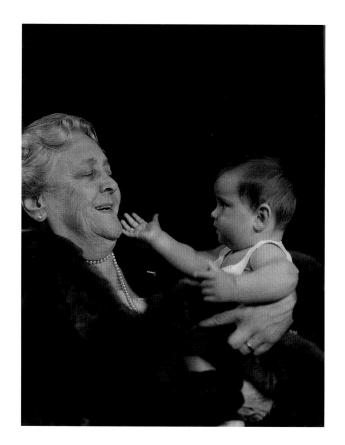

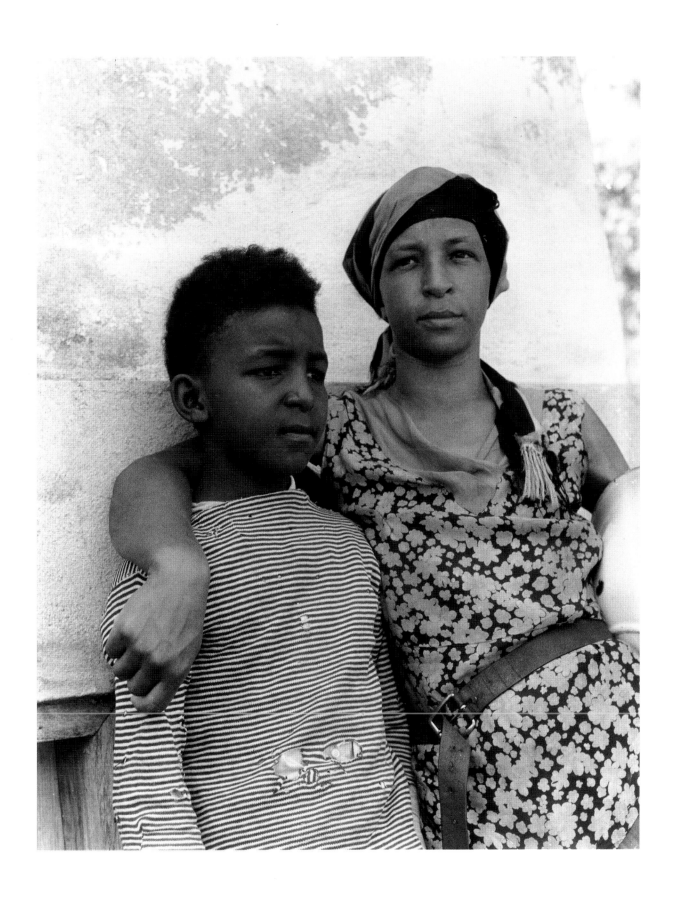

PLATE 86

Rebecca and Son, Hume, Virginia, 1934

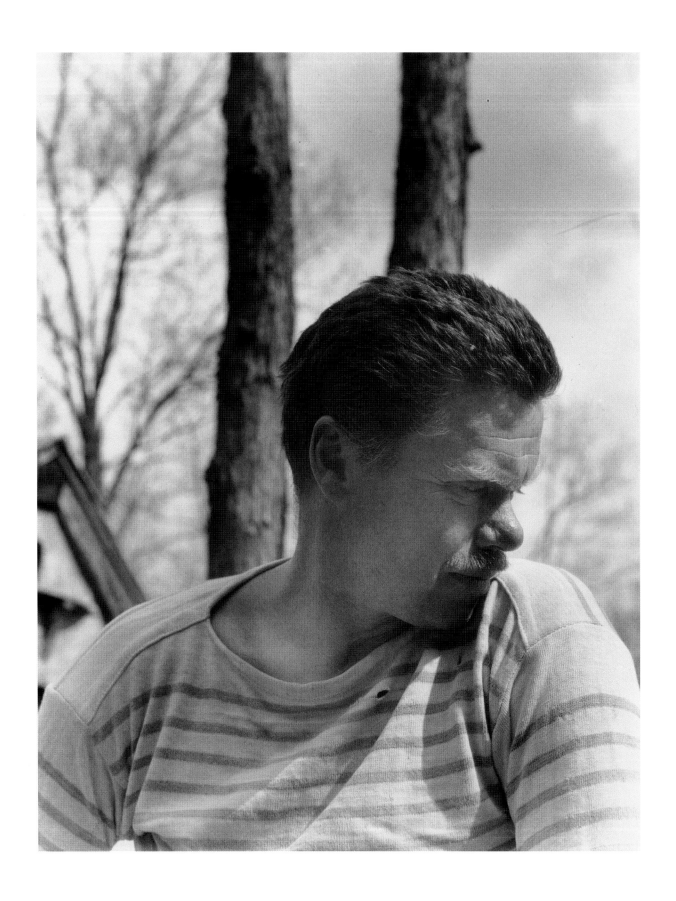

PLATE 87

Henry Varnum Poor, Artist, 1934

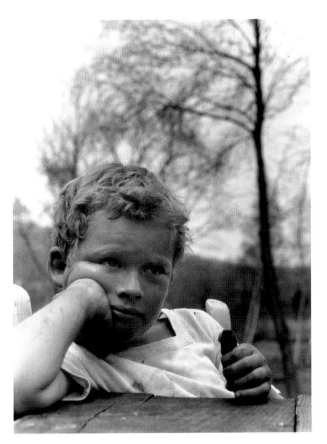

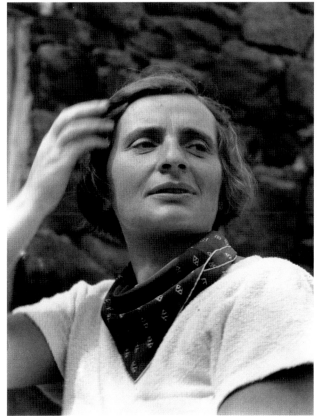

PLATE 88

Henry Varnum Poor's Son, 1934

PLATE 89

Mrs. Henry Varnum Poor, 1934

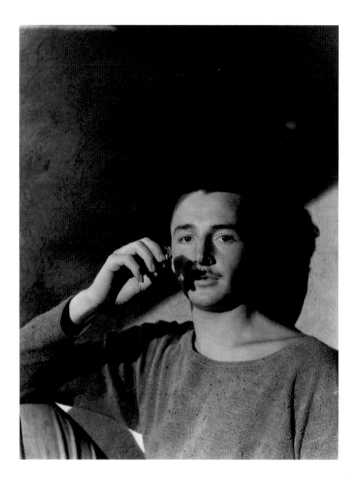

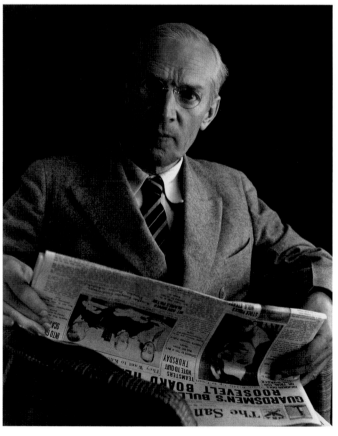

PLATE 90

Charles Griffin Farr, Artist, Hume, Virgina, 1934

PLATE 91

Upton Sinclair, 1934

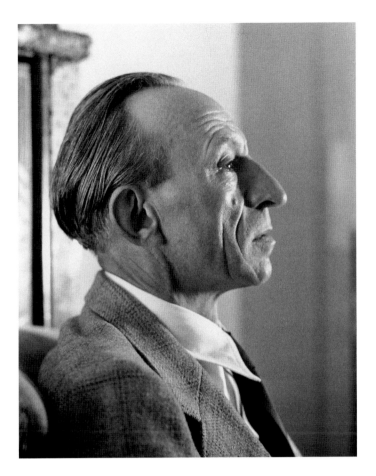

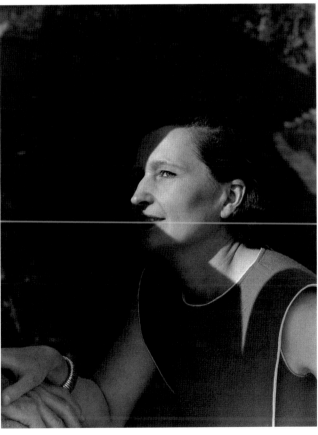

PLATE 92

Amédée Ozenfant, Painter and Critic 2, 1935

PLATE 93

Madame Ozenfant, 1935

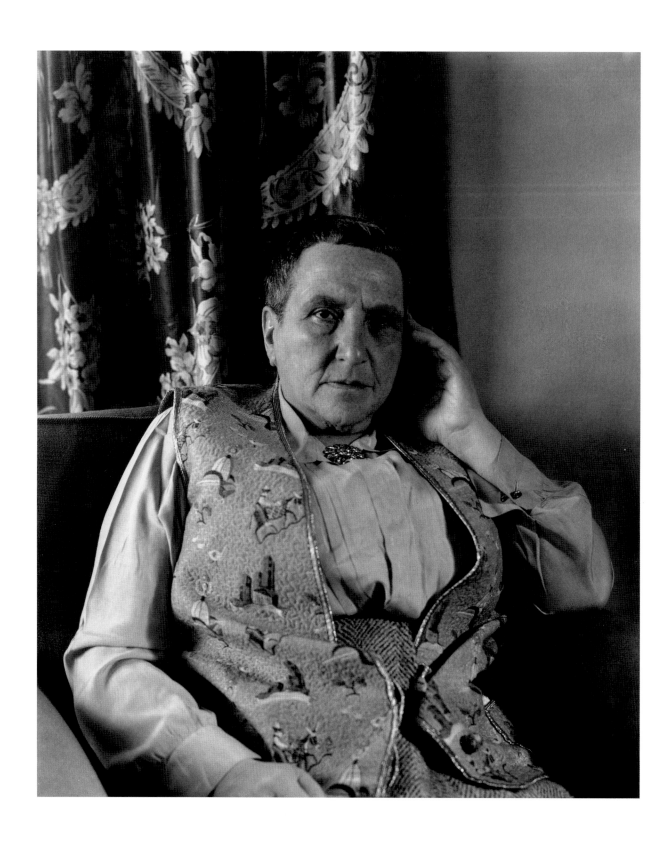

PLATE 94
Gertrude Stein, Writer, 1935

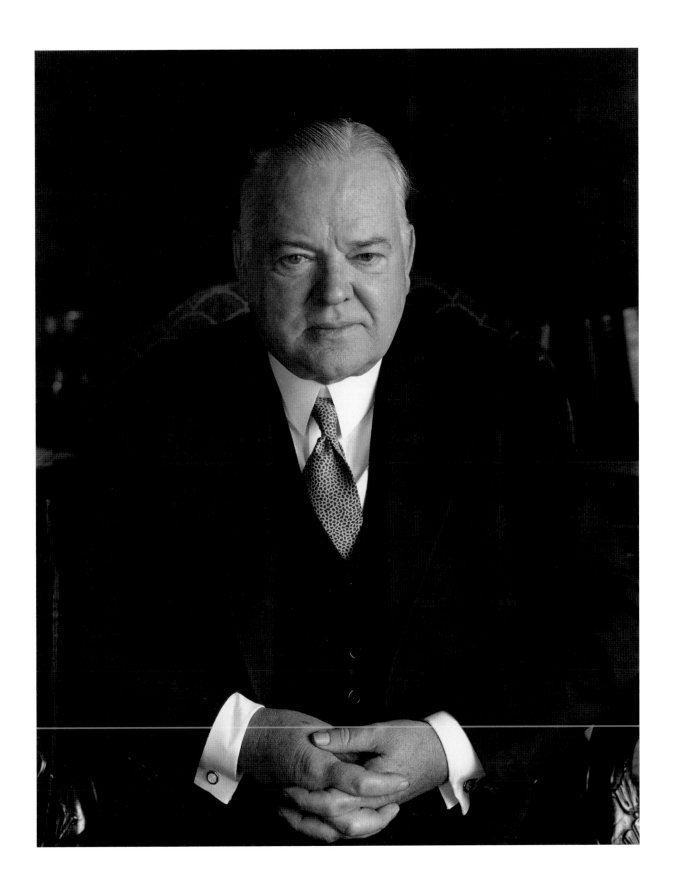

PLATE 95

Herbert Hoover 2, 1935

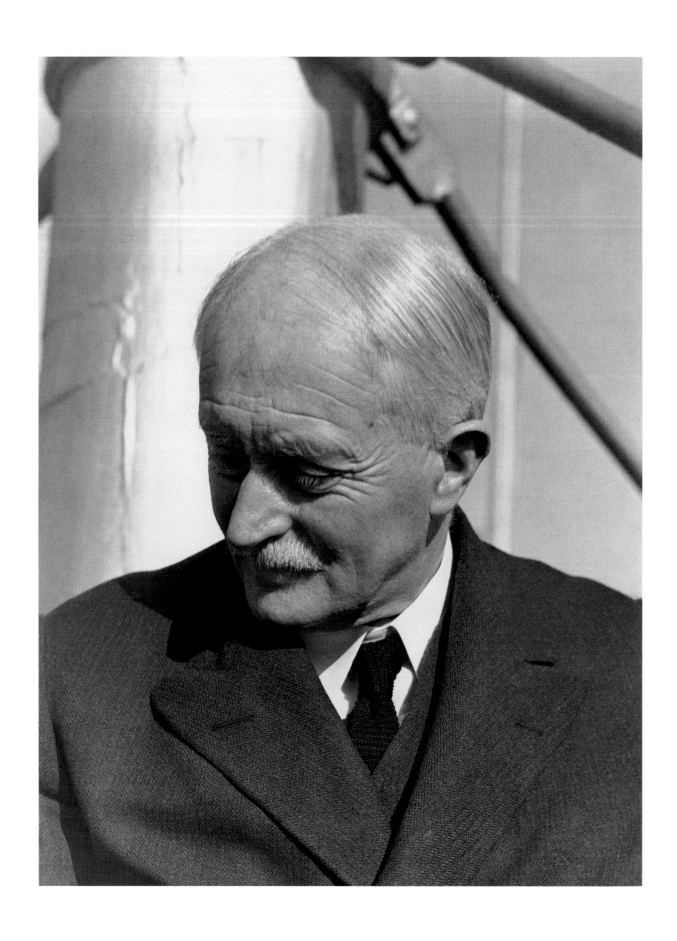

PLATE 96
John Masefield, Poet, 1935

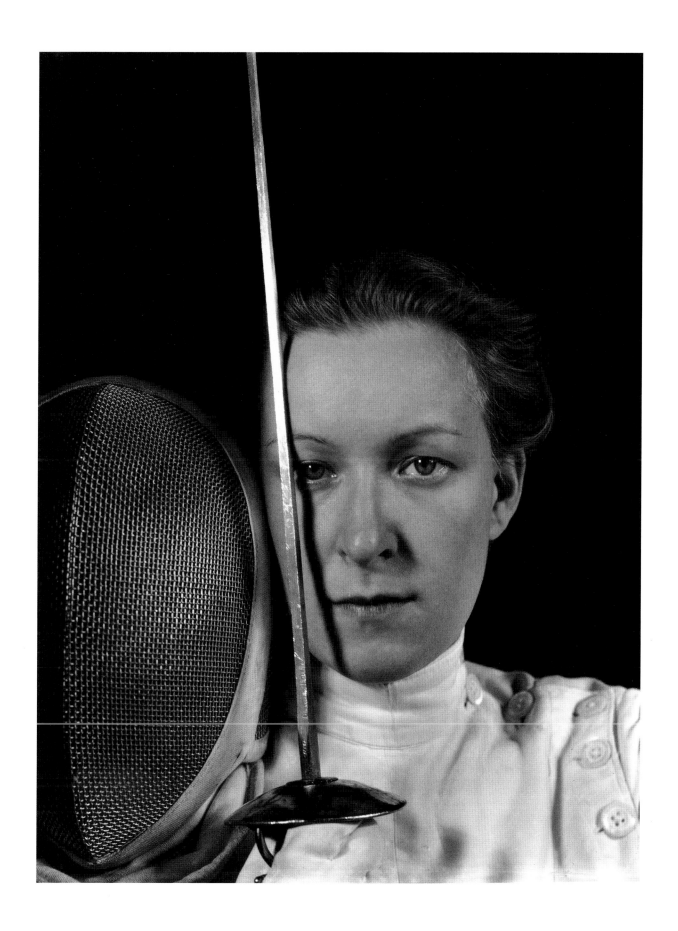

PLATE 97

Helene Mayer, Fencer, 1935

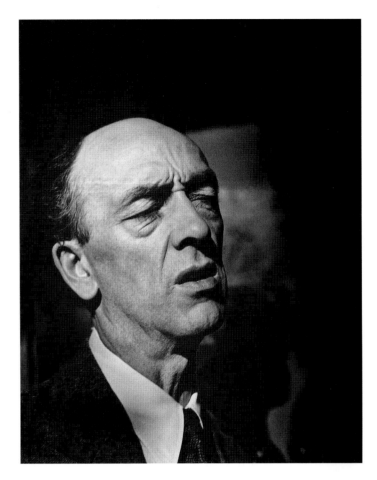

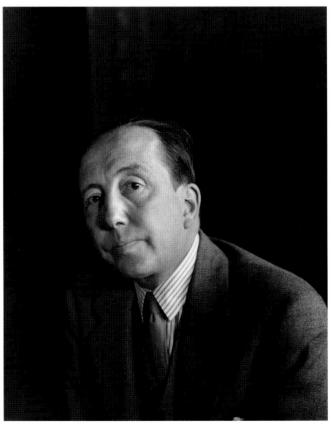

PLATE 98

James Stephens, Writer, 1935

PLATE 99

William Rose Benét, Writer, 1936

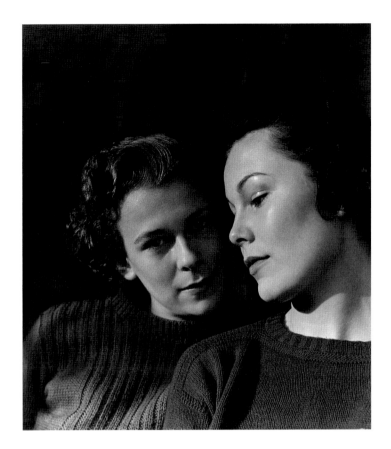

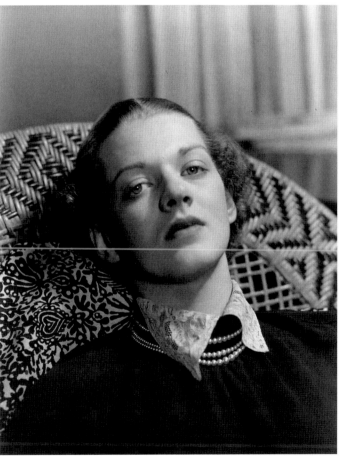

PLATE 100

Jean and Ginny Carleton, 1936

PLATE 101

Mary Margaret Rupp, 1937

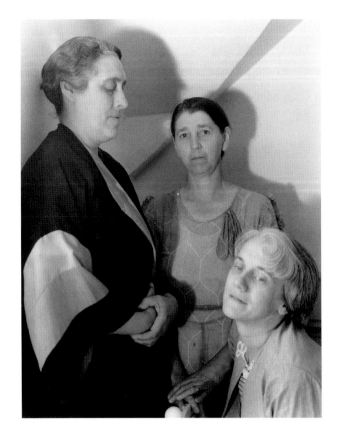

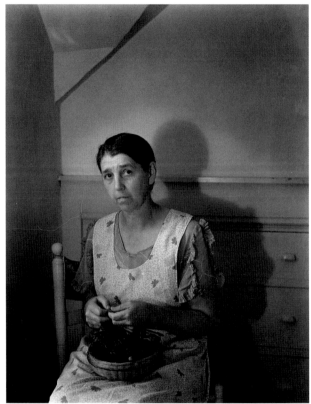

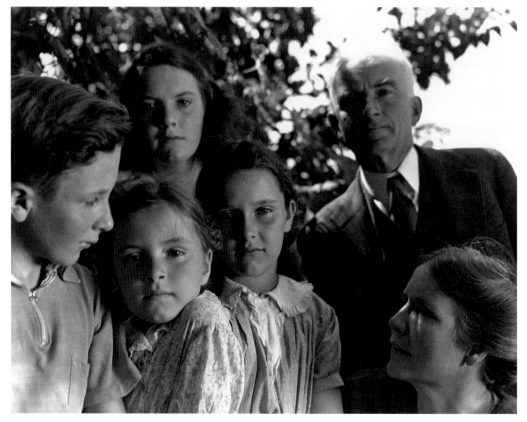

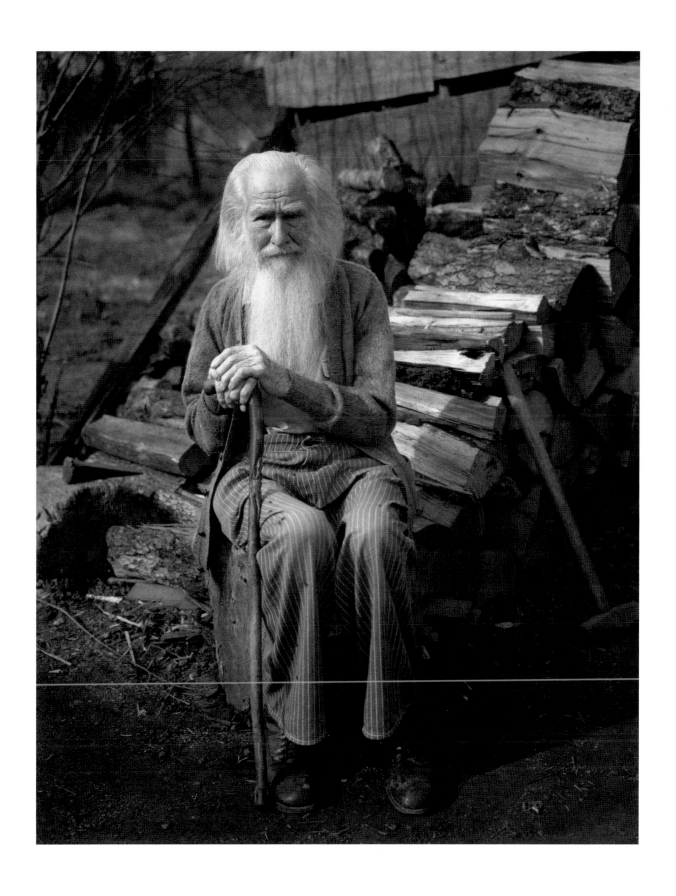

PLATE 105
My Father at Ninety, 1936

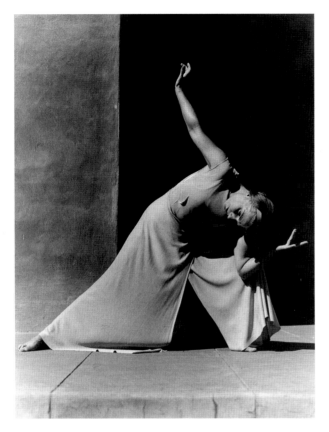

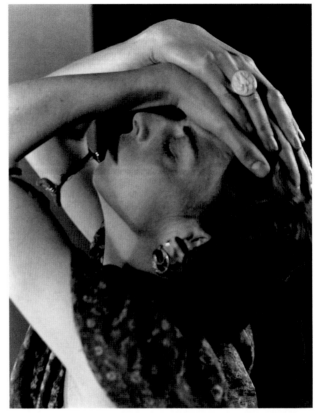

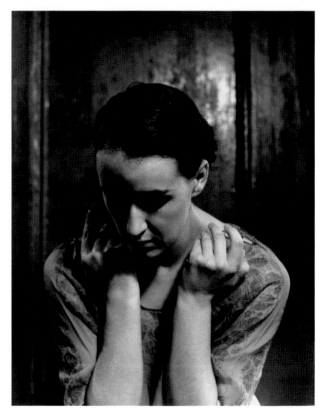

PLATE 107
Elizabeth Ginno (Mrs. John Winkler), Dancer, 1937

PLATE 106
Hanya Holm, Dancer, 1936

PLATE 108
Marian Van Tuyl, Dancer, late 1930s

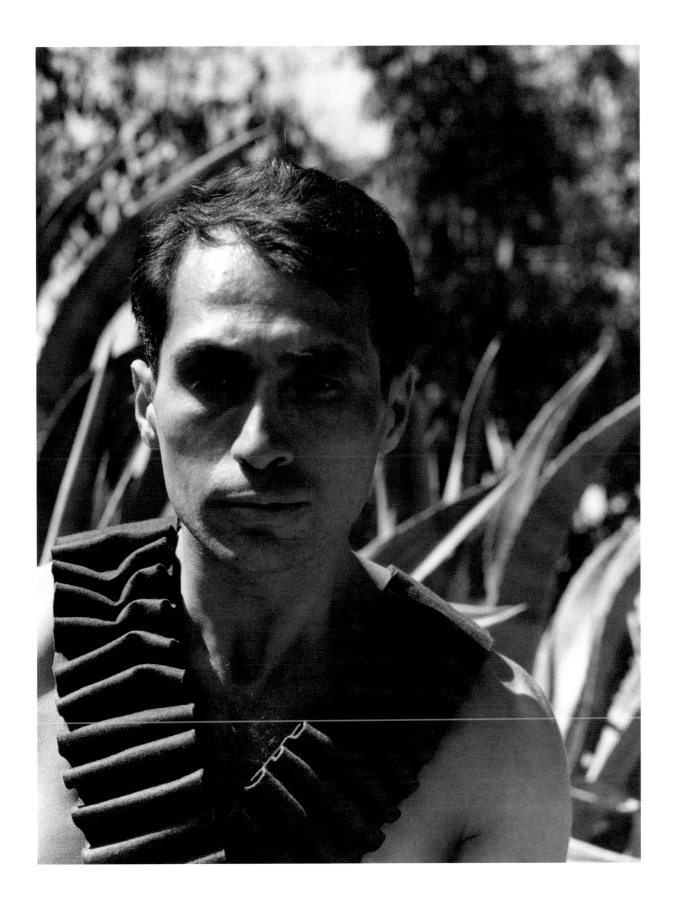

PLATE 109

José Limón, Dancer and Choreographer, 1939

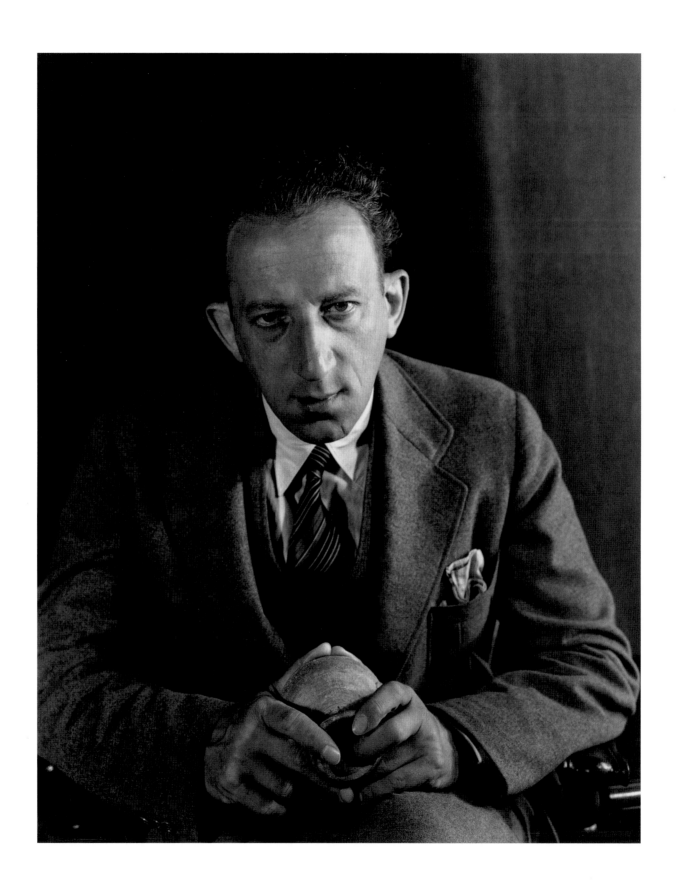

PLATE 110

Alfred Salmony, Chinese Art Scholar at Mills, 1937

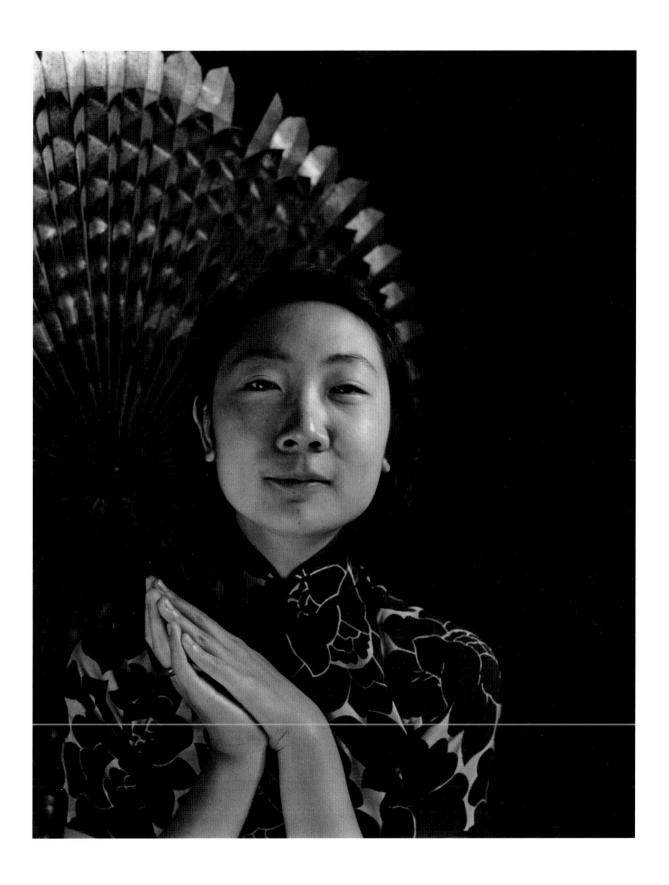

PLATE III

Shen Yao, Professor of Linguistics at the University of Hawaii, 1938

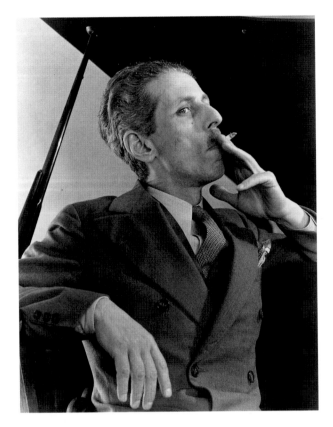

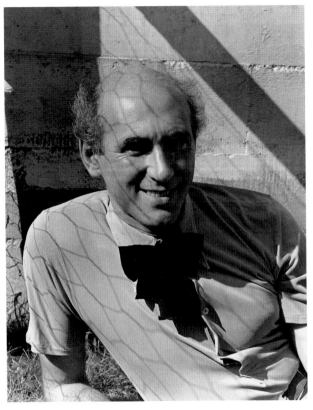

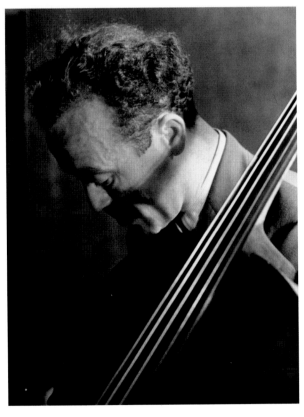

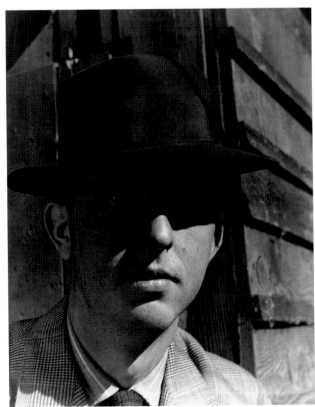

PLATE 112
Émile Robert Schmidt, Pianist, 1937

PLATE 114
Micho Schneider, Cellist, 1939

PLATE 113
Marcel Maas, late 1930s

PLATE 115
John Webb, Architect, 1939

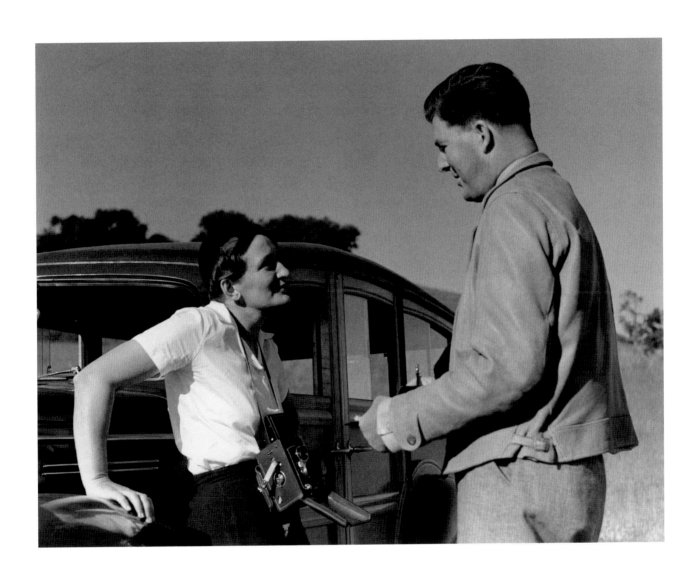

PLATE 116

Dorothea Lange and Paul Taylor 2, 1939

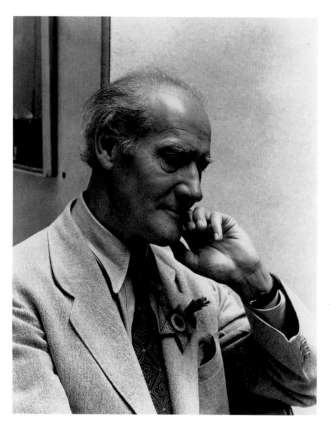

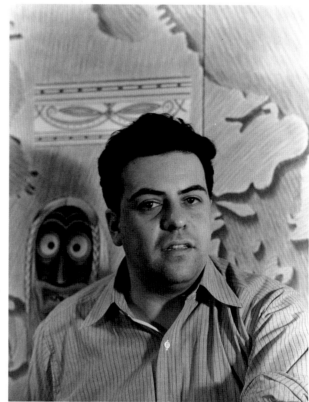

PLATE 117
Lyonel Feininger, Painter, 1936

PLATE 118
Miguel Covarrubias and His Mural, Treasure Island, 1939

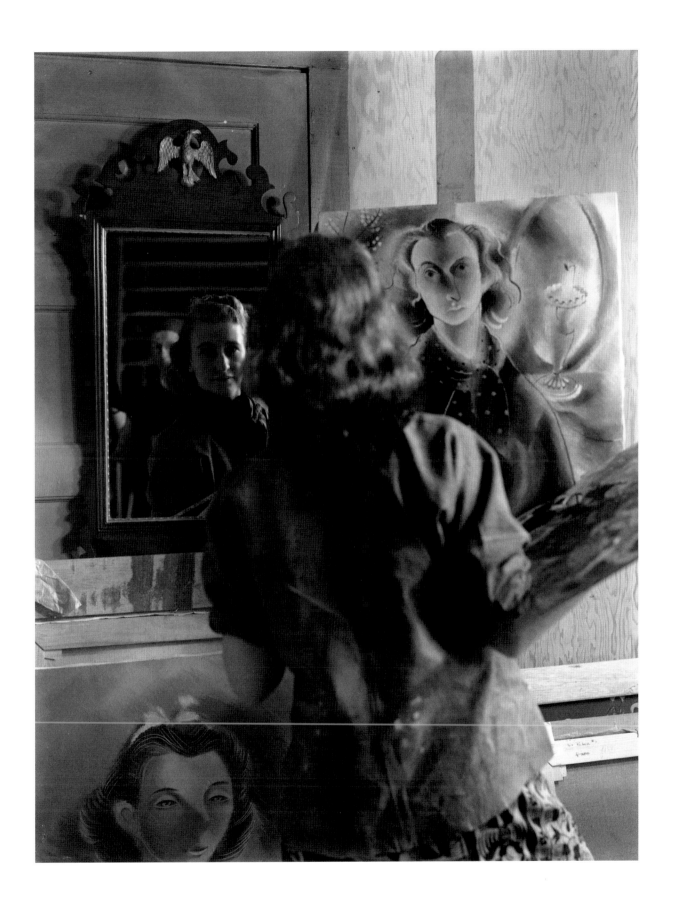

PLATE 119
Jane and Alice and Imogen, 1940

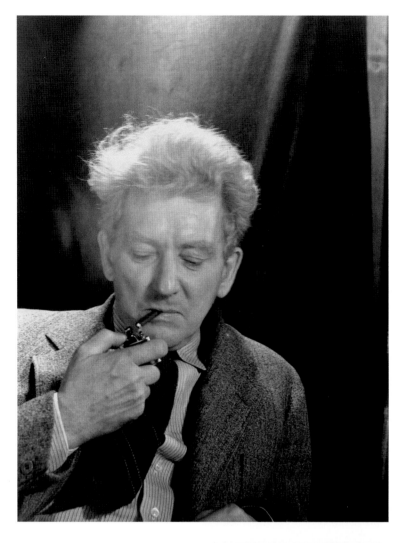

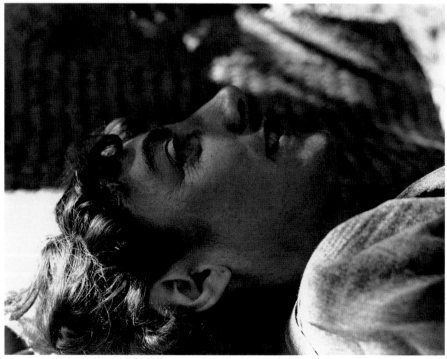

PLATE 120

Raymond Boynton, Painter, 1941

PLATE 121

Mrs. Raymond Boynton, 1941

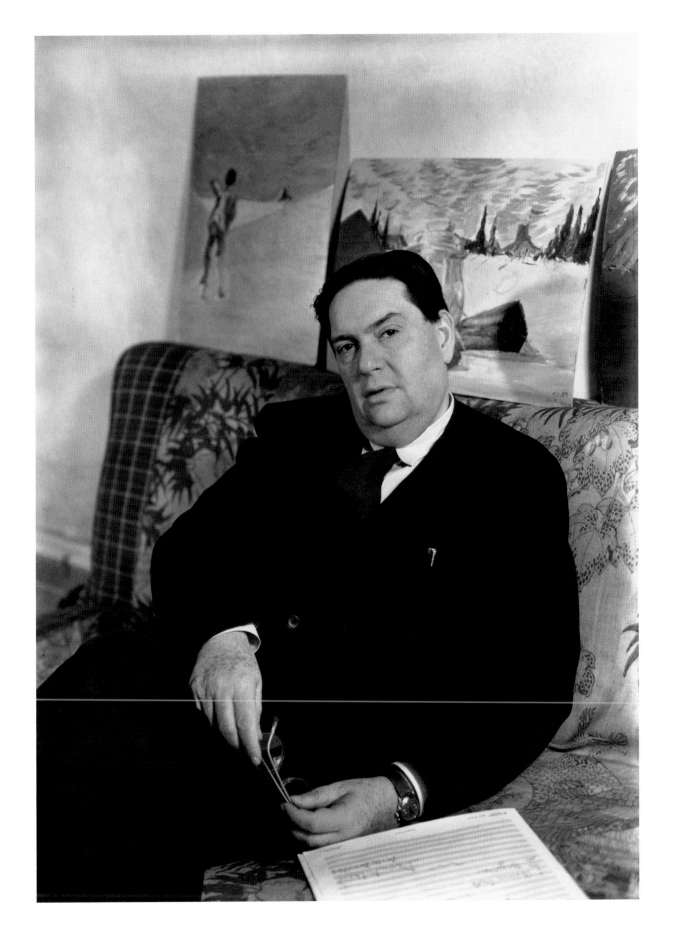

PLATE 122

Darius Milhaud, Composer, 1945

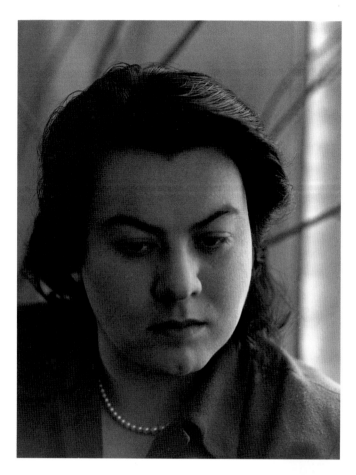

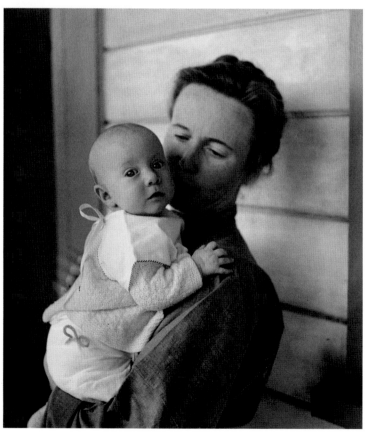

PLATE 123

Muriel Rukeyser, Poet, 1945

PLATE 124

Elizabeth and Joan Partridge, 1945

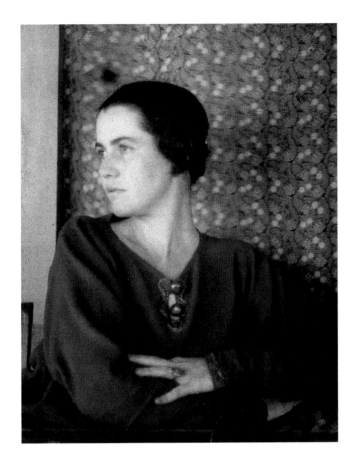

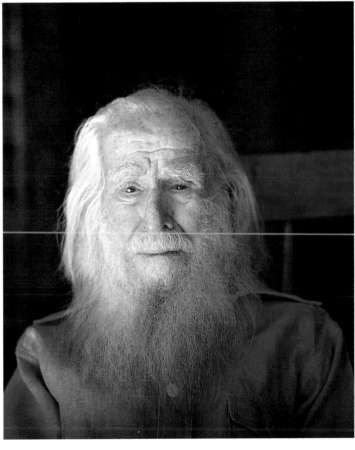

PLATE 125

Lydia Gibson, about 1915

Autochrome

PLATE 126

Isaac Burns Cunningham, 1940

Kodachrome

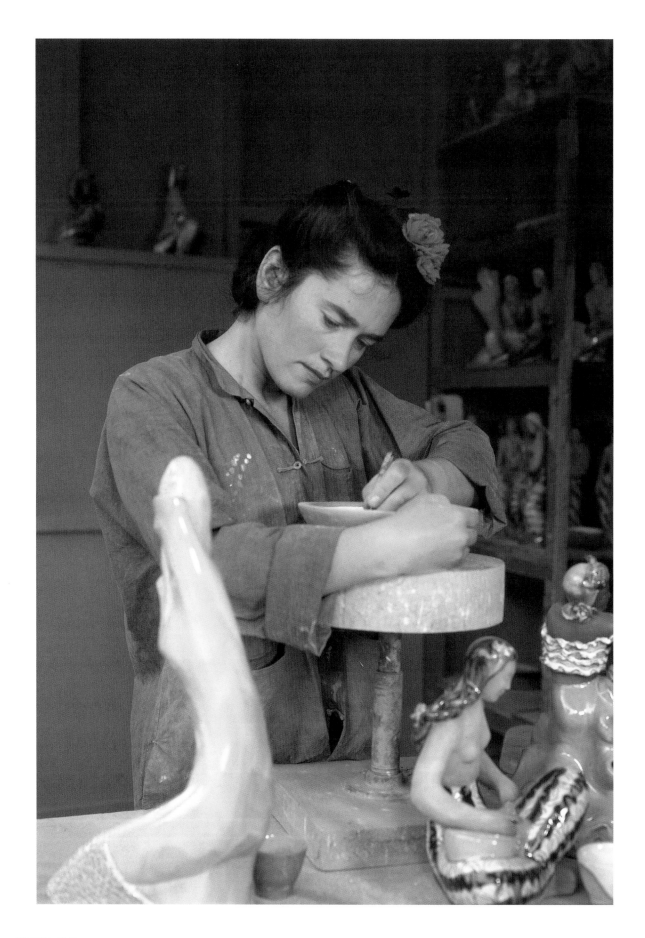

PLATE 127
Mary Erckenbrack, Sculptor, about 1940
Kodachrome

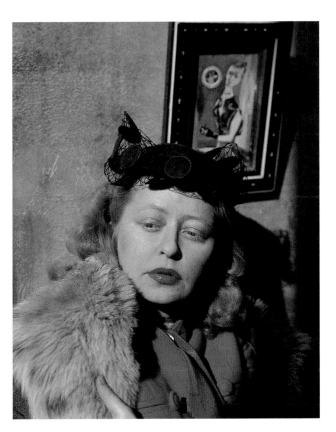

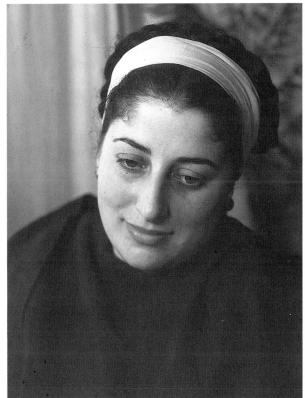

PLATE 128

Leah Rinne Hamilton, Painter, 1940s

Kodachrome

PLATE 129

Frieda Koblick, Sculptor, 1945

Kodachrome

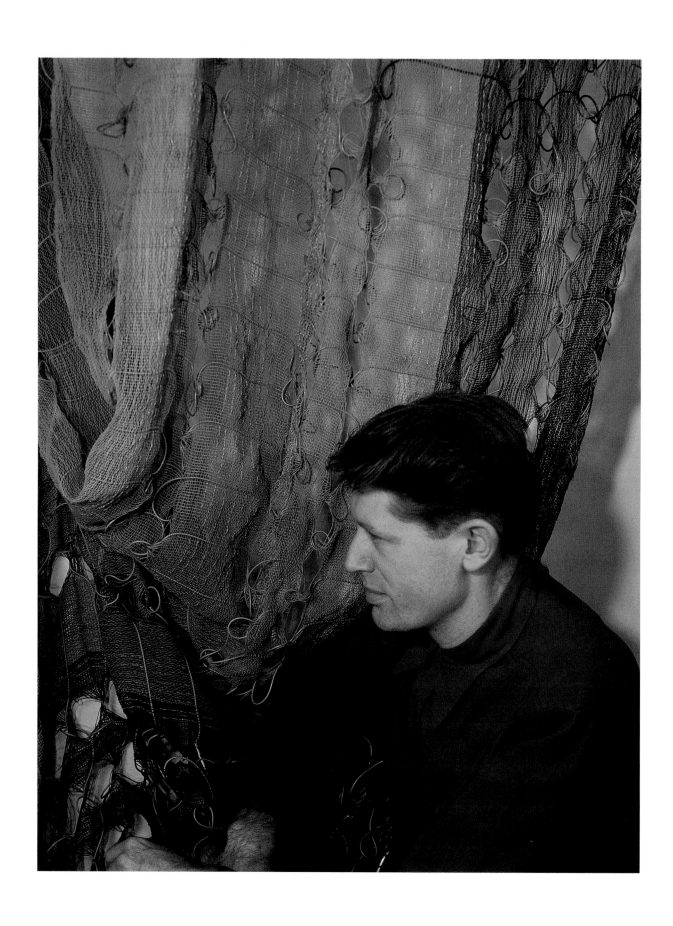

PLATE 130

Henning Watterston, Weaver, 1946
Kodachrome

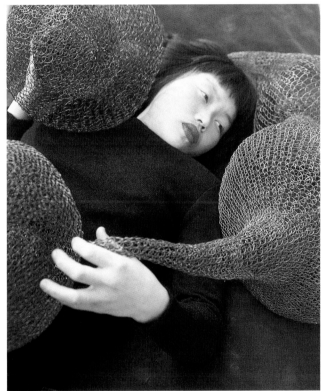

PLATE 131
Lisette Model, Photographer 2, 1946
Ektachrome

PLATE 132
Ruth Asawa, Sculptor, 1956
Ektachrome

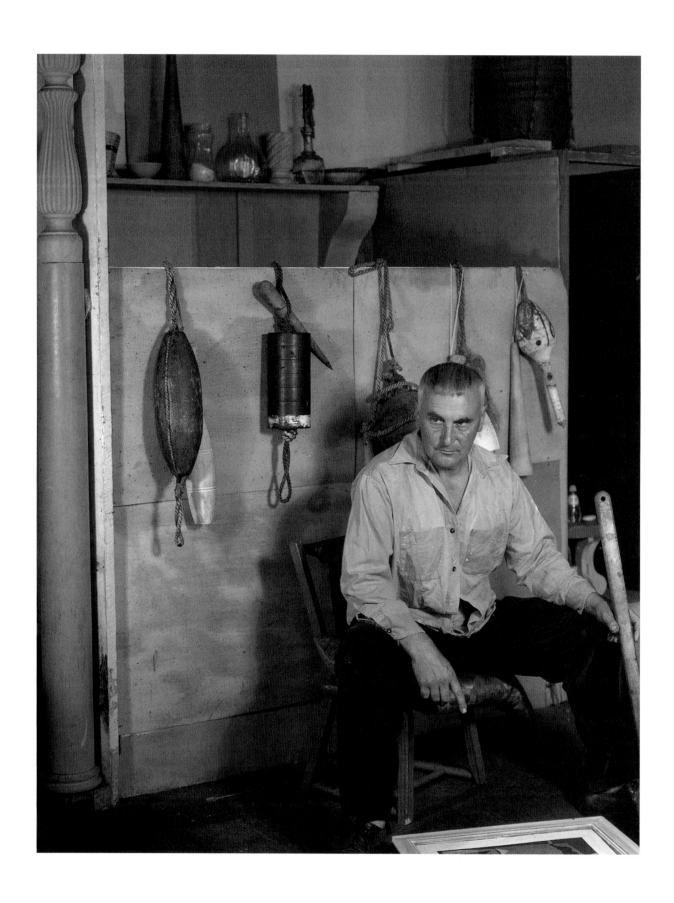

PLATE 133
Jean Varda, Painter, 1948
Ektachrome

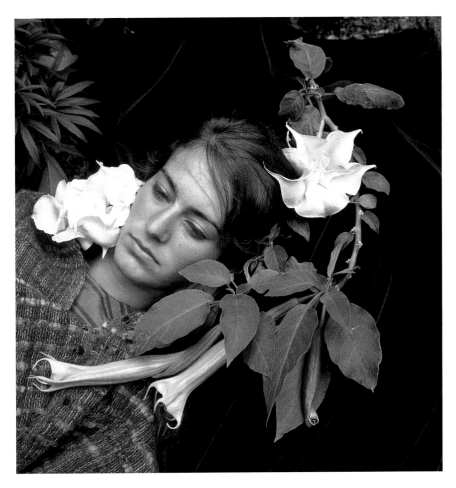

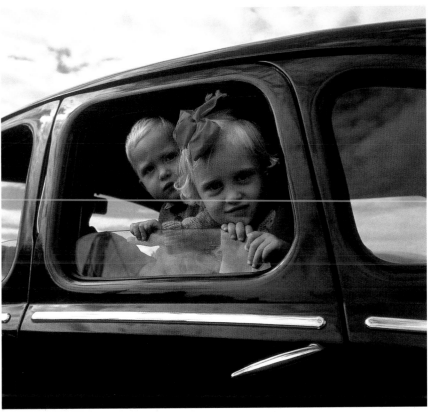

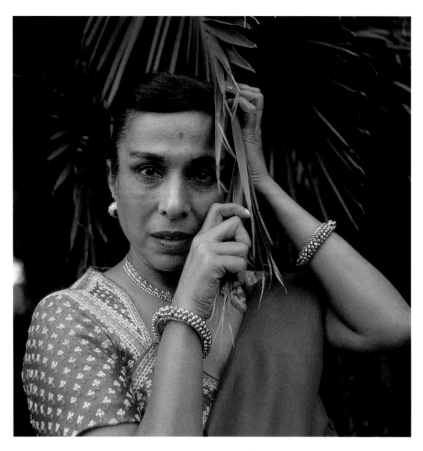

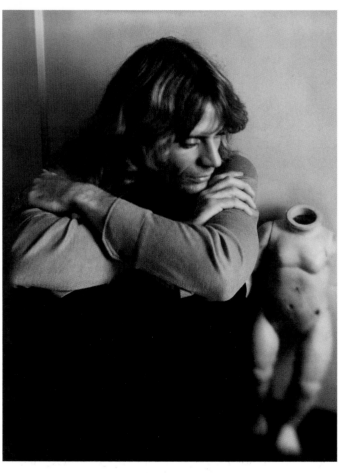

PLATE 136

Ishvani Hamilton, Dancer, 1962

Kodachrome

PLATE 137

Dennis Hall and Doll, about 1970

Polaroid

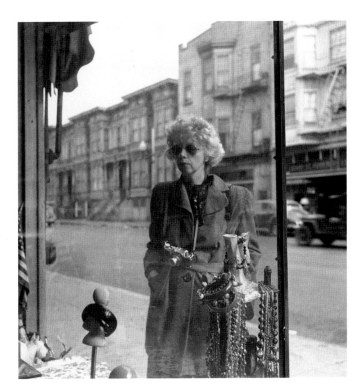

PLATE 138
Lisette Model, Photographer, 1946

PLATE 140
Rose Mandel, Photographer, 1949

PLATE 139
Nata Piaskowski, Photographer, 1948

PLATE 141
Barbara Morgan, Photographer, 1952

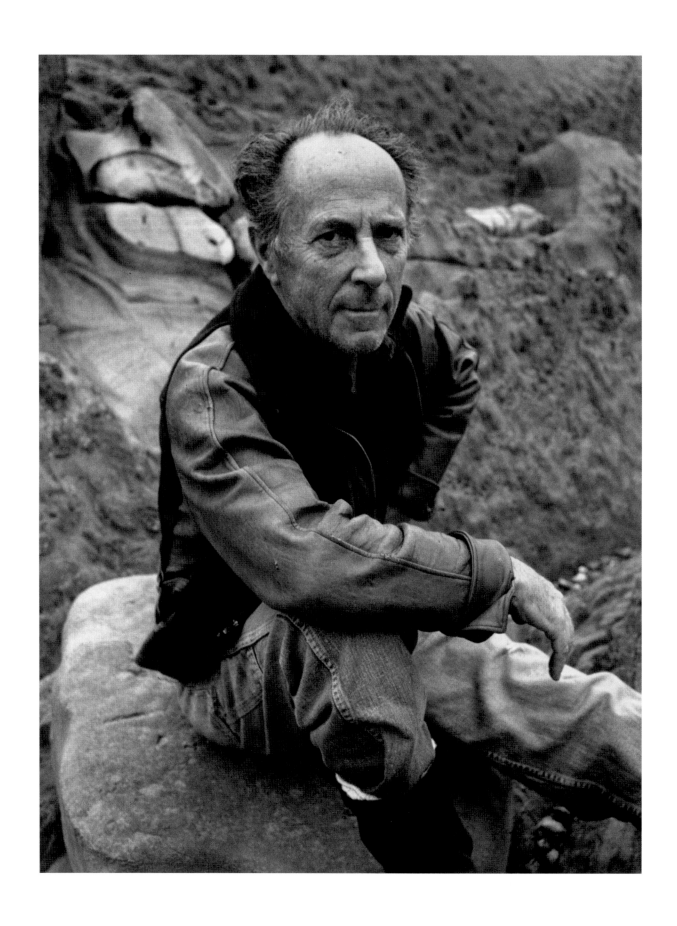

PLATE 142
Edward Weston at Point Lobos 2, 1945

PLATE 143

Charis Wilson at Point Lobos, 1945

PLATE 144

Edward Weston and Charis Wilson at Point Lobos, 1945

PLATE 145
Morris Graves, Painter, 1950

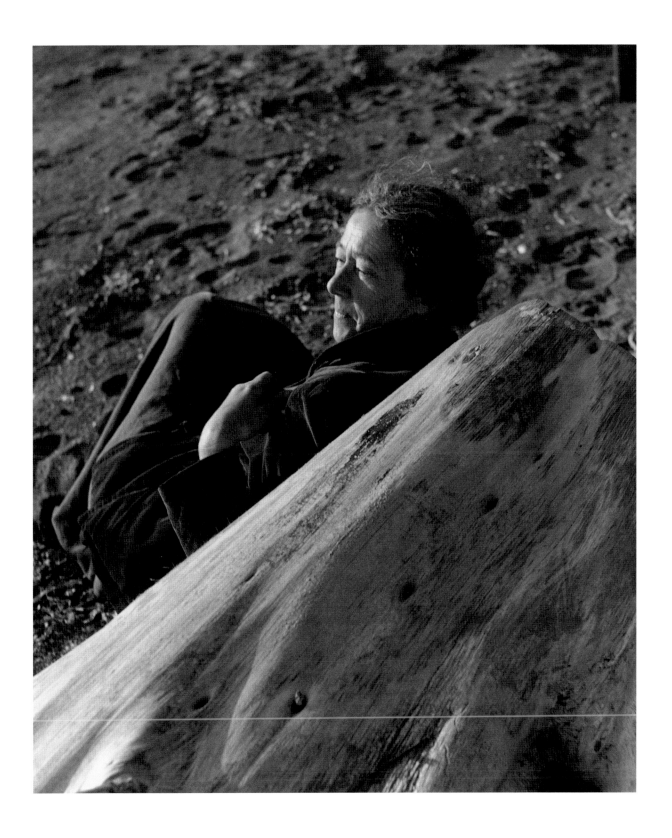

PLATE 146

Consuelo Kanaga, Photographer, 1952

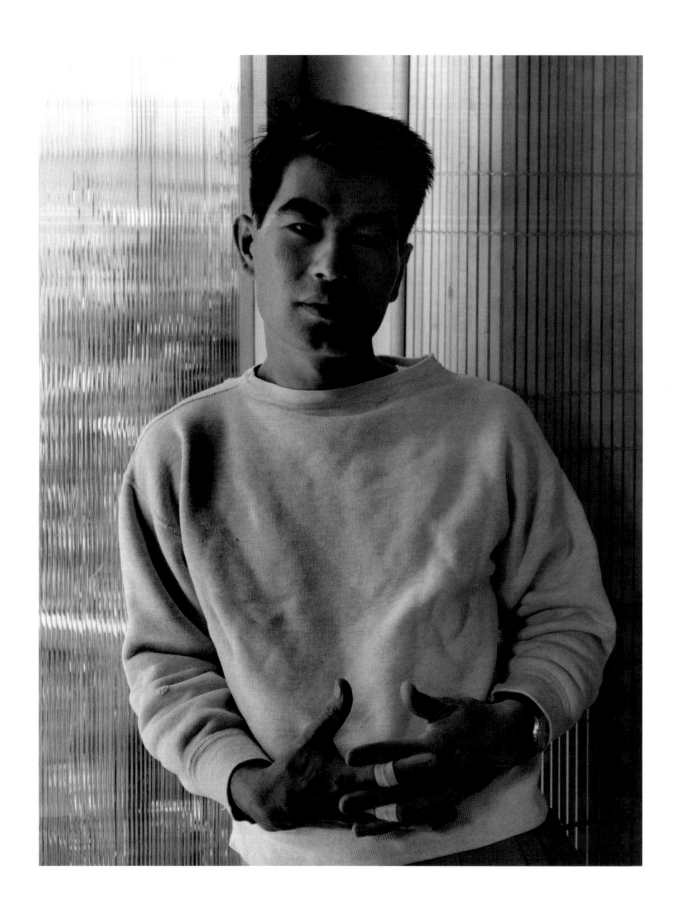

PLATE 147
Yoni Arashiro, Morris Graves' Assistant, 1951

PLATE 148

Blind Sculptor, San Francisco, 1952

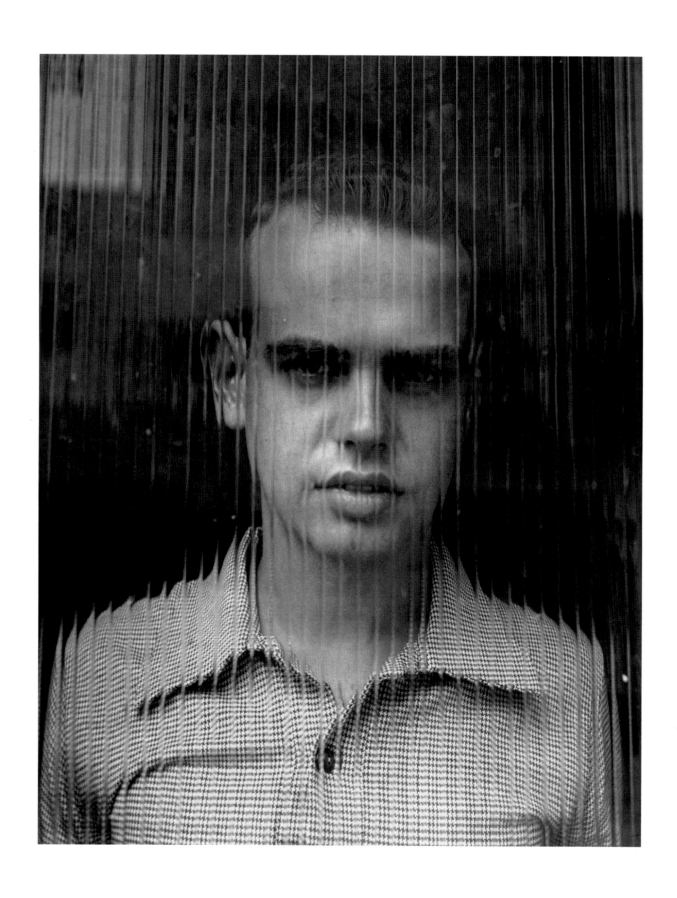

PLATE 149
Jonathan Elkus, 1952

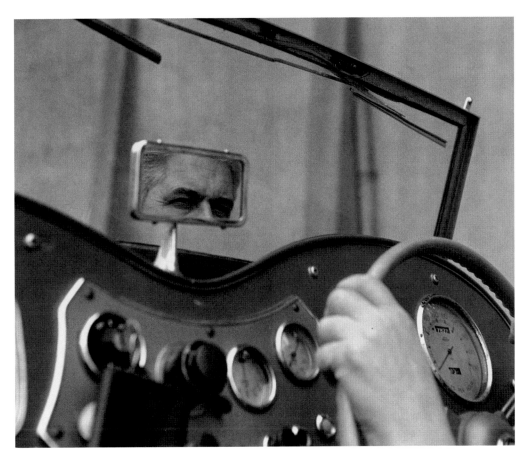

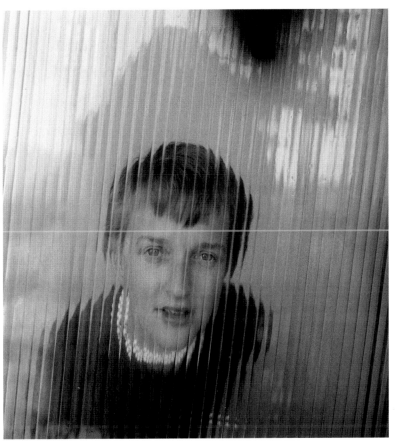

PLATE 150

Paul Burlingame, 1953

PLATE 151

Tekla Wurlitzer, 1955

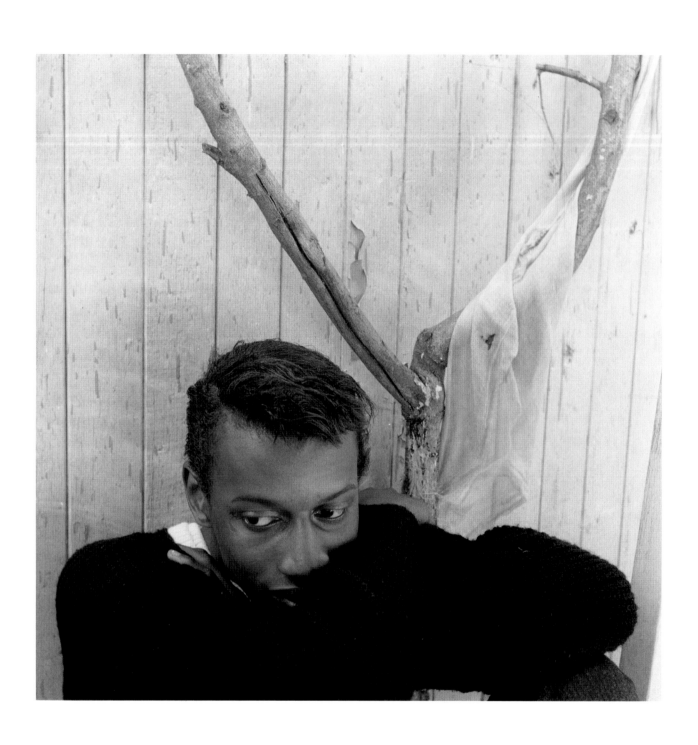

PLATE 152
Stan with Symbol, 1953

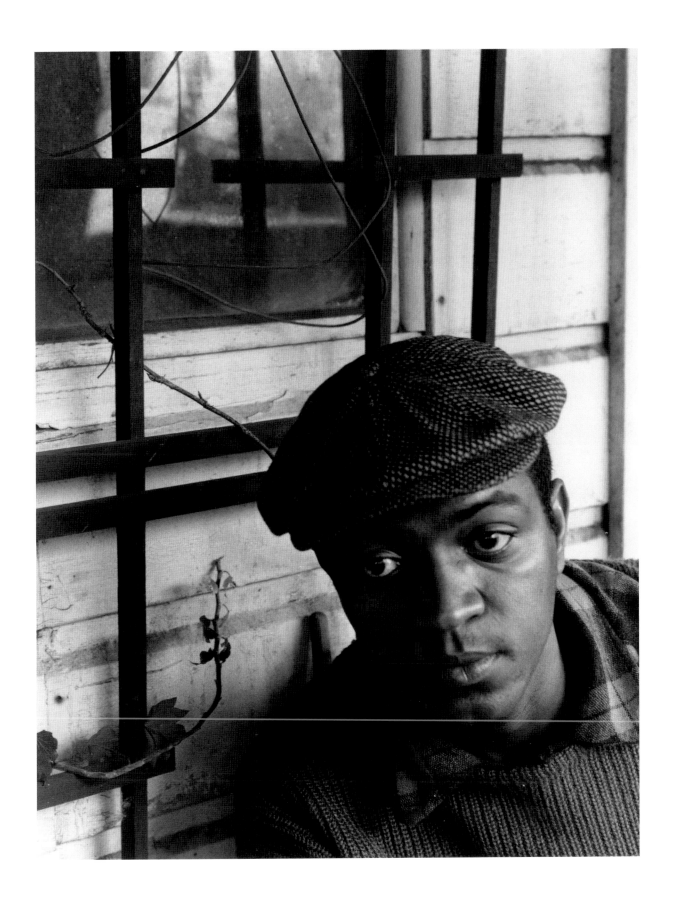

PLATE 153
Larry Compton, 1955

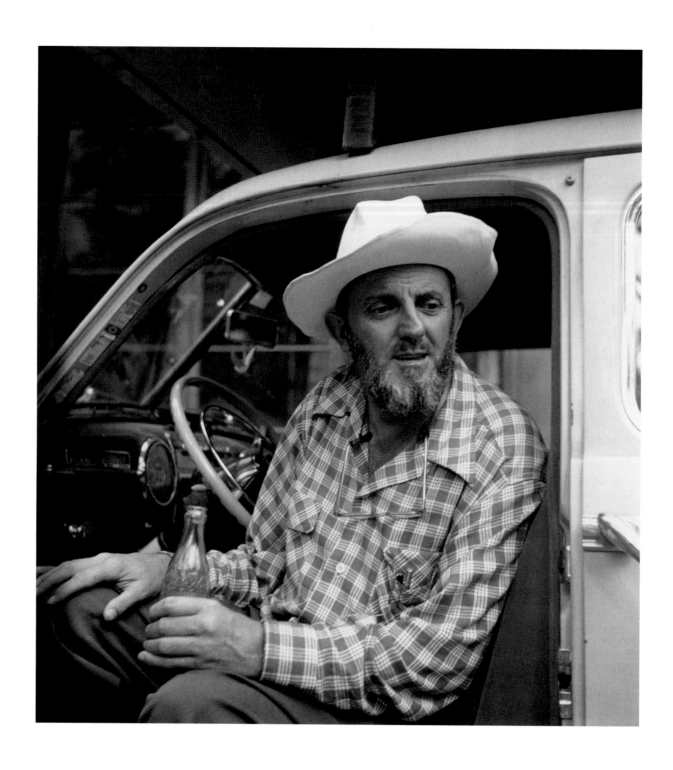

PLATE 154

Ansel Adams, Photographer, Yosemite Valley 2, 1953

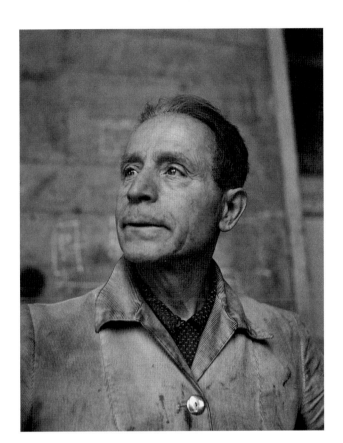

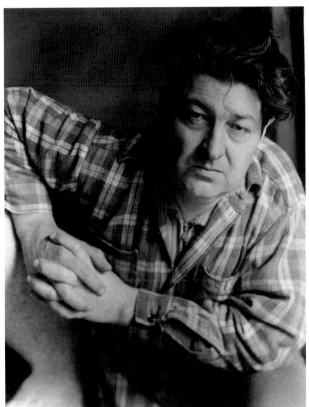

PLATE 155

Benjamino Bufano, Sculptor, 1953

PLATE 156

Raymond Puccinelli, Sculptor, 1954

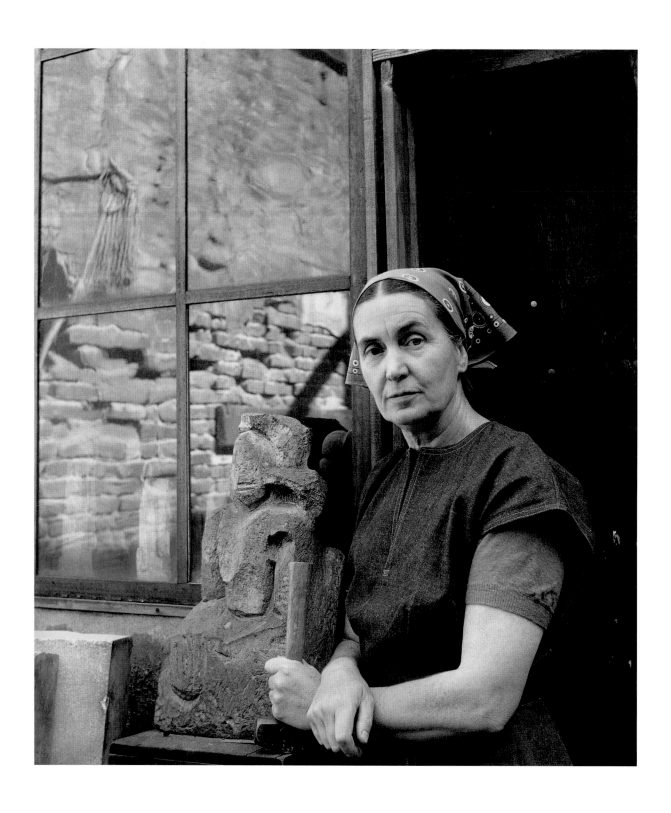

PLATE 157
Ruth Cravath, Sculptor, 1955

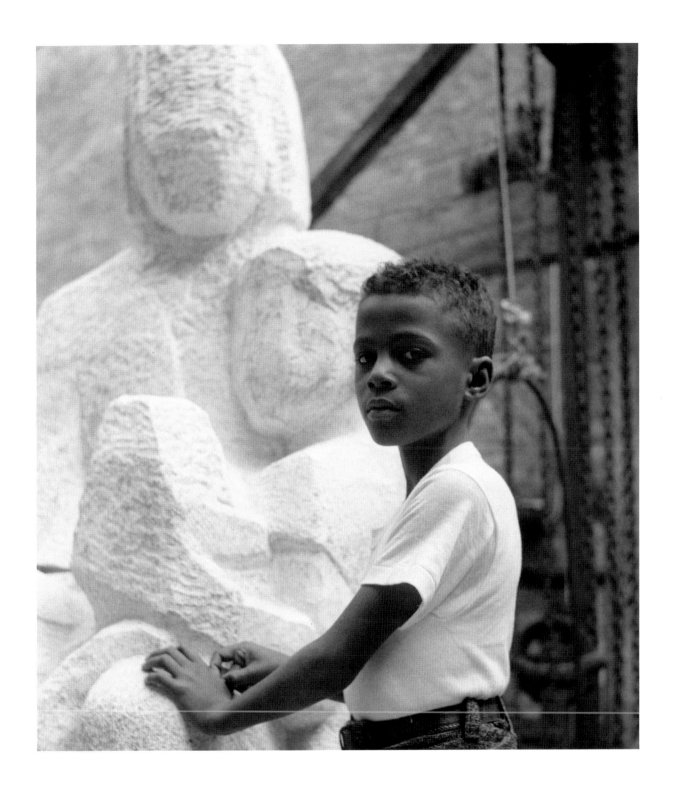

PLATE 158
Ruth Cravath's Model with Sculpture, 1955

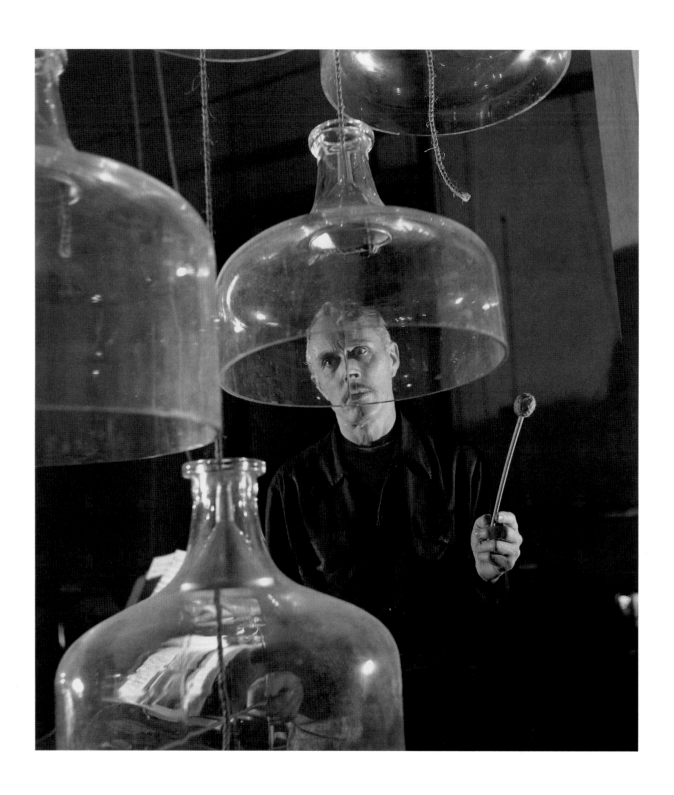

PLATE 159

Harry Partch, Musician, 1955

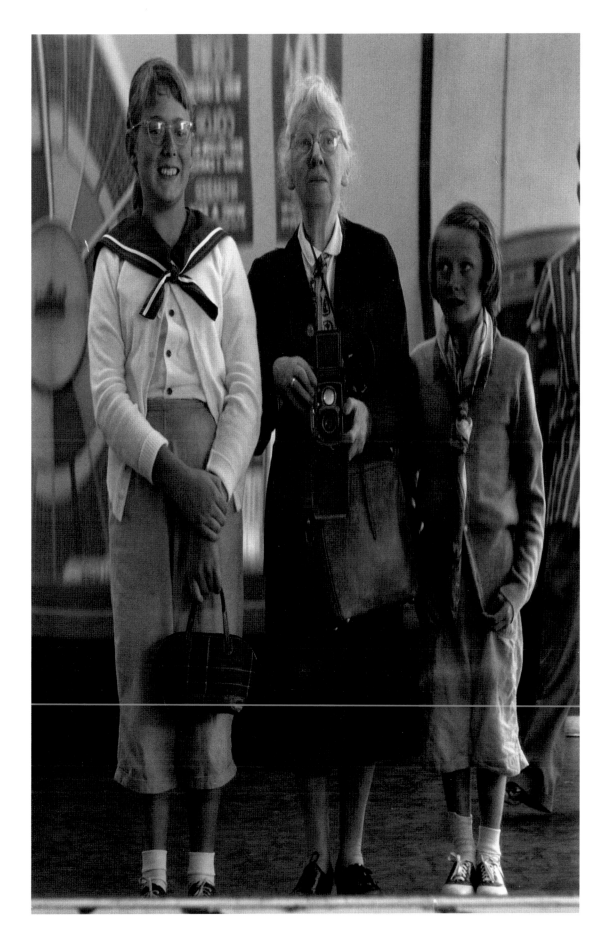

PLATE 160

Self-portrait with Grandchildren in the Funhouse 2, 1955

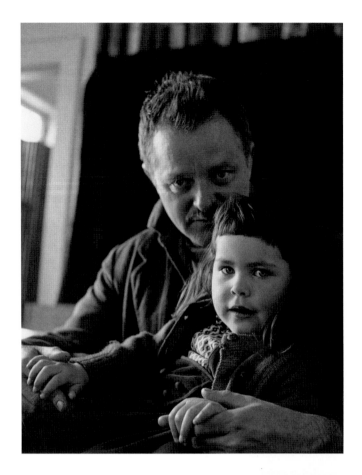

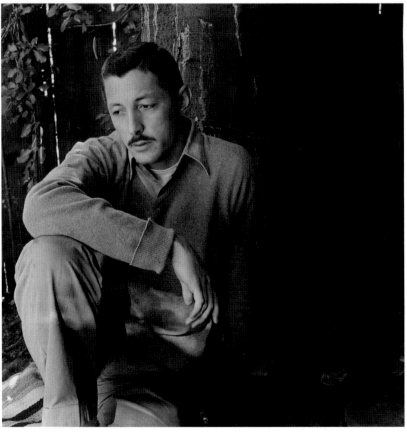

PLATE 161

Kenneth Rexroth, Poet, and Mariana Rexroth, 1953

PLATE 162

Evan Connell, Writer, 1956

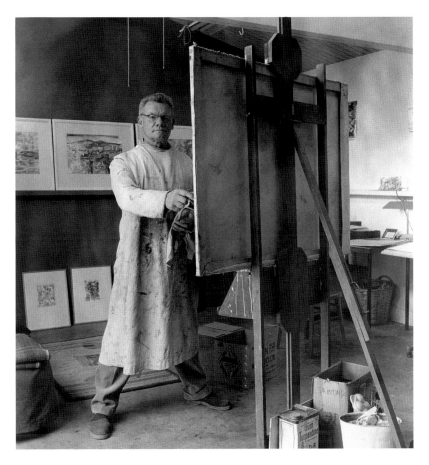

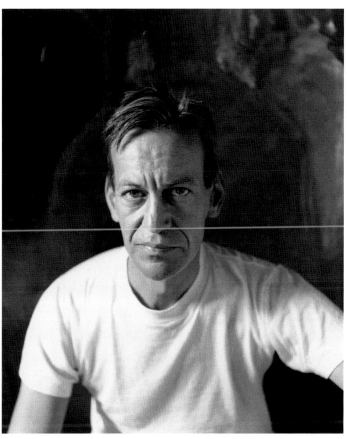

PLATE 163

Glenn Wessels, Artist, 1956

PLATE 164

David Park, Painter 2, 1958

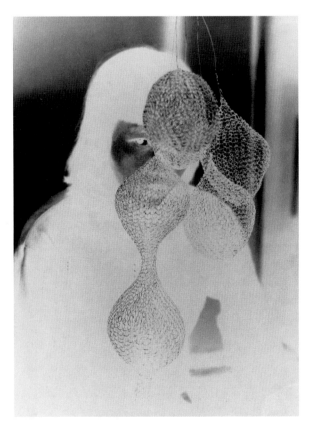

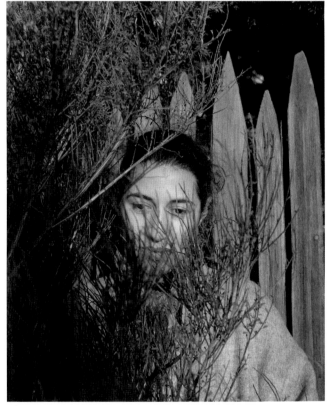

PLATE 165

Ruth Asawa, Sculptor (Negative), 1956

PLATE 166

Barbara Cannon Myers, Photographer, 1956

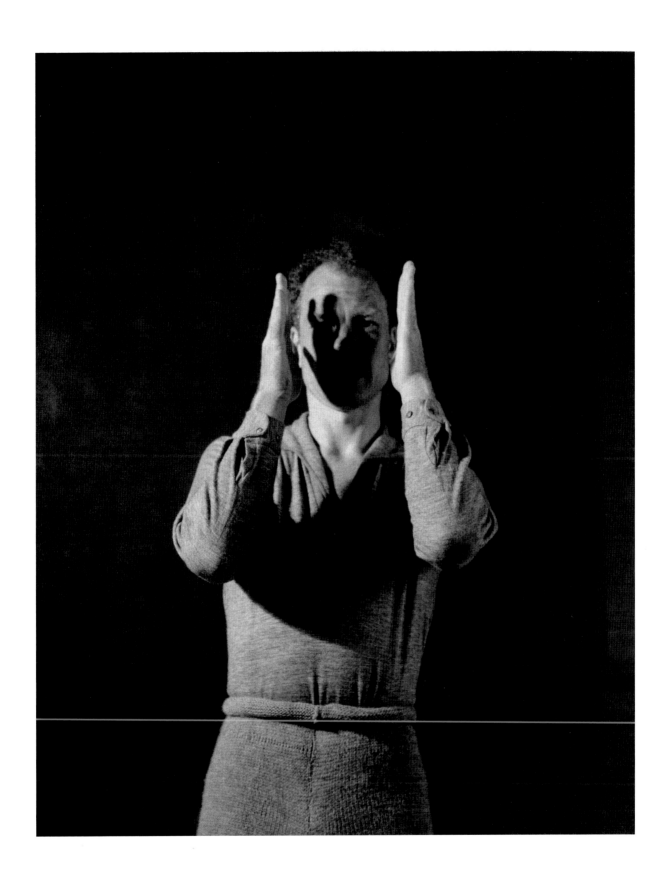

PLATE 167

Merce Cunningham, Dancer and Choreographer 2, 1957

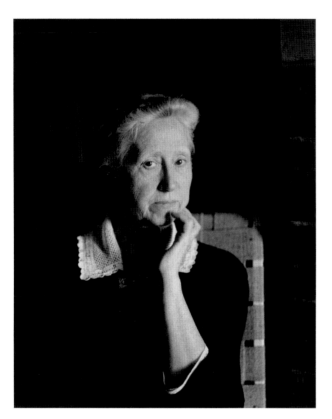

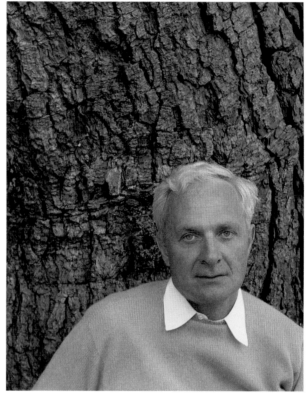

PLATE 168

Marianne Moore, Poet, 1957

PLATE 169

Stephen Spender, Poet, 1957

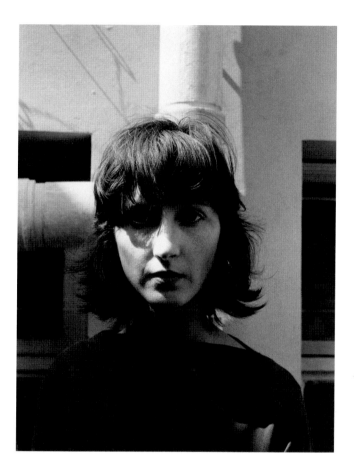

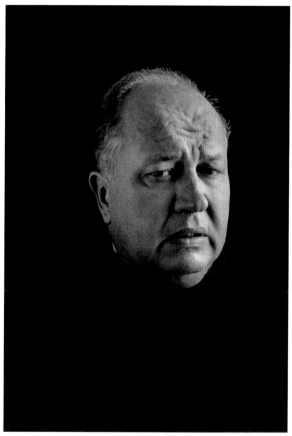

PLATE 170

Roberta, 1959

PLATE 171

Theodore Roethke, Poet 2, 1959

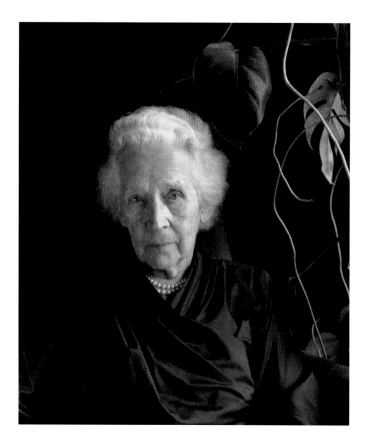

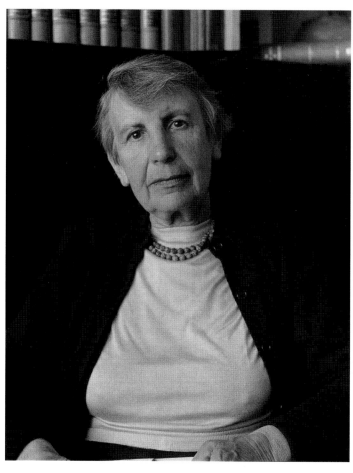

PLATE 172

Age and Its Symbols, 1958

PLATE 173

Anna Freud, Psychologist 2, 1959

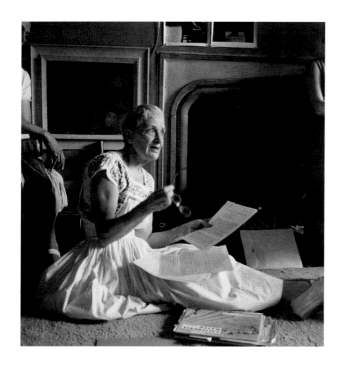

PLATE 174
Dorothea Lange, Photographer, 1958

PLATE 175
Students of Dorothea Lange, 1958

PLATE 176
William Roth Family, 1958

PLATE 177
William Roth Family 2, 1958

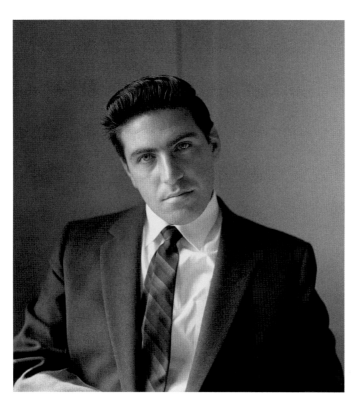

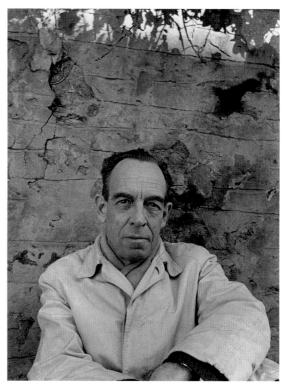

PLATE 178

Paul Caponigro, Photographer, 1959

PLATE 179

Mark Schorer, Writer 2, 1960

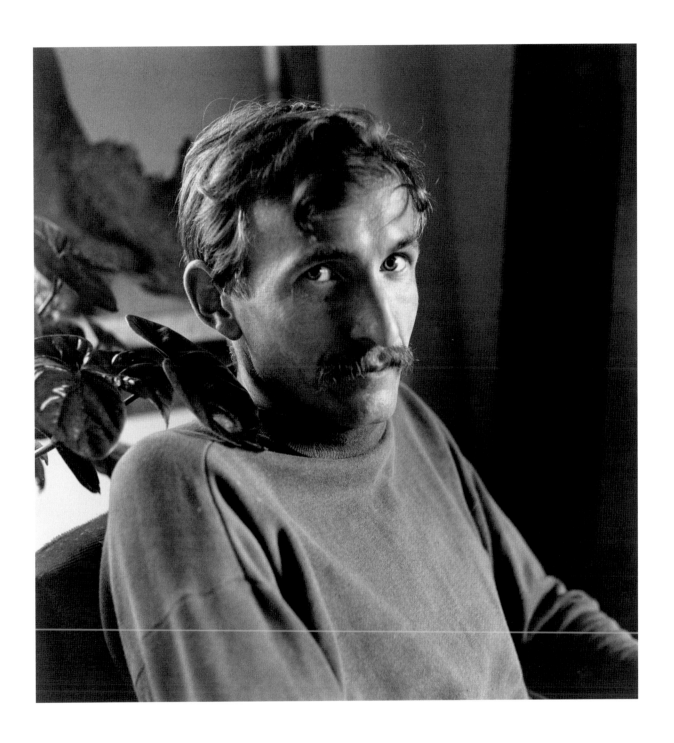

PLATE 180
Walter Chappell, Photographer, 1960

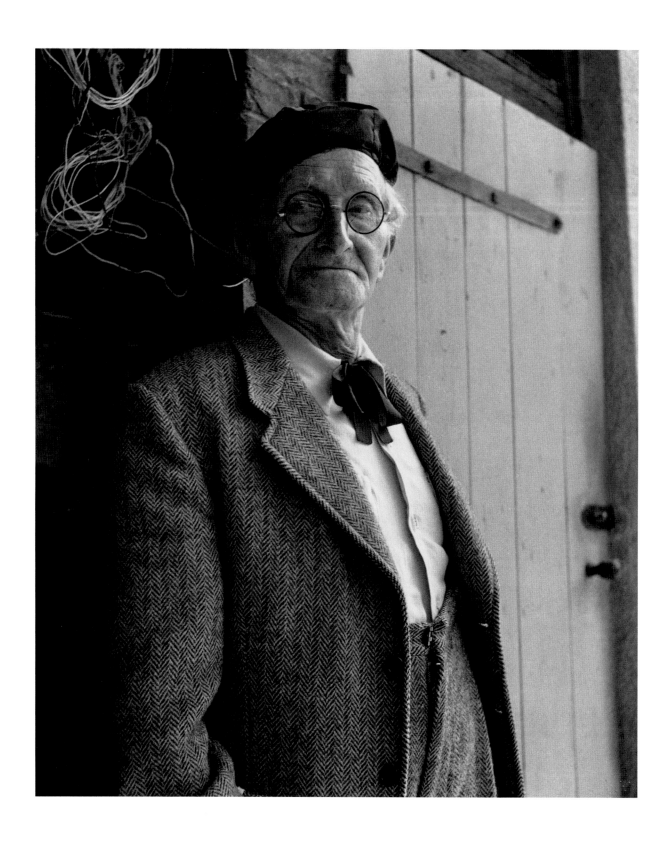

PLATE 181
August Sander, Photographer, 1960

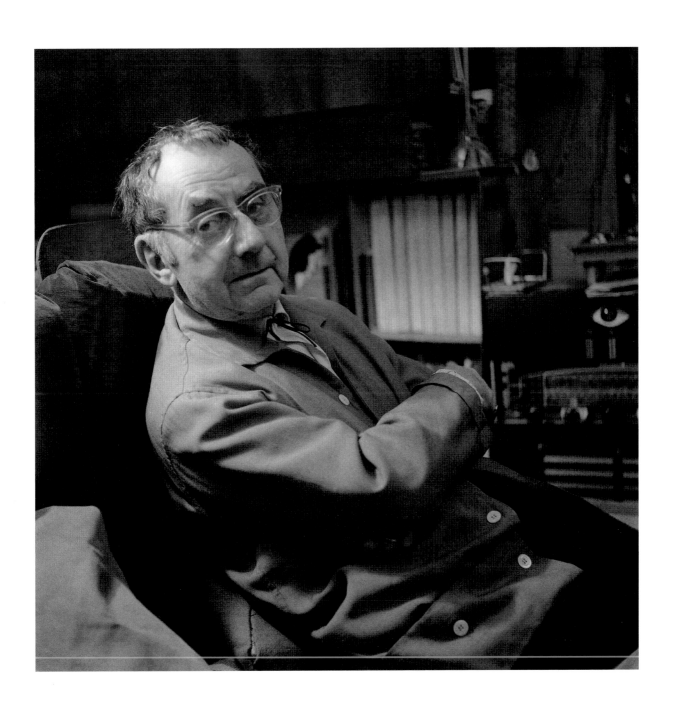

PLATE 182

Man Ray, Photographer, Paris, 1961

PLATE 183

Beth Altman, 1960

PLATE 184

Goodhue Child, 1961

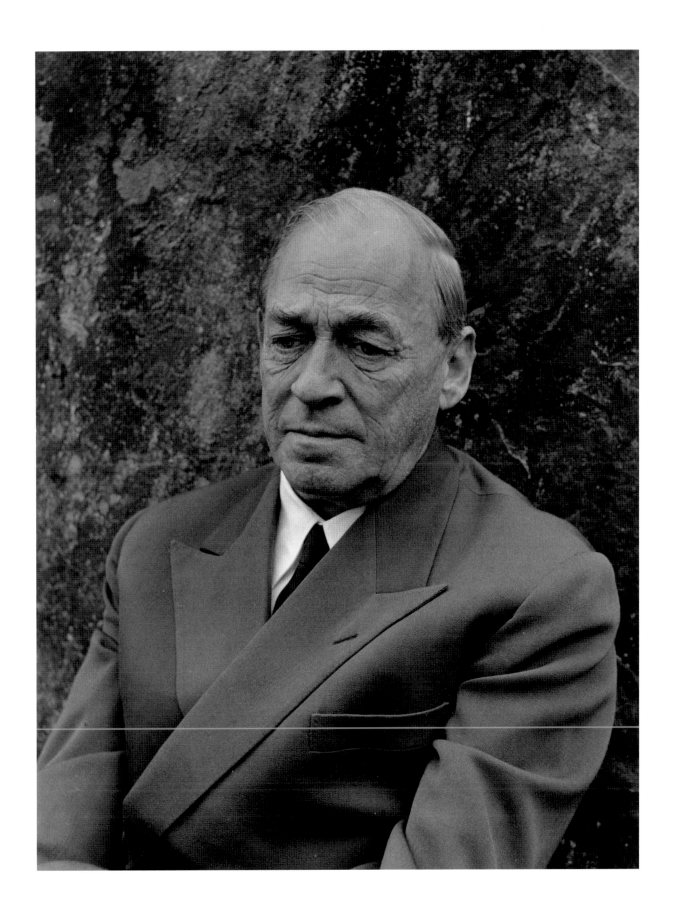

PLATE 185

Alvar Aalto, Architect and Designer, 1961

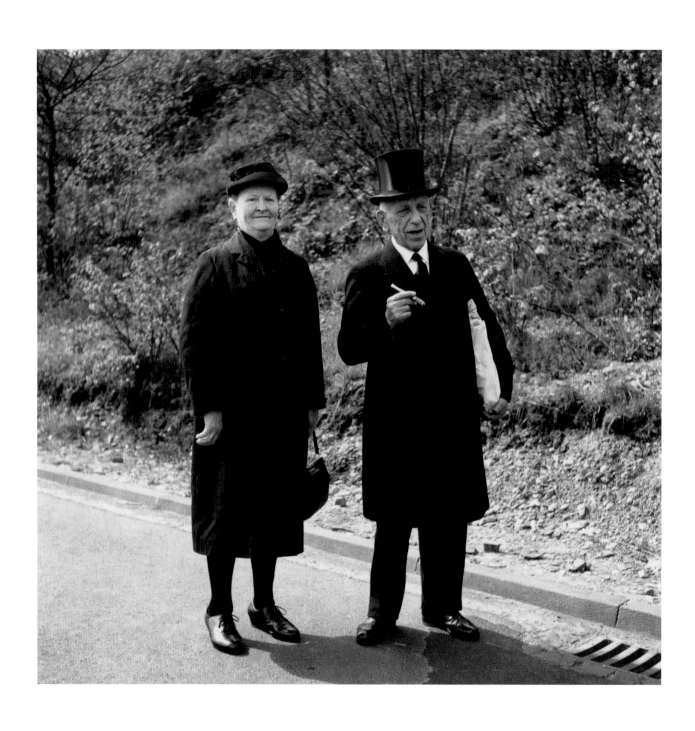

PLATE 186

People on the Road, Germany, 1960

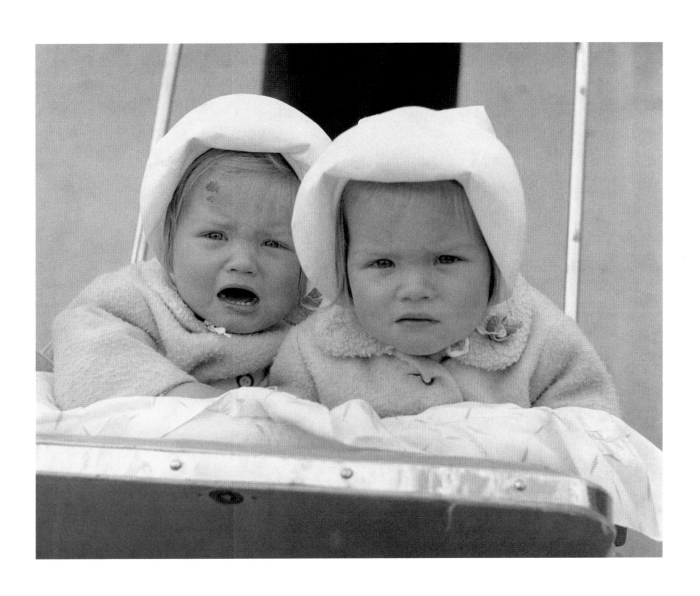

PLATE 187

Twins, Poland, 1961

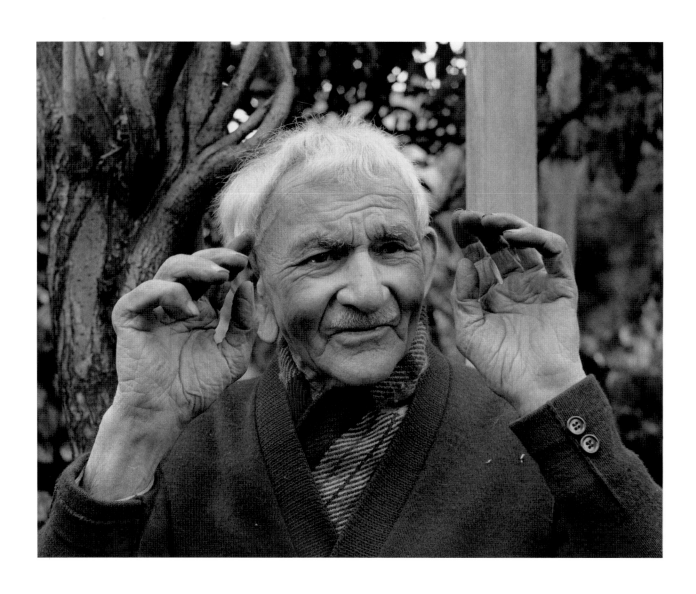

PLATE 188

John Roeder, Sculptor, 1961

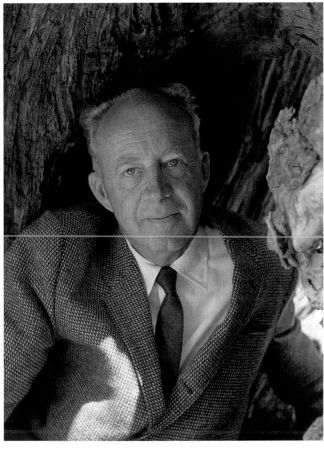

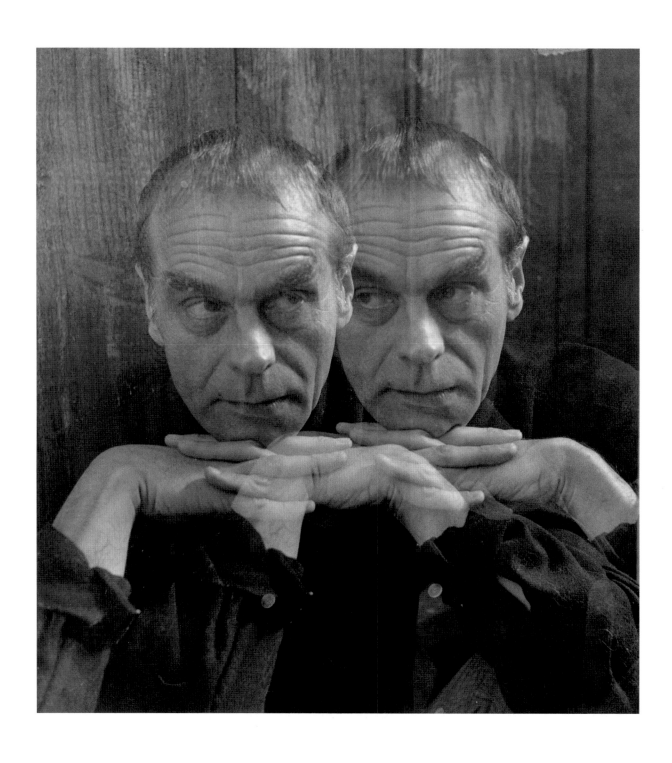

PLATE 191

The Poet and His Alter Ego (James Broughton, Poet and Filmmaker), 1962

PLATE 192

Beth Altman with Taiwan Leaves, 1963

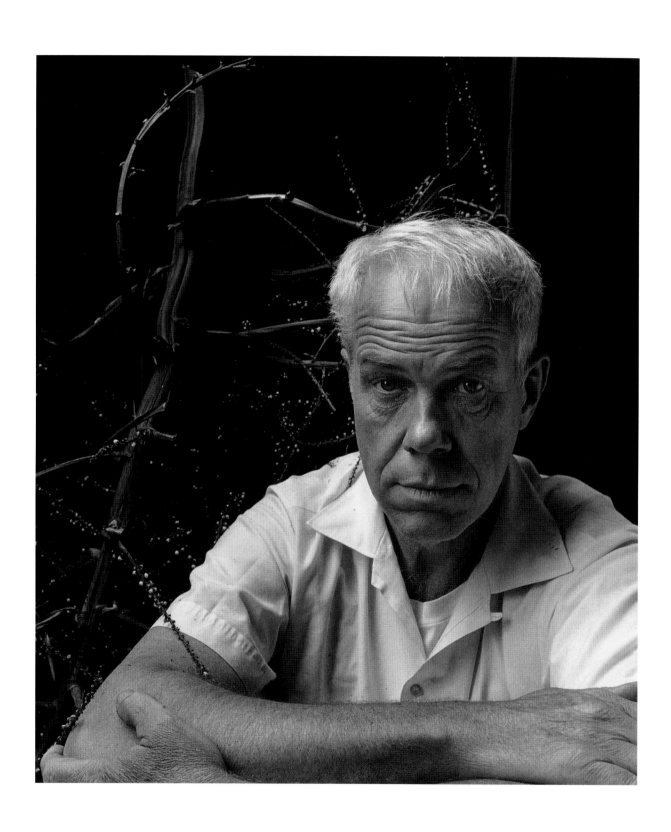

PLATE 193
Minor White, Photographer, 1963

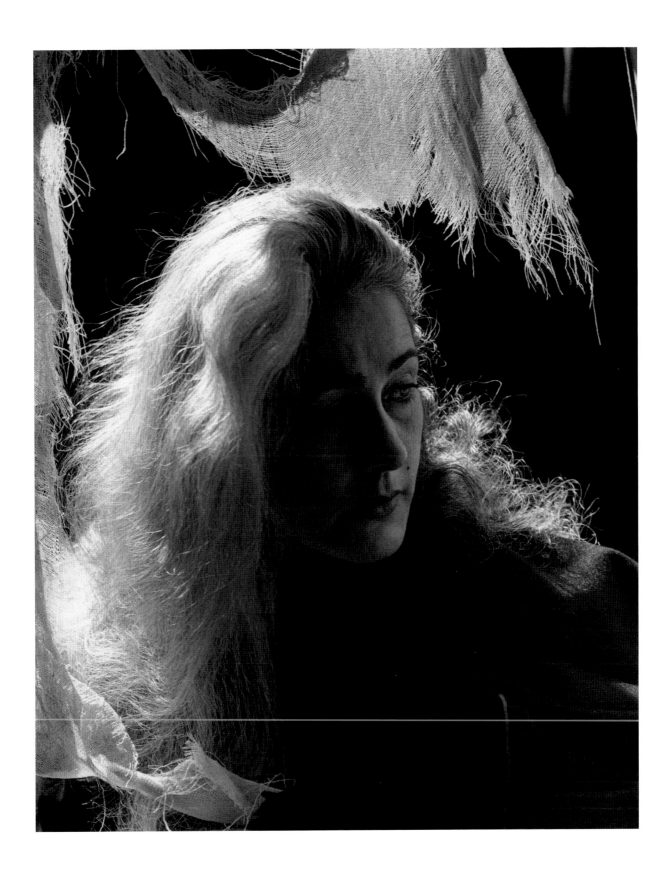

PLATE 194
Woman in Sorrow (Gerrie von Pribosic Gutmann), 1964

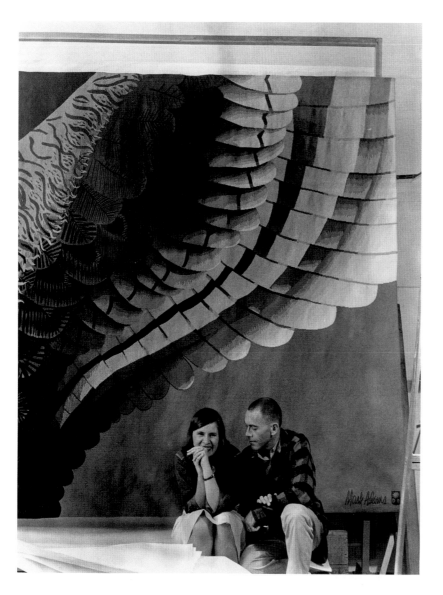

PLATE 195

Mark Adams, Tapestry Designer, and His Wife,
the Printmaker Beth Van Hoesen, 1963

PLATE 196

Adrian Wilson and His Printing Press, 1964

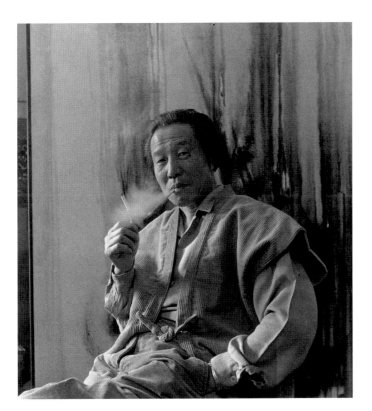

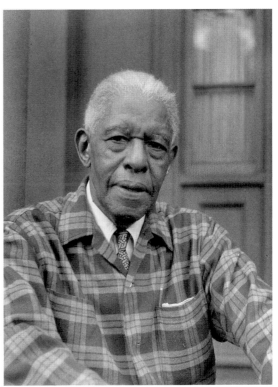

PLATE 197

Hiro, Painter, Portland, 1965

PLATE 198

Roland Hayes, Singer, 1969

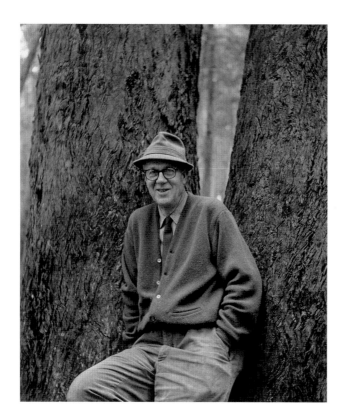

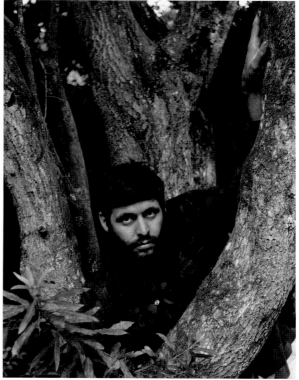

PLATE 199

Wynn Bullock, Photographer 2, 1966

PLATE 200

Fred Padula, Filmmaker, 1967

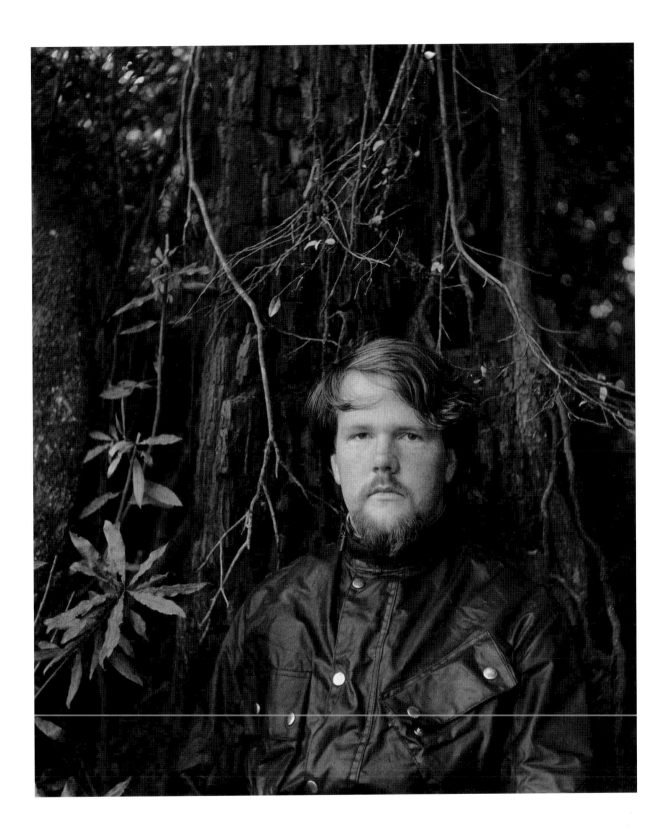

PLATE 201

Peter Adair, Filmmaker, 1967

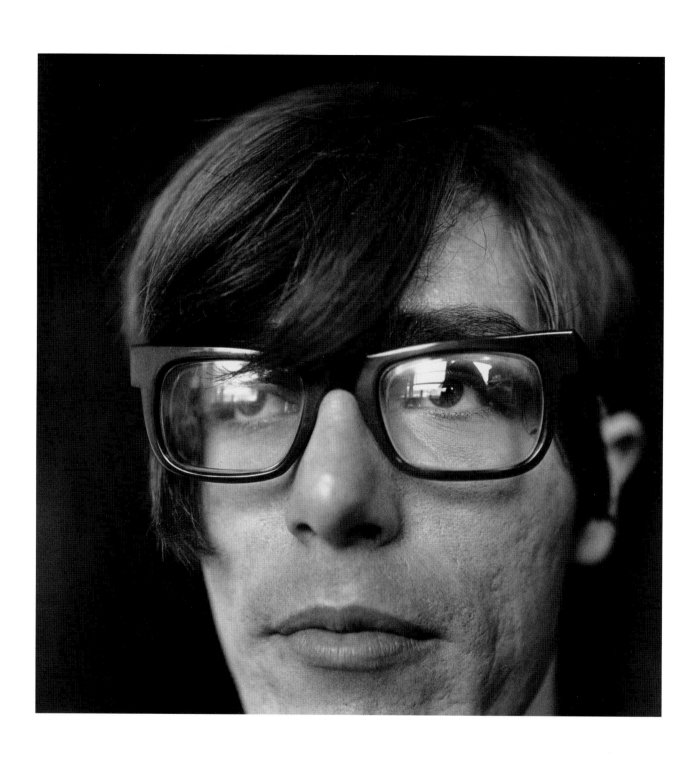

PLATE 202
Lloyd Scott, 1968

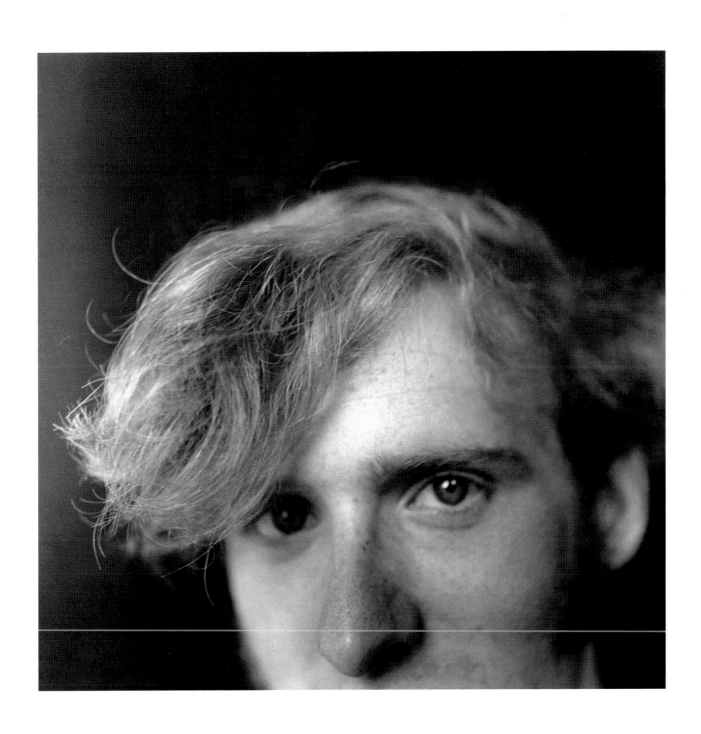

PLATE 203
Thomas Joshua Cooper, Photographer, 1968

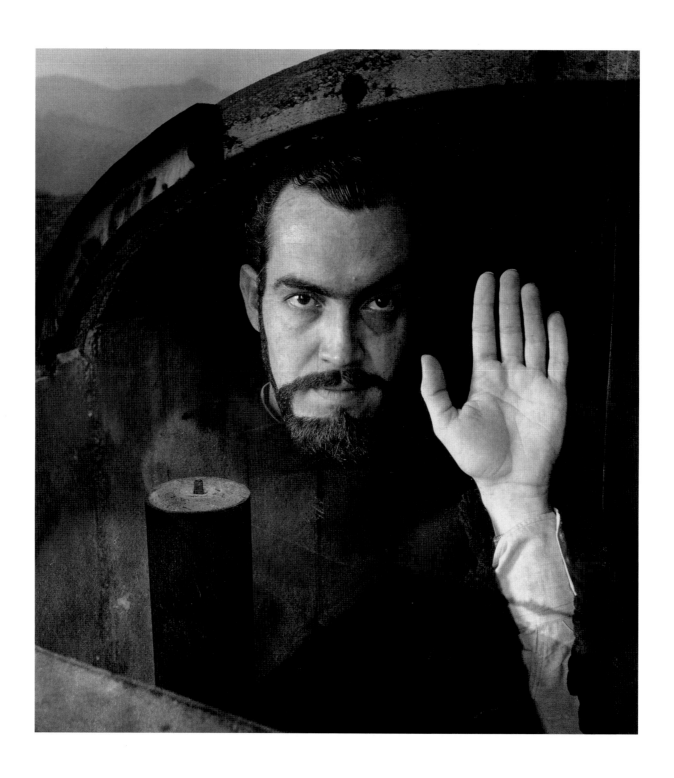

PLATE 204
Warning, 1970

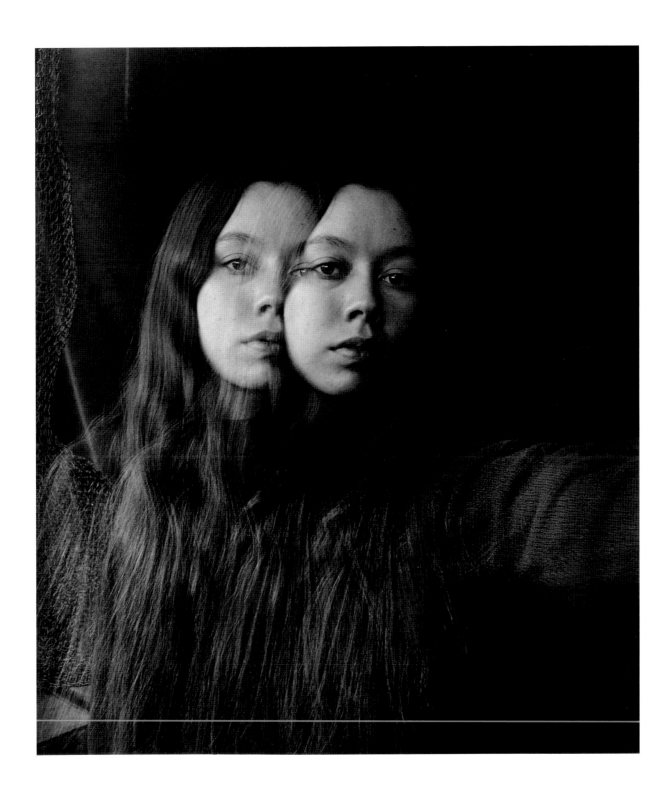

PLATE 205
Two Aikos (Lanier), 1971

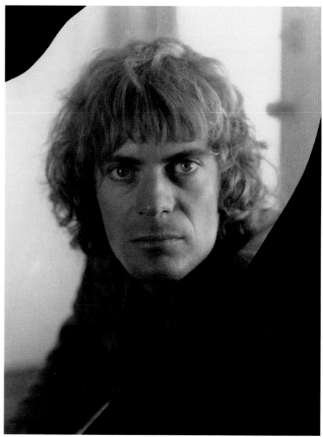

PLATE 206

Chris through the Curtain, 1972

PLATE 207

Dennis, 1972

PLATE 208
Witt the Watchmaker, 1973

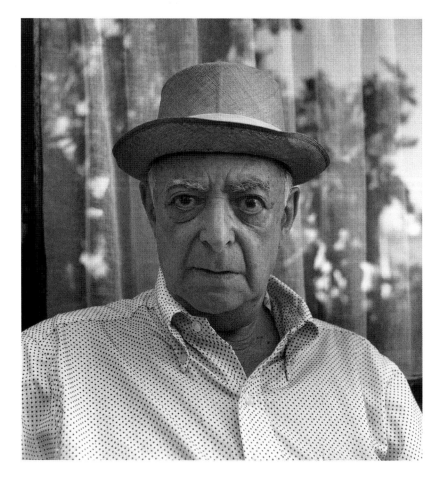

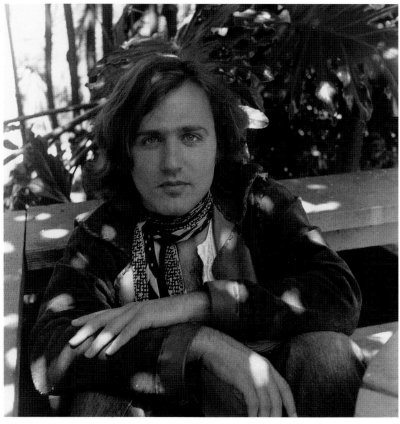

PLATE 209

Brassaï, Photographer, 1973

PLATE 210

Gerard Malanga, Poet, 1973

PLATE 211

Ansel Adams, Photographer 2, 1975

PLATE 212

Martha Ideler, 1975

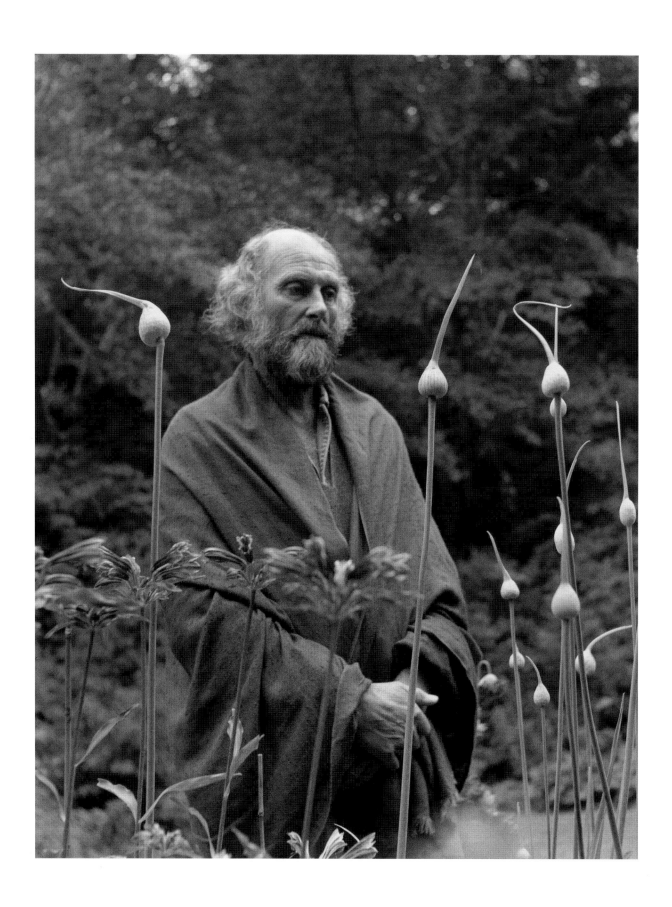

PLATE 213

Morris Graves in His Leek Garden, 1973

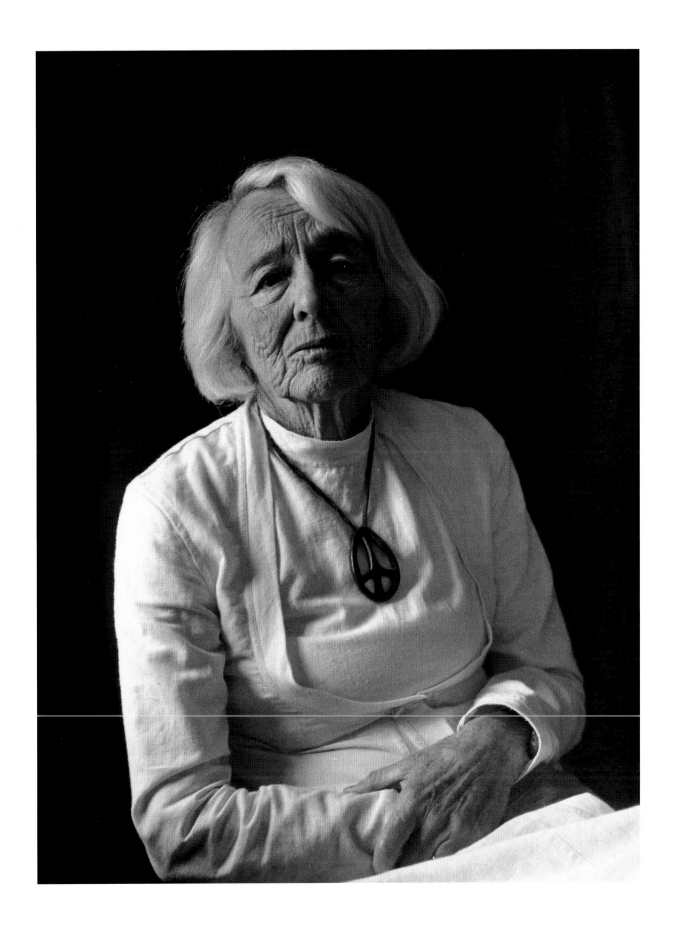

PLATE 214

Dr. Maria Kolisch, Radiologist, 1973

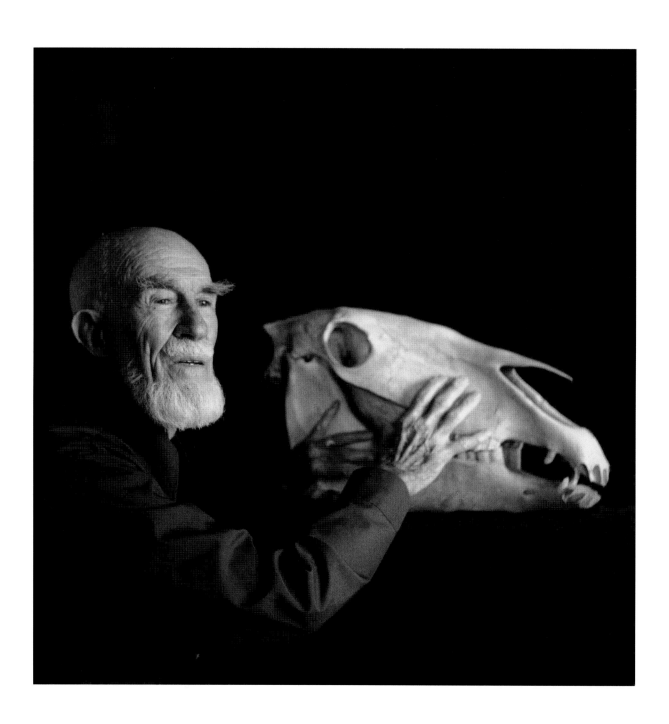

PLATE 215
Roi Partridge and Horse's Skull, 1975

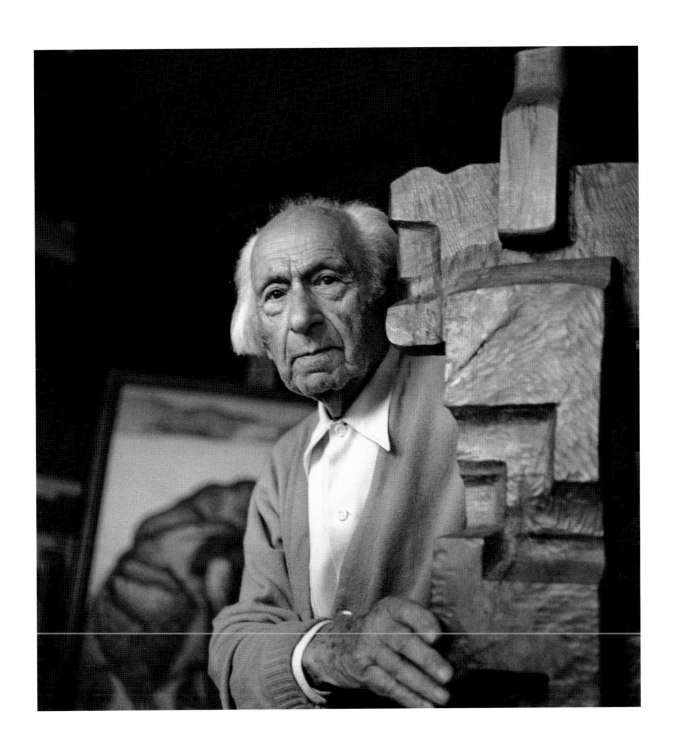

PLATE 216
Peter Krasnow, Sculptor, 1976

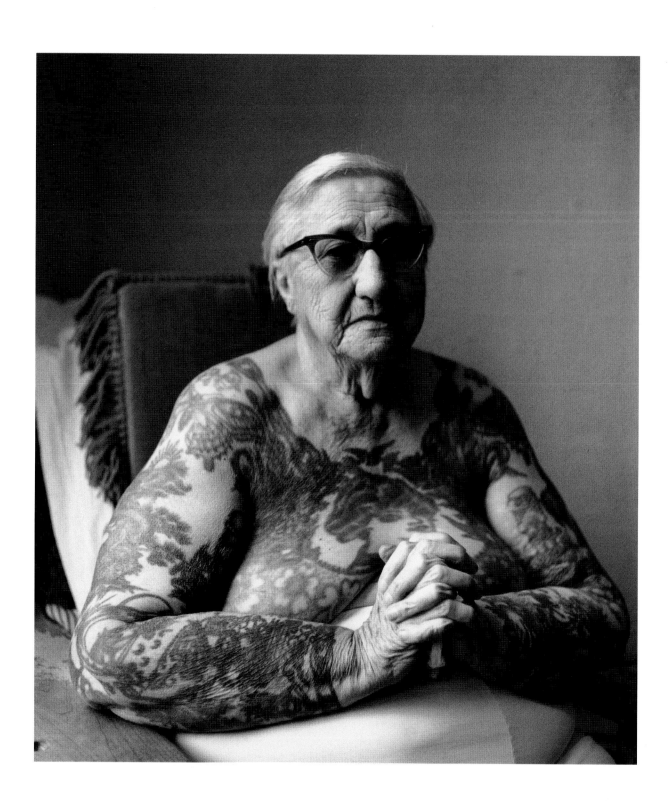

PLATE 217
Irene "Bobbie" Libarry, 1976

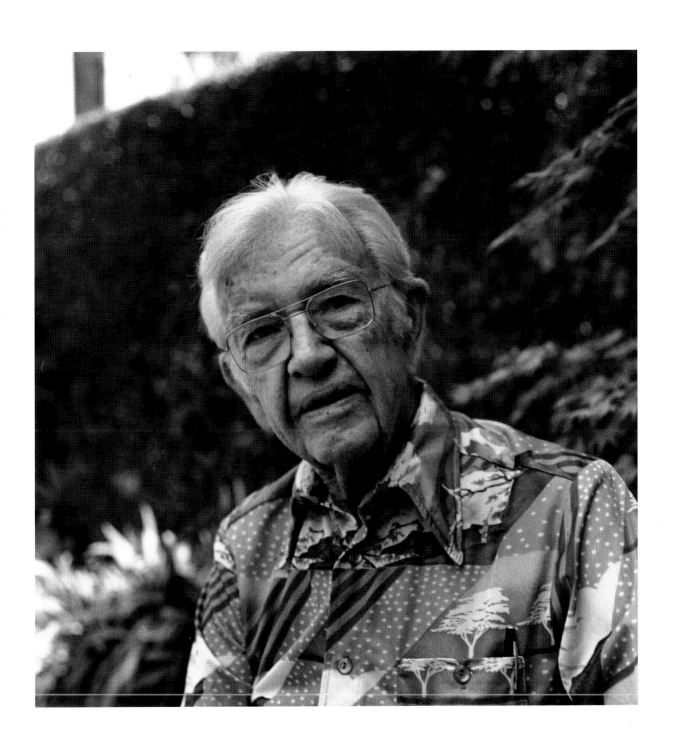

PLATE 218

Karl Struss, Photographer and Cinematographer, 1976

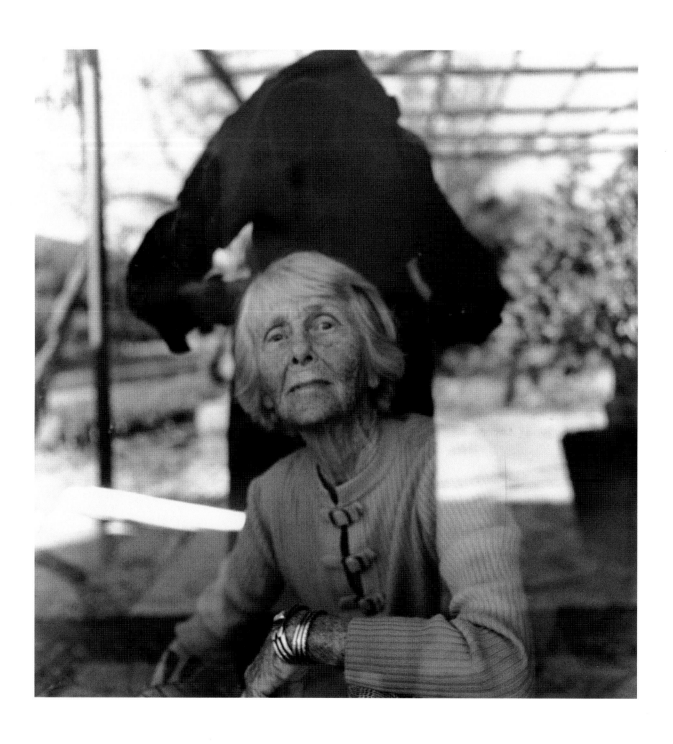

PLATE 219

Self-portrait with Esther Bruton, 1974

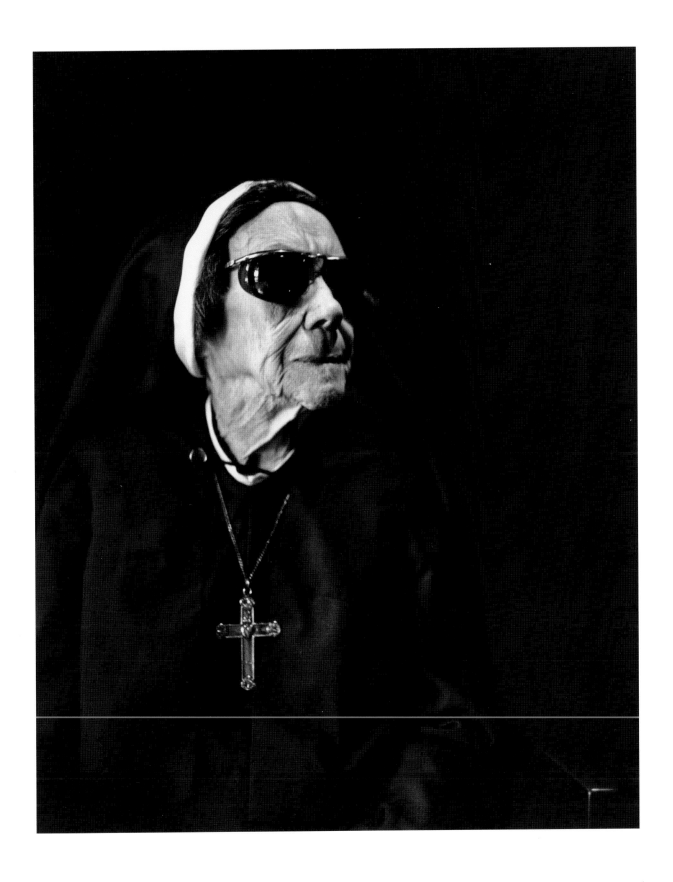

PLATE 220

Nun at Sacred Heart Convent, 1976

Chronology

1883 Born on April 12 in Portland, Oregon, to Isaac and Susan Cunningham.

c. 1889 Moves to Seattle, Washington, with her family.

1903–7 Studies at the University of Washington, Seattle. Majors in chemistry.

1905–6 Acquires a 4-by-5-inch format camera from a mail-order correspondence school. Takes first photographs on the University of Washington campus, including a nude self-portrait out-of-doors.

1907 Writes thesis, "The Scientific Development of Photography." After seeing the photographs of Gertrude Käsebier in *The Craftsman,* she decides to pursue photography as a career. Graduates from the University of Washington.

1907–9 Works in the Seattle portrait studio of Edward S. Curtis. Learns to retouch negatives and print with platinum paper.

1909 Travels to Dresden to study photographic chemistry at the Technische Hochschule. Visits the International Photographic Exposition in Dresden.

1910 Publishes her research on substituting lead salts for platinum in photographic printing paper in *Photographische Rundschau und Photographisches Centralblatt.* Visits Paris and London. In New York, visits Alfred Stieglitz's gallery "291" and meets Gertrude Käsebier. Returns to Seattle and opens a portrait studio at 1117 Terry Avenue.

1913 Publishes "Photography as a Profession for Women" in Pi Beta Phi's journal, *The Arrow.*

1914 One-person exhibitions at the Brooklyn Institute of Arts and Sciences and at the Portland Art Museum, Oregon. Included in the International Exhibition of Pictorial Photography, New York. Illustrated review of her work published in *Wilson's Photographic Magazine.*

1915 Marries Roi Partridge on February 11. Son, Gryffyd, born December 18. Exhibits at the Fine Arts Society, Seattle, with Roi Partridge, John Butler, and Clare Shepard. Included in the Panama-Pacific International Exposition, San Francisco; the Pittsburgh Salon of National Photographic Art; and the Philadelphia Salon.

1917 Moves to San Francisco. Twin sons, Rondal and Padraic, born September 4.

1918 Works in the San Francisco studio of Francis Bruguière. Meets Maynard Dixon and Dorothea Lange.

1920 Moves to Oakland when Roi begins teaching at Mills College. Meets Edward Weston and Johan Hagemeyer.

1921 Resumes commercial portrait business. Photographs the Adolph Bolm Ballet Intime. Creates first sharp-focus nature studies, at Point Lobos, and begins to photograph plant forms.

1922 Joins the Pictorial Photographers of America.

1923 Photographs light abstractions and begins a series of magnolia studies.

c. 1923 Makes first double-exposure photograph.

1928 Included in the Pictorial Photographic Society exhibition, California Palace of the Legion of Honor, San Francisco.

1929 Exhibits at the Berkeley Art Museum. Ten of her photographs included in *Film und Foto* exhibition, Stuttgart.

1931 Photographs Martha Graham in Santa Barbara and Frida Kahlo in San Francisco. *Vanity Fair* reproduces two of her Graham studies and hires her to photograph Hollywood personalities. One-person exhibition at the M. H. de Young Memorial Museum, San Francisco. Exhibits at Julien Levy Gallery, New York.

1932 One-person exhibition at the Los Angeles Museum. Exhibits with Group f.64 at the M. H. de Young Memorial Museum, San Francisco.

1933 One-person exhibition at The Forum Hotel, Oakland.

1934 Included in *Leading American Photographers* exhibition, Mills College Art Gallery, Oakland. Marriage to Roi Partridge ends in divorce in June. Travels to New York for *Vanity Fair*. Photographs Alfred Stieglitz and begins documentary street photography.

1935 One-person exhibition at the Dallas Art Museum. Photographs Gertrude Stein in San Francisco.

1936 One-person exhibition at the E. B. Crocker Art Gallery, Sacramento, California.

1937 Beaumont Newhall includes her in *Photography 1839–1937* exhibition at the Museum of Modern Art, New York. Photographs with 35mm camera.

1938 Begins photographing with 2¼-by-2¼-inch format cameras.

1940 Included in *A Pageant of Photography*, Golden Gate International Exposition, Treasure Island, San Francisco.

c. 1940 Begins photographing in color for *Sunset* magazine.

1941 Included in the *Photographers Exhibition* at Mills College, Oakland.

1947 Moves to San Francisco, where she builds a darkroom and offers portrait sittings.

1947–50 Teaches at the California School of Fine Arts, San Francisco.

1951 One-person exhibition at the San Francisco Museum of Art.

1952 KRON-TV, San Francisco, produces documentary on Cunningham.

1953 One-person exhibition at Mills College Art Gallery, Oakland.

1954 Included in inaugural exhibition at the Limelight Gallery, New York, and *Perceptions* at the San Francisco Museum of Art.

1955 Included in the Bay Area Photographers *San Francisco Weekend* exhibition at the San Francisco Museum of Art. Interviewed by Herm Lenz, along with Dorothea Lange and Ansel Adams, in *U.S. Camera* article, "Interview with Three Greats."

1956 One-person exhibitions at the Cincinnati Art Museum and at the Limelight Gallery, New York.

1957 One-person exhibition at the Oakland Art Museum.

1959 Included in *Photography at Mid-Century*, George Eastman House, Rochester, New York; group exhibition at the Oakland Public Museum; and *The Photograph as Poetry*, Pasadena Art Museum. Edna Tartaul Daniel interviews her for the Regional Oral History Project of the University of California, Berkeley.

1960 The International Museum of Photography at George Eastman House, Rochester, New York, acquires a large collection of her photographs. Travels to Berlin, Munich, Paris, and London. Meets August Sander and Paul Strand.

1961 Travels to Norway, Finland, Sweden, Denmark, Poland, and Paris. Meets Man Ray. One-person exhibition at George Eastman House, Rochester, New York.

1964 One-person exhibitions at the Chicago Art Institute and the San Francisco Museum of Art. Becomes honorary member of the American Society of Magazine Photographers. Experiments with Polaroid film. *Aperture* devotes its winter issue to her work. The Library of Congress acquires a large collection of her photographs.

1965 One-person exhibition at the Henry Art Gallery, University of Washington, Seattle. Included in *Six Photographers 1965* at the College of Fine and Applied Arts, University of Illinois, Urbana.

1965–67 Teaches at the San Francisco Art Institute.

1966 Featured in Fred Padula film, *Two Photographers: Imogen Cunningham and Wynn Bullock.*

1967 Elected a fellow of the American Academy of Arts and Sciences. One-person exhibition at the Stanford Art Gallery, Stanford University, California. Appears in James Broughton's film, *The Bed.*

1968 Receives honorary Doctor of Fine Arts degree from the California College of Arts and Crafts, Oakland. One-person exhibitions at the Museum of History and Technology, Smithsonian Institution, Washington, D.C.; Carl Siembab Gallery, Boston; and the California College of Arts and Crafts, Oakland. Included in *North Beach and the Haight-Ashbury* exhibition, Focus Gallery, San Francisco. Teaches summer session at Humboldt State College.

1970 One-person exhibitions at the M. H. de Young Memorial Museum, San Francisco, and Witkin Gallery, New York. Receives a Guggenheim Fellowship to print her early negatives. John Korty films *Imogen Cunningham: Photographer.* University of Washington Press publishes *Imogen Cunningham: Photographs.* The Smithsonian Institution purchases a major collection of her work. San Francisco Mayor Joseph Alioto proclaims November 12 "Imogen Cunningham Day." *Album* magazine publishes a portfolio of her images.

1971 One-person exhibitions at the Atholl McBean Gallery of the San Francisco Art Institute; 831 Gallery, Birmingham, Michigan; and the Seattle Art Museum. *Creative Camera* publishes a portfolio of her images.

1972 Included in the Group f.64 exhibition at the University Art Museum, University of New Mexico, Albuquerque. One-person exhibition at Ohio Silver Gallery, Los Angeles.

1973 Teaches at the San Francisco Art Institute. The San Francisco Art Commission declares her "Artist of the Year." One-person exhibitions at The Metropolitan Museum of Art, New York; Witkin Gallery, New York; and the San Francisco Art Commission "Capricorn Asunder" Gallery. Included in the International Exhibition of Photography, Arles, France. *Images of*

Imogen exhibition at Focus Gallery, San Francisco. Begins After Ninety project on old age.

1974 Receives the University of Washington's Alumnus Summa Laude Dignatus award. The University of Washington Press publishes *Imogen!* Cunningham donates selected papers to the Archives of American Art, Smithsonian Institution. One-person exhibitions at the Henry Art Gallery, University of Washington, Seattle, and the Oakland Museum.

1975 Creates the Imogen Cunningham Trust on February 14 to continue the preservation, exhibition, and promotion of her work. *Camera* magazine issues "Homage to Imogen" in October. One-person exhibitions at John Berggruen Gallery, San Francisco; Chevron Gallery, San Francisco; and the Occidental Center Gallery, Los Angeles. Included in the *Women of Photography* exhibition at the San Francisco Museum of Art. Receives honorary Doctor of Fine Arts degree from Mills College, Oakland.

1976 Profiled in CBS documentary. One-person exhibitions at the Stanford Art Gallery, Stanford University; the Strybing Arboretum, San Francisco; and Grapestake Gallery, San Francisco. Dies on June 23.

Selected Bibliography

Maschmedt, Flora Huntley. "Imogen Cunningham—An Appreciation." *Wilson's Photographic Magazine* 51, no. 3 (March 1914), pp. 96ff.

Internationale Ausstellung des Deutschen Werkbunds: Film und Foto. Exhibition catalogue. Stuttgart, 1929.

Prall, D. W. *Aesthetic Judgment.* New York: Thomas Y. Crowell Company, 1929.

"'Impressions in Silver' by Imogene [*sic*] Cunningham." *Los Angeles Museum Art News,* April 1932.

Berding, Christina. "Imogen Cunningham and the Straight Approach." *Modern Photography* 15, no. 5 (May 1951), pp. 36ff.

Lenz, Herm. "Interview with Three Greats: Lange, Adams, Cunningham." *U. S. Camera* 18 (Aug. 1955), pp. 84–87.

Hall, Norman. "Imogen Cunningham: Sixty Years in Photography." *Photography* (London) 15 (May 1960), pp. 20–25.

Daniel, Edna Tartaul. "Imogen Cunningham: Portraits, Ideas, and Design" (transcript of 1959 interview). Berkeley, Calif.: Regional Cultural History Project, General Library, University of California, Berkeley, 1961.

White, Minor, ed. "Imogen Cunningham." *Aperture* 11, no. 4 (1964).

Imogen Cunningham, Photographs 1921–1967. Exhibition catalogue. Foreword by Beaumont Newhall. Stanford, Calif.: Stanford Art Gallery, Stanford University, 1967.

Imogen Cunningham: Photographs. Seattle: University of Washington Press, 1970.

Jay, Bill. "Imogen Cunningham." *Album* (London) 5 (June 1970), pp. 22–38.

[Osman, Colin]. "Photographs by Imogen Cunningham." *Creative Camera* (London), no. 85 (July 1971), pp. 222–31.

Massar, Phyllis Dearborn. *Photographs by Imogen Cunningham.* Exhibition catalogue. New York: Metropolitan Museum of Art, 1973.

Imogen! Imogen Cunningham Photographs 1910–1973. Seattle: Published for the Henry Art Gallery by the University of Washington Press, 1974.

Kramer, Hilton. "Remembering Cunningham and White." *New York Times,* Aug. 1, 1976.

"Remarkable American Women 1776–1976." *Life,* special report, 1976, p. 43.

After Ninety, Imogen Cunningham. Seattle: University of Washington Press, 1977.

"Imogen Cunningham: The Queen." *Newsweek,* Oct. 21, 1974, p. 67.

Cooper, Thomas Joshua, and Gerry Badger. "Imogen Cunningham: A Celebration." *British Journal of Photography Annual 1977* (1978), pp. 126–39.

Dater, Judy. *Imogen Cunningham: A Portrait.* Boston: New York Graphic Society, 1979.

Mozley, Anita Ventura. "Imogen Cunningham: Beginnings," in "Discovery and Recognition." *Untitled* 25 (1981), pp. 41–45.

Imogen Cunningham, Frontiers: Photographs 1906–1976. Exhibition catalogue. Text by Richard Lorenz. Berkeley, Calif.: The Imogen Cunningham Trust and United States Information Agency, 1987.

The Eclectic Spirit: Imogen Cunningham. Exhibition catalogue. Essay by Richard Lorenz. Glasgow: Glasgow Museum, Kelvingrove, 1990.

Rule, Amy, ed. *Imogen Cunningham, Selected Texts and Bibliography.* Essay by Richard Lorenz. Oxford: Clio Press, 1992.

Lorenz, Richard. *Imogen Cunningham: Ideas without End, A Life in Photographs.* San Francisco: Chronicle Books, 1993.

————. *Imogen Cunningham: The Modernist Years.* Tokyo: Treville, 1993.

Imogen Cunningham: The Poetry of Form. Exhibition catalogue. Introduction by Pradip Malde. Frankfurt: Fotografie Forum and Edition Stemmle, 1993.

Lorenz, Richard. *Imogen Cunningham.* Exhibition catalogue. New York: Howard Greenberg Gallery; Berkeley, Calif.: The Imogen Cunningham Trust, 1995.

————. *Imogen Cunningham: Flora.* Boston and New York: Bulfinch/Little, Brown, 1996.

Acknowledgments

Imogen Cunningham: Portraiture would not have been possible without the trust, cooperation, and generosity of the entire Partridge family. Cunningham's three sons and their wives, Gryff and Janet Partridge, Padraic and Marjorie Partridge, and Rondal and Elizabeth Partridge, have shared valuable information, archival materials, and photographs for the preparation of this book. As administrators of the Imogen Cunningham Trust, Rondal and Elizabeth Partridge have spent countless hours in producing and preparing the prints for the book from Cunningham's original negatives, and to them I am forever grateful. The able assistance of Katie Pratt, Joshua Partridge, and Craig Withrow at the Cunningham Trust has also helped enormously.

Ed Marquand of Marquand Books has once again proved to be invaluable as an advisor and friend, and deserves the most sincere appreciation for bringing this book to publication. It would be impossible for me to work without the keen editorial skills and advice of Suzanne Kotz, who has again, as in our past projects, streamlined the text into coherence. Rondal Partridge has printed with remarkable skill and patience all the reproduction photographs from Cunningham's original negatives and transparencies. M. Lee Fatherree has also provided several superb copy photographs for text illustrations.

I would like to thank Robert G. Smith for his valuable support and encouragement, and I am ever appreciative to Trisha Schaller for her generous assistance. Thank you, Patricia Lorenz and Eric Jacobs, and the many other friends and colleagues who deserve heartfelt gratitude: Nona R. Ghent, Larry Newhard, Robert McDonald, Judith Dunham, Edward De Celle, Arthur Tress, Van Deren Coke, and Evangeline J. Montgomery of the United States Information Agency-Arts America.

Professional thanks are due the many individuals who generously provided time and information to this project: Dianne Nilsen, Amy Rule, and Trudy Wilner Stack, Center for Creative Photography, University of Arizona; Drew Johnson and Janice Capecci, The Oakland Museum; Joseph Struble, Janice Madhu, and Barbara Puorro Galasso, International Museum of Photography at George Eastman House; Katherine Ware, The J. Paul Getty Museum; Patricia Willis and Lynn Braunsdorf, The Beinecke Rare Book and Manuscript Library, Yale University; Anna Koster, de Saisset Museum, Santa Clara University; and Amy Conger.